COVERED IN INK

Covered in Ink

Tattoos, Women, and the Politics of the Body

Beverly Yuen Thompson

NEW YORK UNIVERSITY PRESS

New York and London

NEW YORK UNIVERSITY PRESS
New York and London
www.nyupress.org

References to Internet websites (URLs) were accurate at the time of writing.
Neither the author nor New York University Press is responsible for URLs
that may have expired or changed since the manuscript was prepared.

Library of Congress Cataloging-in-Publication Data
Thompson, Beverly Yuen.
Covered in ink : tattoos, women, and the politics of the body /
Beverly Yuen Thompson.
pages cm. — (Alternative criminology series)
Includes bibliographical references and index.
ISBN 978-0-8147-6000-0 (cl : alk. paper)
ISBN 978-0-8147-8920-9 (pb : alk. paper)
1. Women—Psychology. 2. Tattooing—Social aspects. 3. Body image
in women. I. Title.
HQ1206.T4676 2015
306.4'613—dc23 2015004163

New York University Press books are printed on acid-free paper,
and their binding materials are chosen for strength and durability.
We strive to use environmentally responsible suppliers and materials
to the greatest extent possible in publishing our books.

Manufactured in the United States of America

10 9 8 7 6 5 4 3 2 1

Also available as an ebook

CONTENTS

ACKNOWLEDGMENTS

This book is dedicated to the women who shared their stories to make this book possible.

This book could not have been completed without the ongoing assistance of those at NYU Press: Jeff Ferrell, Ilene Kalish, Caelyn Cobb, Dorothea Stillman Halliday, Jennifer Dropkin, and Charles B. Hames.

Also, my mother, Margaret Yuen, and her unending support.

Finally, my father, Robert G. Thompson (even though he hates tattoos).

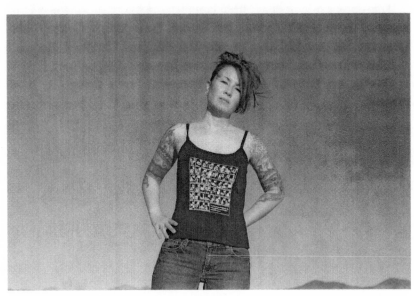

Figure 1.1. Beverly Yuen Thompson, author.

Introduction

Becoming Covered

Genesis

Right hip. My first tattoo was nothing special; it was regrettable, even. I was seventeen years old and attending Cornish College of the Arts in Seattle. Somehow, I had become consumed by a destructive relationship. He owned a coffee shop across the street from a tattoo studio owned by Vyvyn Lazonga—one of the most prominent female tattoo artists in the nation. I did not know Vyvyn was famous at the time. I didn't even know the difference between a good tattoo and a bad tattoo. But somehow, we mutually agreed to the unfortunate plan of getting a tattoo to commemorate our unstable relationship. It was matching, of course, combining his zodiac sign Leo and a women's symbol, representing my budding feminism. The tattooist, Tina Bafaro, luckily talked us out of getting "his/her name forever" scripted beneath the symbol. She said many people who got relationship tattoos broke up. She had accurately predicted our future ending. While this first tattoo was based on an unfortunate decision, I had been lucky enough to end up in one of the best studios, filled with amazing women artists. That left an impression on me.

Left upper arm. When I got my second tattoo—the word "feminist" scripted on my outer left arm—I returned to Tina. I felt so strongly about my developing political consciousness that I wanted the identifier branded on my arm permanently. I wanted the cursive script to be in rainbow colors, one color for each letter. Tina pointed out that different colors would be more visible than others and fade at different rates, making the word illegible. The script needed to be solid black ink. Two symbolic snakes wrapped around the back of the arm, illustrated with a few different colors, creating a band with the scripted word. I learned

to trust the tattooist with the visual representation—she was the professional artist and I was not. I was quickly realizing this while attending art school. I could not draw, it turns out. But I gained an immense respect for the talent it took to be able to render an idea visually. The tattoo was the perfect symbol of my commitment to my awakening political identity.

Right shoulder. At nineteen, I was back in Spokane, my hometown, spending my days doing undergraduate course work in Charissa Vaunderbroad's tattoo shop while she tattooed. We would team up and talk to the customers about their tattoo ideas. I couldn't help but collect several tattoos from her during this time idling in the shop, in exchange for mixed tapes and a few $20 bills that I begged off my father. I was back living in my dad's house while finishing my last year of college. During study breaks, I planned out tattoo designs with Charissa. The first tattoo she did on me was the character Hothead, from the graphic novel *Hothead Paisan: Homicidal Lesbian Terrorist.*[1] This comic followed the misadventures of the anti-hero Hothead, a scrawny, androgynous, pissed-off dyke, constantly confronting misogynist culture. But she was not beat down by the daily humiliations. She had weapons. To me, this comic was an outlet for the anger I felt at the discrimination I endured based on gender and race. I felt powerless to fight back in my real life. I selected an iconic image of Hothead, her face scrunched up, disgusted with the world. Two "ai-ai" little girls, one with a gun, the other with a knife, were in the background. Hothead's pet cat Chicken, always providing the calming voice of reason against Hothead's destructive impulses, was on the back of my shoulder. We didn't start this tattoo until eleven o'clock at night. Tattooing is an intimate, embodied act, and the relationship between the individuals affects the interaction. All day, Charissa had been tattooing people she would have rather not. But between friends, it was a special, bonding event.

Right arm. The next tattoo I received from Charissa, a band on the same arm as my Hothead tattoo, was all about our friendship, and again, feminist politics. I didn't even know what I wanted image-wise; I just wanted her to tattoo me again. "You design it," I offered. "Just make it about women's empowerment, somehow." She drew three different stylized goddesses with colorful patterns in the background. At first, we couldn't decide on the colors. For weeks, she would color in the tattoo

outline with Sharpie pens to try out the different color variations. We worked slowly. The tattoo took nearly eight months, as we worked on it in short spurts. Looking back, I prefer to have tattoo designs planned out long before I acquire them. But this one was spontaneous. And lacking such planning, in the end, I had trouble accepting the design. This band was the most visible tattoo I had, nestled right above my elbow and the "ditch," as tattooists call it, or the bend of my arm. With this more prominent tattoo, I was starting to attract more attention, of both the wanted and unwanted kinds. Strangers on the street, in stores, or at school would stare at the ink on my arms and ask all kinds of questions about the process of tattooing. They would ask silly and uninformed questions, with "Did that hurt?" or "What does that mean?" being among the more common inquiries. Sometimes they would be belligerent and rude. They would touch the tattoo, and I would recoil in shock. Or they would say that they loved the tattoos, but often used awkward phrases that would leave me uneasy: "Nice tats," which sounded too close to "Nice tits," and "Love the ink," which was just so impersonal and insincere. "What does that mean?" was too personally invasive and left me at a loss for what to say without having to reveal the intimate details of my life and ideological orientation.

Right upper arm. Years later, while attending graduate school at the New School for Social Research in New York, the desire for a tattoo hit again. I wanted a big colorful snake on my right arm. It would twist and turn its way underneath the armband and past Hothead, ending right above the cat named Chicken. I found the tattooist Emma Porcupine (now Emma Griffiths) because she was known for tattooing the feminist folk singer Ani DiFranco as well as the author of the *Bamboo Girl* zine, Sabrina Margarita Alcantara. Over three sessions at her studio on the Lower East Side, Emma tattooed a vivid green snake twisting its way from my elbow to over my shoulder. Later, we added gray shading of Japanese-like waves in the background, completing a solid half sleeve on my right arm. Now I had really crossed the line for appropriate tattoos for women. I had started to wear clothing to cover up the tattoo in various settings. I was becoming increasingly sensitive to the attention that my tattoos attracted. In my graduate classes, if I exposed my tattoos, I felt that my professors were judging me. I was introverted and never spoke in class; they didn't have much on which to base their opinion

of me otherwise. I felt that my tattoos were beautiful and reflective of my inner self, yet I feared misunderstanding from the general public. This discrepancy between my self-expression and public perception became more of a factor in my daily life. The snake's head slithered its way past my elbow and onto my forearm, its tongue exploring the territory. What would I wear today? Living in Manhattan's Chinatown, I feared the intense scowls of the older Chinese women as they passed me on the streets. I would wear a sweater in the middle of steamy summers, just to avoid their socially sanctioning glares.

Left shoulder. In graduate school, I had written my dissertation on the "anti-corporate globalization" movement, as it was crudely labeled at the time by the corporate media. I had been swept up in the excitement of a vibrant social movement emerging so suddenly with the World Trade Organization protests in Seattle during December 1999. It consumed me for years. However, the beginning of the war in Afghanistan, and then in Iraq, quickly shifted the anti-corporate globalization movement into an anti-war movement. While writing my dissertation, I got another tattoo. It was an antique scroll with the First Amendment scripted within, placed on my left shoulder. Since then, I joke that it is a historical document, a reminder of liberties once granted. The "feminist" armband capped off the First Amendment scroll, appropriately enough. These tattoos show that I am someone who wears her politics on her sleeve.

My story exemplifies many typical qualities of a tattoo collector. First tattoos are often less thoughtful than subsequent designs and can be rushed into to mark adulthood or permanently emblaze a passing fancy. However rudimentary, tattoos often symbolize something that the wearer has a strong emotional attachment to, be it a pop cultural reference, a hobby, a relationship, a life event, or a material item. Most people stop after receiving one, two, or three tattoos and therefore do not become involved in the subcultural world of tattooing. People with a few small tattoos can be referred to as "lightly tattooed." While tattoos were historically considered a masculine domain, often associated with hyper-masculine subcultures such as the military or criminal cultures, women have had different experiences with tattoos. While men can collect many tattoos, which serve to strengthen their masculine identity, women's tattoo collections can threaten their feminine identity—unless

they specifically choose feminine tattoos. Women are socially pressured to keep their tattoos feminine in design (flowers, dolphins, fairies), placed in a few areas (hip, breast, ankle), and small in size. When women cross these permissible designations and collect tattoos that are of so-called masculine design (snakes, skulls, zombies), visibly placed (forearm, leg), and large in size, they begin to receive social sanctions that reinforce the deviant-ness of tattooing, as well as the gender transgression of the design. By crossing these lines, a collector becomes "heavily tattooed." This book is about heavily tattooed women and their related social interactions. While most lightly tattooed individuals usually do not have a strong connection to the tattoo subculture, those who become heavily tattooed are more likely to have such an association. By spending time in tattoo shops and at conventions, reading tattoo magazines, and watching tattoo television shows, one becomes more immersed in the culture and, often, becomes more heavily tattooed. This affects one's future tattoo collection with regard to design and volume. Just as the sociologist Howard Becker explored the career of the "marihuana user," who learns the rituals of the practice, so too do I explore heavily tattooed collectors and their social practices as they learn to live up to the norms of the subculture and to adopt mechanisms to mitigate mainstream sanctions against tattooing.[2]

My tattoos got me in trouble. Viewer impression management became a part of my daily life process. I was attracted to the power of tattooing because it provided me with a way to alter my body and express my personality. As a mixed-race Chinese/White and petite woman, I face stereotyping. Tattoos helped me counteract my immutable, embodied characteristics. But this bodily alteration brought me unexpected—and unwanted—attention. It also brought unexpected touching from strangers, as if tattooed skin would feel different. Tattooed people cannot guarantee that the message they are trying to express is actually the one received. Often, there is miscommunication.

I had questions about this subculture I had inadvertently entered: Did other tattooed women have similar experiences? What were the stories behind other people's tattoos? Why were they drawn to them as a form of self-expression? For others, was recounting their tattoo narratives also like reading from a journal of their lives? Did they receive the same kinds of public attention? What were the responses from family,

employers, and acquaintances? Since women artists had done all of my tattoos, I wondered about their position within the industry. Tattooing remains male dominated but is less so each year, as more women enter the profession and secure a place within the industry.

This book is an ethnographic exploration of the social worlds of heavily tattooed women and women tattooists working in the industry. When tattoo collectors begin to modify their bodies with tattoo art, social relationships are transformed as well: Family members may scoff, employment opportunities may shrink, and strangers may stare. For women, this attention also holds a gender component, as they are considered gender transgressive, challenging the ideal of "beauty" to which women are supposed to aspire. For many women, tattoos symbolize a reclaiming of their bodies and a form of resistance to normative femininity, or at least an alternative to it. This research was conducted between 2007 and 2010 and includes participant observation and in-depth interviews with seventy women (and a few men) who are either heavily tattooed or tattoo artists, or both. Participant observation took place at tattoo conventions and tattoo studios across the nation. Some of the primary research cities include Spokane, Washington; Miami; Orlando; Houston; Long Beach, California; and Seattle. With this research, we can look at contemporary ethnographies of tattooed bodies (and other deviant styles) and understand what a sociological perspective, in particular, has to offer. *Covered in Ink* fits within this context of ethnographies of deviant groups.

Sociological Ethnographies of Deviant Styles

Historically, written accounts of tattoo collectors have focused on men in prisons or psychiatric hospitals.[3] These captive bodies were accessible for some researchers and provided the most compelling stereotype of the tattooed body. Tattooing was a popular practice with gangs and in male prisons; therefore tattoos came to be associated with criminality. Researchers—usually psychologists or criminologists—often went inside these human laboratories to conduct further research on tattoos and generalized their findings to people outside of the prison walls. This criminality was particularly male in nature, yet tattooed females were also stigmatized with the tint of criminality. Because criminality

and deviance for women are often represented in a sexually objectifying manner, women's tattoos came to signify female criminality, often prostitution, or as markers of sexual property by bikers and gang members. However, the criminality associated with tattooing historically affects men and women differently. While men appear more masculine, tough, and potentially criminal with their extensive tattooing, tattooed women report being treated like prostitutes or as sexually adventurous women by strangers. While this historical stigmatizing research was often conducted by medical researchers (physicians, nurses, and psychologists), for the purposes of this book, I want to consider what sociology—in particular, the tradition of sociology that is called "symbolic interaction"—can offer to our understanding of deviant style. Symbolic interaction focuses on the microinteractions that take place in daily life to reinforce social structures and belief systems. For example, a stranger reacting with curiosity or hostility toward a woman's tattoos reinforces the ideology that tattoos are deviant. What are described as "gender role scripts" are played out in microinteractions through language and behavior.

In *Crimes of Style*, the criminologist Jeff Ferrell demonstrates the connection between dress style and presumed criminality.[4] For the subjects in the book, their self-presentation or appearance itself attracts the attention (and harassment) of the authorities and moral crusaders, who perceive these deviant styles as indicators of criminality. These styles can include tattoos and body modifications, as well as baggy or sagging pants, graffiti-style clothing, gang colors (blue and red), or shaved heads. These topics are also explored in Robert Garot's book *Who You Claim*, in which he breaks down the symbolism of performing such an identity that goes far beyond any clothing signifiers.[5] In *Cultural Criminology*, Jeff Ferrell and Clinton R. Sanders examine the intersection of criminality and style. Ferrell writes of

that most delicate but resilient of connecting tissues between cultural and criminal practices: style. As will be seen, *style* is considered here not as a vague abstraction denoting form or fashion, but as a concrete element of personal and group identity, grounded in the everyday practices of social life. . . . More broadly, a focus on style begins to expose the lived dynamics of inequality and injustice, the ongoing social process by which

discriminatory legal practices and emerging criminal identities are con-
structed and continued in the situations of daily life.[6]

Ferrell's work provides an important insight for our understanding
of how a heavily tattooed appearance is perceived by the public. This
connection—however historic—between criminality, gangs, and pris-
ons and tattooing continues to be made by the viewer. This background
can help us understand how the stigma of tattooing persists—even as
it is lessening. This topic will be explored in depth in the next chapter.

In Ferrell's books, the criminality and styles discussed are within an
overwhelmingly masculine arena. Our social understandings of crime,
gangs, and prisons are usually focused on the male experience. Are tat-
toos even associated with women in prison? How are deviant styles dif-
ferent for women? As we can imagine, women are more often sexualized
in their deviance, and if they are viewed as criminal, it is often crimes
of a sexual nature that are emphasized, prostitution in particular. Those
women who engage in transgressive styles are often labeled "sluts." Lau-
raine Leblanc conducted participant observation from 1993 to 1995 in
punk subcultures in four North American cities and interviewed forty
girls for her book *Pretty in Punk*.[7] This book shows a community of
women whose primary deviance is one of style and not one of crimi-
nal participation (except for low-level loitering, underage drinking, and
possible drug consumption). These girls may or may not have tattoos,
as many are still legal minors; however, they receive extreme social and
personal harassment directed at their manner of style: punk hairstyles
(shaved heads, mohawks, spikes, unnatural colors, and dreads), dress
(black clothing, punk band shirts, ripped fishnet stocking, combat
boots, short skirts, excessive makeup, and mixing both feminine and
masculine attire), and, possibly, aggressive public behavior, as well as
panhandling. Leblanc's research demonstrates that women's stylistic
deviance often provokes gender-specific harassment (e.g., slut shaming).

A few notable ethnographies focusing on tattoos, in particular,
have recently been published that represent an empathetic turn, away
from the more historical, stigmatizing medical literature.[8] In *Custom-
izing the Body*, Clinton R. Sanders conducted participant observation
in four tattoo studios on the East Coast, spanning seven years during
the 1980s. Sanders's research was based on over 160 questionnaires and

tape-recorded interviews with participants (68 percent were men, and 32 percent were women).[9] The women he interviewed primarily collected small, gender appropriate tattoos:

> The six women interviewees possessed eight tattoos—three on the back or the shoulder area, three on the breast, one on an arm, and one on the lower back. Thirty-five percent of female questionnaire respondents received their first tattoo on the breast, 13 percent on the back or shoulder, and 10 percent on the hip.[10]

Sanders's female participants demonstrate how gender-appropriate tattoos for women were more popular in the 1980s. While Sanders conducted his seven years of fieldwork in tattoo studios, he also began getting tattooed himself, a personal collection of body art that became quite extensive over the years.

Margo DeMello states in the introduction to her book *Bodies of Inscription* that she "defines herself as both insider and outsider to the tattoo community" and does not offer "an 'objective' account of tattooing."[11] She describes her previous involvement in the community as such:

> I have been getting tattooed since 1987 and have defined myself as a member of the tattoo community since 1988 when I began attending tattoo conventions and reading tattoo magazines, as well as collecting more extensive tattoos. . . . [I am] married to a brand-new tattooist.[12]

DeMello's aim was to "explore the current middle-class repackaging of the tattoo" and how its members constitute the "tattoo community." In contrast to Sanders' study, DeMello states that she "spoke with many more women than I did men . . . [and] my informant base was heavily skewed toward the middle class."[13] Since DeMello primarily found her participants at tattoo conventions and online forums, the women with whom she spoke most likely had more than one tattoo, since active community membership implies a dedication to the art. Thus DeMello's study provides insight into the experience of heavily tattooed women and demonstrates how women began to collect more extensively over time.

Michael Atkinson's book *Tattooed* attempts to "explain why a noticeable number of Canadians are tattooing their bodies at this juncture in our cultural history."[14] He spent a few years conducting participant observation at tattoo studios in Calgary and Toronto, thus providing an international comparison. Atkinson had easy access to the tattoo community because he was already an avid tattoo collector.[15] He interviewed a total of ninety-two individuals, forty-four of whom were women. Out of the twenty-seven tattoo artists he interviewed, only four were women. By publication in 2003, he said, "To date, I have only met two female tattoo artists in Canada."[16] And again, the majority of his female participants were lightly tattooed.

More recently, Victoria Pitts researched dozens of body modifiers at public events between 1996 and 2000 for *In the Flesh*.[17] While the previous ethnographies focused on (mostly lightly tattooed) mainstream tattoo collectors, Pitts's study focused on "modern primitives," or those more extreme in their body adornments, with extensive piercing, tattooing, scarification, branding, and so on. Pitts's primary objective was to examine

> the ethnic and racial coding of body practices by white, largely middle-class Westerners, which I believe is an extremely important issue raised by the body modification movement. I place this issue in a postcolonial theoretical context.[18]

While Pitts's research has primarily White participants, like the other studies, she introduces a racialized perspective into her work—in particular, she examines the ways in which White middle-class Americans articulate their adoption of indigenous practices from other countries and contexts. Additionally, her women interviewees were more extensive and transgressive in their body modifications, providing more nuanced insight into gender transgression. While most of the authors include men and women with one or more tattoos, Pitts's interviewees have extensive body art (including piercings, tattoos, scarification, and brandings). For women, having one tattoo is not gender transgressive, as it has become widespread for them to have small, cute, and hidden tattoos; however, having large, public, and gruesome tattoos (zombies, skulls, snakes) invokes social sanctions along gender expectations.

These sociological ethnographies, which have focused on deviant styles and tattoo collecting, provide a foundation for *Covered in Ink*. From these studies we learn that women recently began to collect more visible tattoos. Transgressive styles of tattooing have different implications for men and women. While the participants of Ferrell and Garot's studies—often men of color or poor Whites—face profiling by authorities, White women who transgress femininity are targeted with more interpersonal social sanctions in public, as I explore in the following chapters. Women of color, however, may encounter more of the criminological gaze than White women, who have a wider arena of self-expression. There are other racial differences in how women experience their tattooing practices as well as the social interactions responding to such, yet unfortunately, those nuances are not more fully teased out in this book, and I hope other scholars will contribute to this discussion. What follows is a brief methodological overview for and outline of *Covered in Ink*. While many of these chapter topics are mentioned briefly in the previous ethnographies, *Covered in Ink* gives particular attention to interactions in different institutions and the impact of the interactions on the participants.

Finding Participants

Recently, a student living in Chicago emailed me, looking for advice on making her own short documentary about tattooed women and society's perceptions of them. She sounded excited about her project and was seeking advice on how to get started. She had only one semester to complete the entire project; luckily, she was blissfully unaware of how much work she needed to do. Her second email was less enthusiastic. Reality, it seemed, was dawning. She wanted to find a diverse group of tattooed women to interview for her project; however, she was already getting negative feedback during her attempts to find participants. She was having trouble finding any participants at all, let alone diverse ones. Perhaps she would just make an "audio documentary" she wrote to me in frustration, "it is too late to select another topic for my project." When she approached tattoo shops, she was put off with comments such as "I'm camera shy," and "I would do it, but something just came up." Other folks would not return her calls or emails. "I've hit a

rough patch for now," she wrote in exasperation. In the end, she finally started to make a few connections. Two tattoo shops finally agreed to do interviews, and she found two tattooed classmates, as well as some co-workers, willing to go before her camera. Ultimately, she wrote, "Perhaps I spoke too soon and felt a little discouraged." Non-tattooed, her knowledge about the culture was lacking, and this came through in her approach. She hadn't done her research. For a while, it didn't occur to her to find tattooed people in tattoo studios, until her professor suggested such a strategy.

Why should anyone participate in a research study, especially members of marginalized communities, who are accustomed to being distorted and stigmatized in official research? Institutional review boards (IRBs) at universities specifically require researchers to write a statement on this very topic. Usually researchers write something vague, like "So participants can contribute to the academic knowledge written about this particular subculture."

Institutional review boards are based upon a medical research model and are thus an awkward fit for gatekeeping qualitative social science. They are obligated to ensure the confidentiality of research participation. Traditional qualitative research often assumes anonymity. But the tattoo artists I interviewed were completely open about their identities. Indeed, it was good for business. What happens when research overseers support anonymity but participants are more than happy to be named? And what if participants' faces are shown on video, as they are in the documentary I produced? In the end, I allowed the interviewed women to select the name they wished to use in print, and they consented to their participation in the video documentary. The resulting documentary, *Covered* (2010), provided the visual representation so important for understanding body art, and it was screened at film festivals, universities, and community spaces.[19]

After gaining IRB approval in 2007 from Florida International University, I began my search for participants in earnest. My first stop was the annual Marked for Life Tattoo Convention in Orlando, Florida—a convention dedicated to women artists (and a few good men dressed in drag were permitted by the organizer Deanna Lippens). Marked for Life was small and intimate, lacking the crowds of other regional

conventions; thus the women artists were easy to approach. I couldn't have picked a better convention to find participants. I would return to Marked for Life for the next five years as my research progressed, continuing to collect narratives from the artists and build relationships.

During the first summer of research, I headed to Spokane, Washington, my hometown, to spend time at Constant Creations Tattoo Studio, as I had during those undergraduate college days. Charissa was excited to participate in my research, and it brought back memories of working on creative projects together. Twenty of her customers made their way through the makeshift interviewing studio, set up in the unused piercing room next to the tattoo booths, where I conducted videotaped interviews.

I made two other connections with tattoo industry women via *Myspace.com*, a social networking site popular in the early 2000s, before Facebook dominated the landscape. Jennifer Wilder was a shop manager and tattoo apprentice at Abstract Art in Webster, Texas. I interviewed twelve women at the shop she managed over the next several days. There were four male tattooists working in the shop, besides the shop manager. The tattooists called upon their partners and female clients to participate. Another group of around ten to twelve women participated in Webster. Through *Myspace.com*, I was put in touch with Tiffany Garcia, a tattooist at Outer Limits Tattoo and Body Piercing. This shop was one of four owned by Kari Barba, a pioneer female tattooist. Barba had purchased and restored this historic tattoo studio, previously owned by Bert Grimm, a prominent tattooist in the early days of tattooing, and part of Long Beach, California's navy history. She had refashioned the studio as part tattoo museum, with historic photographs of legendary artists and images of the transformation of the shop. It is the only business from the original Pike amusement zone still operating. Barba employs many women at her four studios, nearly all of whom I was able to interview.

I returned to Vyvyn Lazonga's shop on the Seattle waterfront—the place where I was first tattooed. Jacqueline Beach was now my primary contact at this all-female shop, as Tina Bafaro had moved on to open her own place. Vyvyn prepared for a tattoo over a mastectomy scar, one of her specializations, as I interviewed her about her extensive career. In

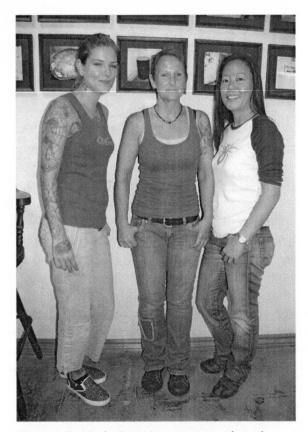

Figure 1.2. Kari Barba (center) is a tattooist with nearly
thirty years of experience. She has apprenticed many female
artists out of her four shops in Southern California. On
the left is tattooist Chrystal Puckett, and to the right is
Yvonne La, both of whom work out of the Outer Limits
Tattoo Studio.

the end, I was able to interview most of the women in the shop, includ-
ing her apprentice, Suzy Todd. Overall, I was able to find many of the
women I interviewed through my personal contacts. From there, social
networking sites like *Myspace.com* provided a connection with most
of the remaining participants. Finally, these connections were able to
invite their friends and clientele to the interview spaces I created in art-
ist's shops, for days on end.

Participant Demographics

In total, I was able to interview sixty-five participants. In terms of age, the women I interviewed were somewhat younger than the tattooed population at large. Most of the tattooed are in their thirties and forties, a demographic that has had time to acquire tattoos and that has lived during a decade in which it was most popular. Eighteen- to twenty-five-year-olds have fewer tattoos than those in the older age group, and tattooing is slightly less popular with them. Yet my sample has the highest number of participants in the eighteen- to thirty-year-old age range, with thirty-five participants. The other age groups are as follows: for thirty- to forty-year-olds there were eighteen participants; for forty- to fifty-year-olds there were five participants; for fifty- to sixty-five-year-olds there were six participants; and for participants over sixty-five there was one participant.

The study was fairly inclusive of people of color, with Black and Native American participants underrepresented. The participants' racial demographics were as follows: there were forty-nine Whites, nine Latinas, three Asian Americans, one Black, five mixed race, and no Native Americans. Throughout the research, I found very few African Americans at the shops and tattoo conventions that I attended. At a typical tattoo convention, I would often see only one African American male tattooist, if any. Yet it is apparent that African Americans do get tattooed in significant numbers. Therefore I suspect that there is a good deal of segregation in the tattoo world, with African American's getting a lot of their work from African American–owned shops. This segregation stems historically from the overlap between tattoo shops and bikers or motorcycle clubs, which did not hide their racist sentiments. One racial issue I have observed is that some White tattooists will comment on Black skin being texturally "tougher," as well as darker, obscuring some color inks.[20] Yet others tattooists specialize in darker skin. I have also heard some African American tattoo collectors state that they prefer getting tattooed from African American tattooists, who will give them color tattoos without arguing that their skin is too dark for color. I have talked to one mother of a Black male tattooist who told me stories of the racist treatment that her son endured during his tenure at one shop.

I also imagine that there is significant segregation of White and Chicano tattooing in the Southwest as well. This racial segregation in the tattoo world should be a topic for further study.

This study was skewed toward women employed in the tattoo industry, with thirty-one out of sixty-five being tattooists, apprentices, or shop managers. Out of the remaining participants, eight were students, five worked in retail, four were teachers, one worked in a warehouse, one was a security guard, one worked in an office, and nine participants' occupations were unknown.

I did not specifically ask about sexual orientation, but I would estimate that 20 percent of the participants were bisexual or lesbian, a higher rate than in the general population, but certainly a minority of participants. This topic was discussed only incidentally, but in retrospect, I should have included more discussion about the connections between sexual and gender identity and tattoo collecting. Some participants had pride tattoos, such as rainbow flags, pink triangles, or other related imagery. Others had tattoos that represented pride, but less obviously so. Some heterosexual women said that they are assumed to be lesbian by the public because of their extensive tattoo collection or because of particular images. For example, Hispanic Panic (her Roller Derby name), has a Rosie the Riveter tattoo, for which she received anti-lesbian slurs. My feminist armband with "woman-power" images has also made some assume that I am a lesbian, as one woman in public said, "No straight girl would have a tattoo like that." I personally identify as bisexual, so her comment was not entirely off base. My previous research has focused on the social construction of bisexual and mixed-race identity of women in the United States, and this research background on sexual and racial identity could have been brought into this work in a more consistent manner to explore the overlap of these identities with tattoo collections.[21] Are lesbian, bisexual, or queer-identified women more open to acquiring non-gender normative tattooing? Or are they less so because of further stigma? How do non-gender normative tattoo collections overlap with gender identity, such as for those that identify as androgynous, gender-queer, or transgender? Are tattoos used as part of a gender identity body project in order to present oneself in a particularly gendered manner? Such topics would be excellent for further studies.

Overview

In chapter 1, "Sailors, Criminals, and Prostitutes: The History of a Lingering Tattoo Stigma," I show that tattoos have undeniably had a historical association with criminal behavior. Even now, the more tattoos a person has, the more he or she is associated with gang membership, imprisonment, or sexual deviance for women. Why did these associations develop? The stereotypes that tattooed individuals encounter today are based on outdated and irrelevant associations (often based on research bias): sailors, gang members, criminals, the mentally ill, and sexually deviant women. This chapter outlines the history of early tattooing: from the encounters between sailors and global indigenous people, the emergence of coastal tattoo shops, early sideshow performers, outlaw tattooing, and the association of women with criminal men and/or sexual deviance. While tattooing was not widespread before the 1950s, the social movements and cultural revolutions of the 1960s began connecting the counterculture with body modification practices. Women began to collect tattoos in larger numbers. By the 1980s and the 1990s, tattooing was becoming mainstream, with an explosion of tattoo shops springing up across the nation. By 2000, a substantial portion of our society had become tattooed: college students, mothers, and white-collar professionals. While the practice of tattooing has saturated mainstream society, these historical associations with criminality continue to linger.

In chapter 2, "'I Want to Be Covered': Heavily Tattooed Women Challenge the Dominant Beauty Culture," I show that feminist theories have been instrumental in bringing the materiality of the body into social theories. This chapter draws upon theories of embodiment to understand how women are positioned in relation to the beauty culture. Body modifications such as plastic surgery and dieting are more socially acceptable than other body modifications, as they are oriented toward the achievement of beauty ideals. Women are supposed to desire beauty—simply observe the messages of advertisements aimed at them. When women become heavily tattooed (going beyond the small, cute, and hidden design), it is considered masculine, ugly, and a betrayal of the beauty culture. This betrayal is captured in the popular insult, "You're such a pretty girl, why would you do that to yourself?" In this

chapter, the participants discuss their initial attraction to tattooing, what their tattoos means to them, how they navigate social pressures to conform to ideal femininity, and ultimately, how they choose their own pathway for embodied self-expression. The participants struggle with beauty culture and self-perception, like most women. However, the participants redefine the practice of tattooing as a beauty practice. Even when they are collecting snakes, skulls, and zombie imagery on their bodies, they feel beautiful in their ability to express themselves in their own, alternative manner.

In chapter 3, " 'I ♥ Mom': Family Responses toward Tattoo Women," I explore the reactions that participants have received from family members (parents, grandparents, lovers, children, and extended family). Many of the participants started collecting tattoos at an early age. For many of them, their ink collection began while still living with parents. Parents overwhelmingly respond negatively to their children's tattoo collections but slowly come around toward acceptance. Grandparents, however, are often the most unaccepting family members. This demonstrates the generational bias against tattooing. Those who came of age before the 1960s saw few tattoos in their social worlds. Subsequent generations were exposed to tattoos among their acquaintances or within popular culture and therefore had more references for understanding the practice. The participants' own nuclear families—their partners and children—had the least problems with their body art. Children of tattooed parents were raised with the practice normalized. When individuals become tattooed, it affects not only their lives but also their family relationships. This chapter presents the impact of these relational outcomes.

In chapter 4, " 'Covering' Work: Dress Code Policies, Tattoos, and the Law," I examine workplace policies that ban the display of body modifications, such as tattoos and piercings, that are both legal and routine. Many companies desire to maintain a "clean-cut" image, via employee appearance, for the benefit of their customers (and financial bottom line). However, with these policies, companies reinforce the association of tattooing with deviance as well as discriminate against those with body modification. Employment discrimination is a serious threat for heavily tattooed women. They must often consider the employment policy when deciding upon their next tattoo or their next job. They may have

to be able to completely cover all their artwork with clothing. This chapter will examine various types of employment policies against tattooing. These employment sectors include: the military (with routinely shifting laws), blue-collar, white-collar, and service industries. This chapter places tattoo discrimination within the larger context of employment discrimination. It is estimated that one in every three to five people in the United States has at least one tattoo. With this large percentage of the population having tattoos, it is only a matter of time before employment policies become more tolerant. This chapter concludes with the argument that body modifications should not be grounds for termination.

In chapter 5, " 'Is the Tattoo Guy Here?': Women Tattoo Artists' Experience Working in a Male-Dominated Profession," I focus on women tattoo artists who have often faced occupational stigma, discrimination, and invisibility. Like many women working in non-traditional professions, tattooists have faced many barriers, and also opportunities, as they have entered the tattoo industry. The literature on women's employment often focuses on individual professions, yet the tattooing industry has not been highlighted for analysis. This is an important addition to the narrative of women in male-dominated professions, as women are a small, but quickly growing, minority of tattooists and, I argue, are having a profound impact on the industry.

In chapter 6, "Tattoos Are Not for Touching: Public Space, Stigma, and Social Sanctions," I focus on how heavily tattooed women are often stared at, questioned, and touched by strangers in public spaces. Strangers may try to pull back clothing in order to see a tattoo more completely, often without warning or permission. Strangers may approach the tattooed person and ask invasive personal questions about "what the tattoo means." All of the participants in this study have had this experience and found the intrusions offensive. Using Erving Goffman's theories of behavior in public places, this chapter examines the interactions between strangers and the tattooed women in relation to their body modifications. By examining the perspective and desires of the participants in regards to public interactions, we can begin to formulate an outline of behavior for a "tattoo etiquette" that promotes respectful interactions and mutual understanding.

In the conclusion, I discuss how this book has demonstrated that the simple act of getting inked can change one's social relationships

significantly. Based on historical associations of tattooing with criminality, tattooed individuals still suffer stigma and discrimination, though it has decreased significantly in recent decades. For the women in this book, they feel that the lingering stigma is inappropriate, as their behavior does not reinforce stereotypes. Instead, the participants suggest the development of a "tattoo etiquette" for public interactions, during which heavily tattooed people are treated no differently than the non-tattooed. By further toning down the public recognition of tattoos between strangers, we can begin to entertain what it would mean if heavily tattooed people no longer faced a social distinction, for better or worse, and were allowed to go through their day unmolested.

Covered in Ink explores the sociological issues related to being a heavily tattooed woman in contemporary American culture and as such is a sociological exploration of stigma, subculture, and gender. Historically, tattoos have constituted a subculture with its own norms, values, and social interactions. This subculture has been male dominated until recently, and women's presence has been transformative for it. While women have been at the margins of the subculture, they are now more integrated than ever before, influencing the style of tattoo art, the health regulations, and the shop culture (and television culture of tattoo shows). The practice of tattooing has also had an impact on gender presentation. While women can permissibly have small, cute, and hidden tattoos, the women in this book go beyond these boundaries and have tattoos that are covering extensive amounts of skin, are publicly viewable, and often depict "grotesque" imagery (such as zombies, skulls, and snakes). In public, these women are reminded by strangers and friends that their ink is gender transgressive and goes beyond the bounds of appropriate body decoration for women; however, as I will show, the women themselves view their body art as beautiful, as making themselves more beautiful. This book explores that world of beauty.

1

Sailors, Criminals, and Prostitutes

The History of a Lingering Tattoo Stigma

When European mariners began exploring the seas and encountering people from distant lands in the 1700s and 1800s, they were exposed to various tattooing practices. They recorded their interactions with the indigenous people in notebooks, along with drawings of their unfamiliar surroundings, the people, and depictions of the tattoos. The Europeans learned that these tattoos were cultural practices that marked significant stages of life development. Some of these voyagers became interested in these practices and began becoming tattooed themselves.[1] For sailors, these were mementos of places where they had been. When these voyagers returned home to Europe and exposed their tattoos, however, their peers considered this behavior inappropriate. In short, it was taken as a visible rejection of their own cultural values.[2]

Some of the places where these voyagers and missionaries encountered indigenous tattooing included Micro Polynesia, Fiji, and the Samoan Islands. In Micro Polynesia, tattooing was a central art form and was considered "decorative, protective (as a kind of wrapping or armor), erotic and social."[3] In Micro Polynesia, as well as Fiji, women were the tattooing experts, and tattoos on women were considered beautifully ornate. In Samoa, male tattooing was considered the counterpart to female childbirth, "as expressed in the saying: 'The man grows up and is tattooed / The woman grows up and she gives birth.'"[4] The "tatau" in Samoan culture was utilized to express "a very local (albeit transnational/diasporic) set of identities and experiences."[5] These tattoos were hand tapped into the skin with a hoe-like utensil called an *ausogi'aso*, made from the incisor teeth of a wild boar, which were affixed to a piece of turtle shell. The tattoo for men, called a *pe'a*, consisted of a black ink design that covered the skin above the waist, over the thighs, and ending around the knees, so densely colored it appeared that the man was

wearing shorts. Getting the tattoo was a ritualized process taking weeks to complete, if not longer. Some men took years to complete their tattoo, as they also had to exchange valuables, such as woven blankets, which could also take time to earn, in this barter exchange of items for tattooing. However, it was considered undignified to have an incomplete *pe'a*, so they were strongly motivated to complete this significant cultural marker. Women also received tattoos, called a *malu*, over their thighs, though of a lighter design than that of the men, as their child-birthing practices balanced out their proof of pain tolerance.

When the religious missionaries later followed in the footsteps of the first Western voyagers, they were scornful of these indigenous practices as they clashed with their own religious perspectives. As outsiders, unfamiliar with these lands or people, the missionaries attempted to control the population and obliterate their behaviors—with violence.[6] They imposed their religion and biblical interpretations upon the populations they encountered, encouraging the indigenous people to adopt Christianity, with the threat of death if they resisted. Using Leviticus 19:26–28 from the Old Testament of the Bible as justification, the missionaries condemned tattooing: "Ye shall not eat any thing with the blood: neither shall ye use enchantment, nor observe times. . . . You shall not make any cuttings in your flesh for the dead, nor print any marks on you."[7] In 1814, Samuel Marsden of the Church Missionary Society was one of the first to actively condemn the practice of *ta moko*, the Maori practice of tattooing.[8] As the colonies were further established, the practices of tattooing became targets for suppression. The White missionaries were violently aggressive in stamping out indigenous practices and forcing their own religious practices of Christianity upon the native people. By the 1830s, Tahitian tattooing had been largely abandoned.[9] Samoan tattooing persisted for a while, in spite of the foreign-imposed prohibitions, but it eventually faded as well, though never completely.[10] By the time Darwin circumnavigated the globe on the *Beagle* in 1836, tattooing customs had nearly disappeared.[11] In Alaska, the wearing of labrets (ornaments piercing the lip and below the bottom lip) and nose ornaments, as well as tattooing, disappeared from Eskimo life after encounters with missionaries.[12] It was not until the 1980s that native tattooing practices began to reemerge. Both locals as well as foreigners with some connection to Samoan culture have taken on the traditional *pe'a* and

malu tattoos.[13] In Tahiti, a network of tattooists developed to fill the demands for traditional ink from locals as well as tourists.[14] Thus the ethnic reclaiming of lost cultural practices emerged alongside the 1990s White "modern primitive" movement.

Sideshow of Human Oddities and Electric Tattooing

In 1876, for the first time, indigenous people were put on display for an American audience at the Centennial Exhibition in Philadelphia.[15] Entire villages were constructed that supposedly represented how the indigenous actually lived—all created for the entertainment of White audiences. Such expositions of indigenous villages became increasingly common, eventually leading to world fairs, carnivals, and sideshows. These practices became immensely popular forms of entertainment for many decades. Such expositions were the predecessors to circuses and sideshows, which emerged as significant markets for the entertainment business. It was P. T. Barnum, in particular, who developed sideshows featuring human "oddities," such as disabled people, the morbidly obese, bearded ladies, and tattooed men and women.

Olive Oatman was the first known tattooed woman displayed for entertainment purposes. Most of her family was killed in Arizona in 1851 by an unknown Native American tribe while they were part of a Mormon caravan making its way across the country. The tribe, which could have been the Tolkepayas, of the western Yavapai Tribe, captured Olive and her sister Mary Ann and held them as slaves for years before selling them to the Mohave Indians. It was the Mohave who gave the two women the traditional chin tattoo, a blue ink design with four vertical lines from the mouth to the bottom of the chin, with two horizontal lines on either side. Years later, after her sister Mary Ann died in captivity, Olive was reclaimed at Fort Yuma in California and reintegrated into the White world.[16] Her story made headlines across the West, and it wasn't long before she was offered opportunities to capitalize on her wild misfortune. In 1857 the pastor Royal B. Stratton wrote a book about Olive and Mary Ann called *Life among the Indians*.[17] To promote the book, Olive—a demure-looking woman who wore her straight brown hair tucked away in a bun and the traditional conservative clothing of her Mormon community—went on tour, and the book eventually sold

thirty thousand copies, a significant number for the time. From the royalty money, Olive and her brother Lorenzo, who had been left for dead after the attack but survived, were able to obtain a college education at the University of the Pacific. After her book tour, she eventually married a man and faded into obscurity. But the success of her story began the trend of displaying heavily tattooed women in expositions and carnivals. These women invented compelling stories of being captured by Native American tribes and tattooed against their will. However, unlike Olive Oatman, with her traditional Mohave tattoo, these women were not tattooed with traditional native designs. Rather, their tattoos were crudely hand poked images of U.S. patriotic or Christian themes. Their wild tales both explained their tattooed state and negated their agency—as victims they were freed from blame for their unusual appearance—but allowed them to capitalize on their experience for an audience.[18]

The first human oddities show was in 1901 at the Buffalo World's Fair, thus "solidifying the association between tattoos and carnivals in North America."[19] Some of the pioneer tattooed ladies at the turn of the century included Nora Hildebrandt, Irene "La Belle" Woodward, Anna Mae Gibbons, Betty Broadbent, Artfullete, Serpentina, Pictura, Lady Viola, and Artoria among others. The tattooed women (and men) had their full bodies covered with the blue ink imagery, crudely drawn tattoo designs often of religious or patriotic themes, with only their hands, necks, and faces free of ink. But their designs and performances could be impressive; for example, "Sideshow *frau* Annette Nerona, wore an assembly of German statesman, artists and intellectuals including Bismarck, Wagner, and Goethe, and she also performed as a snake charmer and magician."[20] Since electric tattoos had not yet been invented, these tattoos were primitively inked by using a needle applied by hand or by using tools that held several needles together at once to be applied by hand force. These inks, offered in limited, primary colors, would often fade to blue, green, or black. In addition to their tattooed body display and tales of abduction, the performers would sell booklets that recounted their stories, complete with photographs, for supplemental income.[21] By the 1920s, over three hundred tattooed people were employed in circus sideshows, thus instigating a glut in the business.[22] Tattooed ladies stole the show from the men, as they came to wear revealing costumes and created a sense of exoticism and eroticism as part of their performance.[23]

For women in the audience, the tattooed ladies could represent their fantasy of "freedom—the freedom to choose what to do with their bodies, the freedom to live an unusual life not limited to the narrow selection of choices that were presented to them."[24]

As the three hundred tattooed men and women toured with expositions and circuses, tattoo shops were only beginning to be established in the United States. Some of the tattooists worked with the circuses and would tattoo patrons, as well as performers, while in town. Tattoo shops began to open in port cities to offer services to sailors in town for R&R. Martin Hildebrandt, a German immigrant who tattooed servicemen, established the first tattoo shop in the United States in New York City in 1846.[25] Hildebrandt was later joined by Charles Wagner, considered the most talented and prolific American tattoo artist of those early years.[26]

In 1875, Samuel O'Reilly opened his tattoo shop on the Bowery. Soon after, in 1891, O'Reilly patented the first electric tattoo machine. Before this invention, tattooists would hand poke crudely drawn and uneven designs into the skin. While these early performers' tattoos resembled children's drawings, the advent of the electric tattoo machine made tattoos look better. The operator had more control of the flow and pacing of the ink injection and could create a finer line and shading than with the traditional hand poke method. This machine was based on the perforating pen, invented by Thomas Edison, a motorized pen designed as an offshoot of the telegraph machine. It dictated a new style, based on using multiple needles to form lines, creating thick lines, with solid shading, and a splash of color, including red, black, blue, and green. Soon, tattooist "Lew-the-Jew" Alberts—a former sailor who had tattooed his shipmates—brought about another important invention that would change the face of American tattooing. Appalled by the crude designs that were being hand poked into his fellow enlistees, he utilized his background in wallpaper design to develop what are now called "flash sheets." These wallpaper-like sheets were covered with simple designs and placed on the walls of tattoo parlors. The client could pick designs off the wall, which were often military patriotic images such as flags and eagles, and the tattooist could create an acetate stencil replicating the outline image onto the skin. From there, he could trace the outline and create a more uniform image onto the skin, and create a production line of these simple designs, covering sailors in them all day

long. Tattooists soon developed their own flash sheets and sold them, but they were easy enough to plagiarize. Some tattooists hid errors in the designs, so that careless copiers would reveal their plagiarism at the expense of their customers' permanent designs. With sailors lined up and flowing out the door during their short breaks, tattooists' skill was in their ability to keep up the fast pace of putting uniform designs on the recruits. Some tattooists would offer only one or two designs a day, so much the better for quick turnaround. As tattooed sideshow perform-ers faded in popularity, sailors, as well as criminals and "undesirables," increasingly came to occupy the tattoo shop. By 1900, tattoo shops were spreading from their costal, sailor-serving beginnings into most major American cities.

Criminality and Tattoos

Both military personnel and inmates live in total institutions, in which their personal identities are erased by the imposition of a uniform appearance. Both enlistees and inmates attempt to individualize them-selves and identify their group membership by acquiring tattoos. While military regulations against tattoos fluctuate as the need for new recruits ebb and flow, acquiring new tattoos in jail or prison is strictly prohib-ited. Thus tattooing is underground and conducted in unsanitary con-ditions, without proper equipment and, often, improper artistic ability (although the world of prison tattooing can also produce impressive artistic renderings, considering the limitations). Other inmate tattoos are collected on the outside. For military enlistees, their tattoo designs often reflect their particular branch of the military, especially for male members (women enlistees often collect more personal and less mili-taristic imagery). For inmates, their tattoos often reflect their gang or group affiliation, their identity as a prisoner, or other personal imag-ery.[27] For both enlistees and inmates, tattoos can also provide a tougher appearance, which is useful in such hyper-masculine spaces.[28]

One of the most historically well known criminologists is the Italian Cesare Lombroso, born in 1835. He was also a physician and an early contributor to the philosophies of eugenics, psychiatry, and Social Dar-winism. One of his primary claims was that criminality was inherited and physically identifiable,

that the criminal was identifiable by regressive features such as a small skull or large jaws and secondary characteristics such as tattoos, all of which signify atavism, and a retarded developmental association between criminal and species of a "lower order."[29]

Lombroso's theories essentialized a biological criminal element that could be perceived by the outer appearance of individuals, including tattooing, a non-biological trait that came to represent an internal, psychiatric disorder. Besides criminality, tattooing was often associated with mental illness; indeed, the two were linked—criminality *was* a mental illness, made visible by telling signs such as tattooing and regressive facial features. While Lombroso's theories may have been debunked, they linger on in the foundations of contemporary criminology. In 1968, Richard S. Post published an article entitled, "The Relationship of Tattoos to Personality Disorders," in which he states:

> The purpose of this paper is to show that the presence of a tattoo, or tattoos, can serve to indicate the presence of a personality disorder which could lead to, or is characterized by, behavior which deviates from contemporary social norms . . . If the presence of a tattoo does indicate a personality disorder, perhaps that disorder could be, but is not necessarily, manifested in the form of criminal behavior.[30]

Such theories of profiling also underlie contemporary policing practices. We can see this in the obsessive classification of "gang tattoos" and the rigorous documentation of tattoos on arrestees. The criminologist William Piley encourages police departments to document inmate tattoos to build their database of "gang tattoo" information. Piley demonstrates that vital information can be collected from tattoos: street names, gang membership, turf, and memorials for murdered associates.[31] This style of profiling reads information into the presence of tattoos that may be inaccurate or presumptive. This assumption of criminality based upon the presence of tattoos continues to underlie academic literature on the practice. Many studies on tattooing still utilize prisons, mental health hospitals, or juvenile detention centers as laboratories, thus beginning research with biased sample populations that are used to justify theories of criminality and mental illness.[32]

Mental Illness

If tattooing is used as an indicator of an underlying mental illness, it provides an easy indicator for medical professional to use. Richard Post's participants in his 1953 study in a Kentucky veteran's hospital consisted of tattooed patients with the diagnoses of personality disorder and schizophrenic reaction. According to Post:

> If a person's internal perception of society is such that he feels he must embellish his body with signs, symbols, or figures to reflect his internalized self-perceptions, these markings should be taken as indicators of some type of personality disorder.[33]

Thus, if the tattooed person has not yet become a criminal, or mentally ill, he or she may in the future. The tattoo provides a warning sign for anti-social behavior—even if that behavior has yet to be established.[34] Other studies connect mental illness, depression, suicidality,[35] and visible tattooing. This association of body modification with mental illness continues to influence research. As Victoria Pitts's recalls in her book *In the Flesh: The Cultural Politics of Body Modification*, her research proposal was initially rejected by her university's institutional review board:

> The second and more worrisome objection to the sociological study of anomalously marked bodies was that body modifiers were perceived as sick, people in need, of psychiatric, not sociological attention. In fact, my first application to my university's Institutional Review Board (IRB) was rejected for precisely this reason: body modifiers, said the IRB, needed to be studied by mental health professionals rather than sociologists.[36]

Yet social scientists are the very ones who need to research the social context of tattooing, apart from the medical model of institutionalized deviance.

Deviant Sexuality

In Albert Parry's 1933 book *Tattoo: Secrets of a Strange Art*, he argued that the practice of tattooing was connected to sexual deviance. Parry, a

Russian-born immigrant and professor of Russian civilization at Colgate College, argued that "the sexual elements of sadism and masochism — the pleasurable infliction and endurance of pain — are more than evident in the act of man's tattooing."[37] He equated the physical act of tattooing to sex: the intimacy of the exchange between tattoo artist and tattooee, physical proximity, potential state of undress, and the breaking of the skin barrier to inject pigment (i.e., comparable to the release of semen, or sexual release). For men, such implied sexual deviance can be associated with homosexuality. Indeed, as late as 1968, Richard Post wrote in his article "The Relationship of Tattoos to Personality Disorders":

> In fact, a striking number of the research results in the area of tattoos indicate that there is a high percentage of sexual abnormality connected with the practice of being tattooed. Further, the theory has been forwarded that many tattoo artists are homosexuals.[38]

However, Parry and Post base their assumption not on empirical research but, rather, on speculation. Only one historical tattooist was eventually known to be gay — it was a secret that he did not reveal publicly, even in his autobiography *Bad Boys and Tough Tattoos: A Social History of the Tattoo with Gangs, Sailors and Street-Corner Punks, 1950–1965*.[39] However, the sordid details of his hyperactive sex life were recorded in his biography *Secret Historian: The Life and Times of Samuel Steward, Professor, Tattoo Artist, and Sexual Renegade*.[40] As a counterpoint to the previously mentioned studies, Samuel Steward notes his own contradictory observation regarding homosexuality and tattooing:

> I soon discovered that whenever I mentioned my anchor [tattoo] to other friends, I was at once furnished with many reasons why they would not ever consider getting tattooed. Most of these friends at this time were homosexual, and in the 1950s there seemed to be a particular horror of the tattoos among them.[41]

In his observational fashion, Samuel Steward also briefly mentions "the lesbians" in his social history. During his tattooing career in the 1950s, Steward implemented a new rule of not tattooing women unless their husbands accompanied them, after encountering irate husbands.

"The only exception to this was the lesbians, and they had to be over twenty-one and prove it."[42] Steward continues, "Whenever they came in they frightened the sailors and many of the city-boys out of the shop."[43] Steward describes the tattoos that they would collect:

> In a sense they were no different from the boys getting their girlfriend's names on them. That was all they wanted, perhaps with a little floral design, and then they wanted their name on the "lady" of the pair.[44]

Steward observes that lesbians who were tattooed to show their relationship status by literally being marked with their partner's name were mimicking the practice of biker women being marked with "property of [male partner's name]" tattoos.

For women, sexual deviance implies being a lesbian or bisexual or being "too" sexually active. Lombroso attempted to associate female tattooing with criminality and prostitution in his book *Criminal Woman, the Prostitute and the Normal Woman*.[45] However, he found that, while tattooing was a "defining trait" among male criminals, among female criminals the practice was almost nonexistent, at a rate of 2.15 percent. Therefore the early days of women's tattooing did not parallel that of men, even within the same criminal subculture.

Blood-Borne Diseases

Tattooing has long been associated with the spread of blood-borne diseases. The practice requires the injection of ink pigment into the layers of skin with needles, thus providing an opening for infection under non-sterile conditions. Historically, tattooing was practiced under non-sterile conditions (as were *all* medical practices). In 1944 the first legal action against a tattooist was taken. Charlie Wagner had been tattooing in the Bowery of New York City since opening his shop in the 1890s, but it was nearly five decades later when this legal action occurred. New York City fined him for not sterilizing his needles. Indeed, during this time period, it was customary for tattooists to use the same unsterilized needles and ink on each client. Many shops did not even have running water, and tattooists used a sponge and a bucket of water to clean off the tattoo, using the same bucket of water on all subsequent clients until

they changed it days, or even weeks, later. Considering this laboratory for cross-contamination, it is striking how few outbreaks of blood-borne disease occurred. In 1961, during an outbreak of jaundice and hepatitis B, the city banned all tattoo parlors. This ban lasted for thirty-six years—from 1961 to 1997. Some tattooists speculated that the motivation came from the pressure to clean up the city before it hosted the 1964 World's Fair. Tattooing in New York City moved further underground after this ban out of necessity. Other states and cities followed suit and banned tattooing because of hepatitis outbreaks or scares: Oklahoma, Virginia, Massachusetts, Connecticut, Ohio, Arkansas, Wisconsin, Tennessee, and Michigan. "The military also became publicly opposed to tattoos, due in part to the erotic images soldiers chose as tattoos, but also due to fears that tattooing was a public health hazard."[46] These outbreaks and tattoo bans firmly established a social connection between tattooing and disease that continues to this day.

Since the days of unsanitary conditions, tattoo studios have greatly improved their standards—as have all medical fields. One tattooist reflects, "We weren't wearing gloves in those days. But neither was anyone else! My gynecologist didn't wear gloves; my dentist didn't wear gloves. That was the time period." Currently, the U.S. Department of Health and Human Services and the Occupational Safety and Health Administration regulate tattoo shops, which implement sanitation standards, such as an annual certificate for training employees on blood-borne pathogen requirements, use of an autoclave for sterilizing machines, and requirements for using single-use needles. However, regulation details vary by states, cities, and counties, creating irregularities nationwide, with some states much more lenient than others. Because of the historical association of tattooing with disease and its stigma, tattoo studios are often quite vigilant about sterilization practices. Yet the association of tattooing with disease lingers (for example, if one has received a tattoo within the last year, he or she is banned from donating blood).[47]

The Tattoo Renaissance

While the history of tattooing has stigmatized the practice, the stigma is lessening, and tattooing is now more popular than ever in the United States. Since the 1970s, tattoos have become popular with musicians and

the general public. The media has been instrumental in both slandering and popularizing tattooing. Samuel Steward notes the impact beginning in the 1950s:

> In the early days I did not watch TV, but there was one movie or show that had as a "piquant detail" of the plot the tattooing of a small butterfly on a woman's shoulder. The effect that show had on a number of farm wives in Illinois was amazing. At least fifteen drifted in within two months after the TV showing, and each wanted a small butterfly on the right shoulder blade. Lacking in sophistication and hardly understanding their motives, these women were invariably accompanied by their farmer husbands who stood by—generally approving—while the wife got her butterfly. It was a momentary fad equaled only by the demand among young men for a rose tattoo on the chest, following the movie of *The Rose Tattoo* by Tennessee Williams.[48]

The media, music subcultures, and social protest movements have promoted a tattoo renaissance that has continued to blossom over the decades. Protest cultures challenged body politics, and especially for women, the feminist movement encouraged women to demonstrate control over their own bodies. For some, this resulted in decorating their body with tattoos. The famed artist Lyle Tuttle tattooed Janis Joplin and Cher, among other celebrities. Joplin received both a decorative wrist tattoo representing a fifteenth-century Florentine bracelet and a heart on her breast. Women had already been collecting their small butterfly images, and this catapulted the idea of feminine tattooing even further into the public eye. Joplin hosted a party at which Lyle Tuttle was the esteemed guest. After Joplin's untimely death in the 1970s, Lyle told the *Rolling Stone Magazine* that he replicated her heart tattoo on more than one hundred other female fans of the singer. Tuttle credits the women's movement for the rising popularity of tattooing; it opened 50 percent more of the population to the practice. Tuttle believes that tattooing was the perfect body modification practice for women to take up; as he states, "They paint their toenails, curl their hair, and mess with everything in between." Self-expression and identity politics were central to the women's movement, and tattooing provided the perfect outlet.[49]

Since this initial upsurge, the practice has continued to grow exponentially. The 1980s and 1990s saw tremendous increase in the proliferation of tattoo shops, tattoo collectors, pop-cultural references, tattoo conventions, and increased social acceptance. In the mid-1970s, there were an estimated three hundred tattoo shops in the United States; by the early 1990s, the estimate was at four thousand, and by the mid-2000s, the estimate had climbed to over fifteen thousand.[50] By the late 1990s, tattoo studios were considered among the top six fastest-growing national industries.[51] Since this rise in popularity, the association with deviance has lessened. Indeed, as Karen Bettez Halnon and Saundra Cohen argue, these symbolic forms of "lower-class culture" (muscles, motorcycles, and tattoos) began to gain middle-class status and provided a cultural terrain for gentrification practices.[52] Tattoo television shows have been growing exponentially on the networks. And heavily tattooed participants on reality television are not limited to the tattoo shows but appear on all types of shows, focused on cooking, pawning, and talent scouting. With such a tremendous shift in the culture, the associated stigma of tattooing has definitely lessened, but it still continues to haunt the practice in sometimes surprising ways. This tension—between historic stigma and contemporary popular culture representation—is where contemporary tattooed people exist.

The Rise and Fall of an American Tattoo Stigma

In this chapter, we have seen that the early history of American tattooing was associated with socially marginal populations, which established a social stigma that continues to this day. Originally, American sailors collected tattoos during their travels on the American coastline as well as in other countries. These sailors often engaged in deviant entertainment during their R&R stopovers: drinking, soliciting prostitutes, and collecting tattoos. Their rowdy behavior and deviant consumption stigmatized both the perception of sailors overall as well as the tattoos that they collected. The sideshow performers at the turn of the twentieth century capitalized on this stigma of tattooing in their tantalizing performances of flesh shows and stories of abduction. At the height of sideshow entertainment, there were three hundred heavily tattooed men and women

traveling the country. By mid-century, the circus was in decline after competing with television and movie theaters.

Motorcycle clubs developed in post–World War II America, and their use of tattoos assisted with constructing an intimidating appearance. Street gang members adopted tattooing of selected symbols to demonstrate their membership and loyalty to their gang. While prisons officially forbid tattooing, it is a widespread practice that visually represents loyalty to gangs, crimes committed, cultural imagery, and personal memories. In 1961, with the hepatitis outbreak in New York, tattooing was banned in that state, and others were soon to follow. Research during this time period equated tattooing not only to criminality, but to mental illness and sexual deviance. It was not until the late 1960s and early 1970s that social movements and counterculture members began collecting tattoos to express their identities, ideologies, and open-mindedness to alternative appearances. Since the 1970s, the so-called tattoo renaissance period has been marked by the popularity and mainstreaming of the practice. While gang members, bikers, and inmates still collect tattoos, they are far outnumbered by mainstream collectors.[53] Yet these negative associations with deviant subcultures still persist. How do these associations continue to affect the social interactions of heavily tattooed women in the United States? The rest of this book will address this question by examining the different ways that tattoo collectors negotiate their social world in response to these stereotypes.

2

"I Want to Be Covered"

Heavily Tattooed Women Challenge the
Dominant Beauty Culture

When I discovered feminism at age 14, it rocked my world. I was struggling with identity and body image issues. I imprinted these struggles in the form of tattoos onto my body by collecting several feminist-themed tattoos when I turned 18. Struggling with my own understanding of embodiment, feminism, and representation, I wondered if other heavily tattooed women had similar experiences. Did they feel that they were armoring themselves against the mainstream beauty culture, or were their tattoos another path toward an alternative beauty standard to which they aspired? Why did this beauty need to be labeled "alternative"? Did they feel more empowered than women who were following the dictates of beauty culture more directly? Or were they equally entrenched in beauty aspirations and insecurity? Or was tattooing just one more oppressive form of body modification, not so different from plastic surgery? And is tattooing just one more aspect on the continuum of women's body projects? This chapter explores the overlapping worlds of normative beauty standards in the mainstream media and that of real women who struggle with their own identities as heavily tattooed women in American culture. I provide an overview of various social theories of the body so that we can understand the normative pressures under which women are placed. I next explore what happens to deviant bodies that step outside of normative expectations. Finally, I present the experiences of the participants: their tattoo narratives, encountering social sanctions and struggling to define their agency under these various social pressures.

Feminism and Embodiment Theories

Feminist theorists such as Judith Butler[1] and Anne Fausto-Sterling[2] have argued that there is a need for distinction between our understanding of biological sex and our public gender presentation. Furthermore, they argue that these categories are not a dichotomy (biological sex vs. socially constructed gender) but rather inextricably linked, as our social world affects the physicality of our bodies. While we are used to hearing arguments that justify social inequality between men and women based on biological differences, Butler's main argument is that both men and women are *performing* gender through appearance, movement, voice, and social interactions. Making a distinction between "masculinity" and "femininity" and socially organizing particular human traits as one or the other is an artificial social construction that individuals work to maintain in their daily lives to uphold this mirage (for example, that men are physically dominant, that women speak in a more passive voice). For both men and women, creating a masculine or feminine appearance is central to our identity. This gender construction is significant for our understanding of women's tattooing practice, since tattooing has been historically associated with masculinity. Therefore, as women become heavily tattooed, their femininity can be considered weakened, and we see this when they face public social sanctions along such lines (e.g., "Why would you do that to your pretty body?").

Many theorists who write on the topic of the materiality of the body have described the body as a cultural text, rooted in a particular social context.[3] Bodies are not "ahistorical, precultural, or natural objects," explains Elizabeth Grosz in her book *Volatile Bodies*; rather, they are "inscribed, marked, engraved, by social pressures external to them."[4] For women, this pressure stems from a "hegemonic ideology about femininity."[5] Women are expected to pursue the beauty ideal and often face social sanctions when they "let themselves go" or give up on the pursuit of body maintenance.[6] Alternative body projects that do not pursue beauty are considered deviant: female bodybuilding, gender reassignment, butch lesbians, and heavily tattooed women. In response, many who pursue these alternative body projects often recast them as alternative forms of beauty and self-expression.

The heavily modified body is considered by theorists to be "a distinctively communicative body,"[7] both in person and in media representation. As we saw in the previous chapter, tattoos have historically been associated with masculine subcultures. The female body is read within the context of normative beauty ideals. And while tattoos are becoming increasingly visible in the media, they remain marginal. Tattoos are also understood to be "aspects of the presentation, performance, politics, principles and practices of self."[8] The heavily tattooed body provides an important example for concepts including "subjectivity, textuality, ethics, pleasure, and power/knowledge."[9] It is literally a body-in-progress, telling the story of past journeys and those yet to come.[10] These understandings of the body resonated strongly with the participants, many of whom considered their tattoos to be a visible journey through their life story. Consider these two representative statements from participants. Elisa Melendez states:

> Some people keep a diary. Some people keep a blog, a scrapbook, they knit, or cross-stitch. I just wear it all on me. I can tell you what I was doing in my life. Probably about how old I was. I can tell you that this one took three sittings, and two of them occurred right before my brother's wedding.

Elisa shows us that tattoos not only have autobiographical imagery but also mark time by chronicling both special events as well as one's age. As one ages, one collects more tattoos. Some participants comment on how old they were by noting how many, or how few, tattoos they had at the time (when discussing photographs of oneself, for example). Elisa compares tattooing to socially acceptable ways in which people document their memories: a diary or a blog. She also compares tattooing to a creative form of self-expression. Most participants discussed the ways in which their tattoos represent their life story. A similar comment from Carmen Guadalupe reinforces this point:

> To me they're like little memories that I keep on my skin. Some people take pictures of their little kids when they're small and put them in a photo album. I get tattoos. You remember where you were at—who did

it and the reason why and what you were thinking while you were getting it done.

In the article "Skin Memories," Jay Prosser states that the "skin is the body's memory of our lives."[11] This is especially true for tattooed people, many of whom incorporate personal imagery into their designs as expressions of personal identity. In "The Social Skin," Terence S. Turner argues that the skin provides the frontier of the social self, as well as a boundary between the self and others.[12] Theories by women of color have been especially inclusive of embodiment and identity overlap. Consider how these two passages by theorists apply to both the search for an (ethnic) identity as well as tattooing an image that is self-reflexive. Trinh T. Minh-ha states:

> The search for an identity is, therefore, usually a search for that lost, pure, true, real, genuine, original, authentic self, often situated within a process of elimination of all that is considered other, superfluous, fake, corrupted or Westernized.[13]

Tattoos will show this search for identity, as over time the recipient has inevitably collected both highly personalized, poignant imagery, as well as, perhaps, kitschy tattoos. Both styles of imagery represent the authentic self, demonstrating humor and aesthetics. In this second passage, Gloria Anzaldua writes poetically about the ways in which the body visibly reflects the inner self:

> Even when our bodies have been battered by life, artistic "languages," spoken from the body, by the body, are still laden with aspirations, are still coded in hope and "*un desarme ensangretado*," a bloodied truce.[14]

For heavily tattooed women, their bodies continue "speaking," even when they do not want to be interrupted by strangers who reach out to feel these bodily texts. These personal tattoos often include a lesson learned through a particular life-changing event, the hope that the future will be enriched by this lesson—and its tattooed reminder. "A bloodied truce" is created during the moment of inscription, enduring the pain of permanence in order to earn this lifelong memento.

Ironically, while the heavily tattooed women express themselves in the most visible of forms, they are mis-read by the public and labeled as simply deviant. Maria Lugones writes on the positionality of inhabiting multiple identities: "There may be 'worlds' that construct me in ways that I do not even understand . . . or accept."[15] For tattooed women, their subcultural identity is one that is often mis-read: They are visually representing the stories of their lives; however, strangers may read the ink as anti-social outbursts.

This estrangement from embodied representation particularly colors the experiences of women, as they are engulfed by the prevailing gender norms.[16] Both men and women are in a continuous production of gendered identity through behavior and self-expression.[17] Heavily tattooed women are deviating from gender norms by taking on a "masculine" body adornment and reframing it as "beautiful." This could be considered a form of "camp," which Diane Griffin Crowder defines as a way in which to "call attention to the artificiality of gender roles, to mock the very concepts of masculinity and femininity."[18] Betty Broadbent, a tattooed lady in the circus sideshow during the 1940s, entered a beauty pageant to illustrate this contradiction between beauty standards and heavily tattooed women. She stood no chance of winning.

Beauty Culture Context

Women are hyper-visible; their social value is heavily dependent upon their physical appearance and beauty. In contrast, men's power stems from their social status: their employment and financial ability. Beauty norms, as represented in the models chosen in mainstream advertisements, show bodies that are unobtainable for the vast majority of the population—often weighing up to 23 percent less than average American women. *Vogue Magazine* model Gisele Bundchen weighs 115 pounds and is five feet eleven inches tall, and Kate Moss, at five foot seven inches tall, weighs ninety-five pounds. Yet even with such out-of-reach thinness, air brushing of models by graphic computer editing programs makes their appearance even more unrealistic, reducing the sizes of their body parts, eyes, and mouths, smoothing out skin, and creating an appearance that even the models themselves do not possess. Creating such unobtainable beauty images perpetuates widespread insecurity

Figures 2.1 and 2.2. At the Tampa Tattoo Fest in March 2008, women compete for Miss Tattoo, a tattooed women pageant.

in women and, increasingly, in men, thus creating more demand for products—the ultimate bottom line. Normative beauty standards present a passive and tamed body, anorexic and flawless.

The impact of these unobtainable beauty standards has been significant. Some of these outcomes include an obsession with weight and dieting, eating disorders, hyper-consumer culture, and normative body modifications such as plastic surgery. While tattooing is often called mutilation by critics, plastic surgery, which is much more invasive and dangerous to the body, has become increasingly normalized. Television shows that glorify the magic of plastic surgery inevitably promote the industry. (Tattoo reality television shows also promote their own industry.)

When women conform to a beauty ideal by constricting their eating or by obtaining plastic surgery, they are often rewarded for their adherence (more so than women collecting tattoos). The growth of elective plastic surgery has escalated dramatically over the last few decades and is increasingly common, paralleling the rise of tattoo studios across the nation.[19] In 2011, the American Society for Aesthetic Plastic Surgery conducted a survey and found that over 50 percent of Americans approve of elective surgery, with much higher numbers in various income and age brackets.[20] Emily Jenkins points out an important distinction between plastic surgery and tattooing: Plastic surgery "does not announce itself as artificial. It is—at least, it is supposed to be—invisible."[21] While tattooed women often face social sanctions, women who have plastic surgery often feel an increase in self-esteem and social acceptance afterward.[22] One study found that women who undergo plastic surgery often choose to do this at transitional moments in their lives,[23] similar to tattoo collectors. Victoria Pitts-Taylor points out in her book *Surgery Junkies* that her feminist colleagues were "aghast" when they heard of her own plans for cosmetic surgery—which was a similar reaction to the alternative modifications that Pitts-Taylor represented in her previous book, *In the Flesh*.[24] In some circles, any consideration of body modifications—from surgery to tattooing—represents pathology. Between these two extremes, Pitts-Taylor picks apart the socially constructed narratives of surgery participants, from the normative to the extreme, with an emphasis on the extreme collector, or "surgery junkie." She points out that, on the one hand, feminists pathologize

any consideration of plastic surgery or body modifications, while on the other hand, surgeons attempt to normalize and sell the process to the widest audience as a solution for everything from depression to deformity. Plastic surgery is often considered just one more option available to the discerning consumer who demands the "right" to fix perceived imperfections of their bodies to achieve self-esteem and social status. However, extreme dependency on plastic surgery has been listed in the *Diagnostic and Statistical Manual of Mental Disorders* as Body Dysmorphic Disorder (BDD)—that is, individuals who find their bodies flawed (and this is reminiscent of the association of tattooing with mental disorders). From the outside, the excessive pursuit of plastic surgery and body perfection, and the excessiveness of becoming heavily tattooed, may appear similar in their extremes of body transformation. However, it is the motivation and outcome that distinguishes the processes—one pursues a normative body project, and the other goes against socially acceptable standards of self-presentation.

Encountering the World of Tattooing

Before women are ever exposed to the world of alternative body modification, they have been overexposed to the beauty culture through their personal interactions as well as the media. They have developed an identity based upon their gender performance, sexuality, race, nationality, age, and ability. With the addition of becoming heavily tattooed, their embodiment identities intersect with these other factors. While White women may be given more space to experiment with their body modification, women of color, lesbians, disabled people, and other already-marked bodies will be interpreted more harshly, as multiply "deviant." People of color's bodies are often criminalized and discriminated against; with the addition of heavy tattooing, these pressures can become magnified. Lesbians and bisexual women may face additional stigma if their tattooing reinforces a butch appearance, but less so for a feminine one.

To become heavily tattooed, one must first be exposed to the idea by seeing a tattooed individual in the media or in her personal life. When interviewing participants, I asked them about this initial moment of exposure to the world of tattooing. In Spokane, Washington, I met

Sparkill-icious, a thirty-one-year-old mother of a toddler, a student, and a participant in Roller Derby (hence her use of her Roller Derby name). Her chest-length brown and blond hair cascaded over her shoulders, hiding the tattoos on her neck. She wore eye shadow, a lip ring, and a black tank top that showed off the extensive tattoo work on her arms and chest. A studded belt hinted to her punk rock, subcultural style. For Sparkill-icious, the first heavily tattooed woman she saw was a family friend as a child:

> I was about five years old . . . and there was this woman named Tattoo Julie. I remember this. This is my first memory of childhood. I'm looking up at this lady and she is just fully tattooed. Oh my God, I thought it was the coolest thing I've ever seen in my life.

As a friend of her mother's, Tattoo Julie brought the possibility of becoming tattooed into the realm of her family life. Later on, when Sparkill-icious began her own tattoo collection, it was her stepfather who first tattooed her. Later, she had these tattoos covered up with higher-quality work by another artist, which is referred to as a "cover-up tattoo." Since her family members were very much interested in alternative cultures, Sparkill-icious was exposed early on. Family influence is an extremely important aspect in developing perspective on tattooing, but children do not always follow their parents' perspective. Other women I talked with had parents who attempted to shield their children from the idea of tattooing, yet it backfired. Such was the experience of the Florida tattooist Renee Little. While her mother attempted to shield her from the sight of a heavily tattooed woman when she was a child, Renee was similarly mesmerized:

> I was five and it was the end of the eighties. I remember holding my mom's hand in the mall and seeing my first punk rock chick. And she had a freakin' half-and-half mohawk thing. She had a tattoo of dates on her skull. She was awesome to me. I said, "Mom, what is that?" I remember my mom doing the whole earmuffs thing, and covering my eyes. "Don't look." I'm just like, "That is awesome." [Later] my sister told me, "That's a tattoo." She was older; she knew all. So that was my first sense of anything subcultural.

Though Renee's mother showed disdain toward "deviant" female bodies and their possible effect on her young daughter, Renee was still taken with the style. The image stuck. Regardless of whether parents approve or disapprove of alternative self-presentation, children will have their own particular tastes. The approval or non-approval from parents merely dictates how comfortable their child will be later on in sharing their alternative appearance with their parents. Many of the participants expressed strong resonance with the first time they saw an alternative-looking person. Others came to their taste for body modifications later on in life, in a less dramatic fashion.

Becoming a Heavily Tattooed Woman

The participants in this study are "heavily tattooed," as opposed to "lightly tattooed." Simply having a tattoo is not gender transgressive. Tattoos are feminine so long as they are "small, cute and hidden," preferably located on a sexualized part of the body. As we saw in the previous chapter, when women began collecting tattoos in larger numbers during the 1970s and 1980s, these images were usually always feminine—a small rose on the breast, a butterfly on the ankle, perhaps a small dolphin or sun. These tattoos were small, only a few inches in diameter, and easily hidden, placed on the breast, shoulder, or hip. Tattoo shops had flash images on the wall "for the ladies," on which these small designs lived. Janis Joplin had collected two tattoos from Lyle Tuttle starting in 1970, both of which were small and feminine. Her Florentine wrist bracelet tattoo was bold for being so publicly visible, but it represented an ornate piece of jewelry, and to her it represented women's liberation. Additionally, she had a small heart tattooed on her left breast, about which she stated, "I wanted some decoration. See, the one on my wrist is for everybody; the one on my tit is for me and my friends." She paused and chuckled, "Just a little treat for the boys, like icing on the cake."[25] Her heart tattoo was very much in line with women's tattooing of the day, but the wrist tattoo was one of the first publicly visible tattoos on a woman, and it was bold for the time. As a famous rock and roll singer, she could get away with it. And her statement of the tattoo being "a little treat for the boys" demonstrates the sexual and feminine nature of a

small, cute, hidden tattoo—or "icing on the cake" for a lover. Joplin's tattooist Lyle Tuttle, well-known as a celebrity tattooist, talked about how he enjoyed doing the small tattoos on women during our interview at the Spokane Tattoo Convention:

> It was small butterflies and rosebuds. I loved to put on small, colorful designs, so that was ideal for me. . . . And women are fun to tattoo. I mean, women will hold an intelligent conversation with you. Guys want to talk to you about their god damned Harley Finkelberg, ya know. I'd rather smell perfumes than grease.

Kari Barba, another veteran tattooist from Southern California, recalled that before 1980, there were few female clients, and they would only be in the market for small tattoos:

> They are getting bigger stuff, for sure. It used to be just a little quarter-size piece most of the time. . . . And it used to be when I first started, maybe 10 percent of the clients were women. And now it is definitely fifty-fifty. In fact, sometimes I think we definitely get more women.

Such dainty tattoos are in stark contrast to the heavy tattooing that the participants in this study boldly wear. While most research on tattoos make their distinction between those individuals who have tattoos and those who do not, I mark the distinction between women who are "lightly tattooed" and those that are "heavily tattooed." As tattooing soars in popularity, it is not transgressive for women to have one, or even four, small tattoos hidden somewhere on their body, or perhaps even publicly visible, as long as it has at least two of the three categorizations in the mantra "small, cute, and hidden."

However, when women's tattoos become the opposite of "small, cute, and hidden"—"large, ugly, or public"—they begin to encounter social sanctions for their ink.[26] Encountering social sanctions and prejudice when their tattoos are visible is an indicator that one has become heavily tattooed and "crossed the line."[27] For the heavily tattooed individual, being tattooed usually becomes important to their self-concept, and they become an "elite collector."[28] As defined by Katherine Irwin,

> The elite collector . . . is a subset of heavily tattooed individuals who desire the best art available, pay many thousands of dollars for their tattoos, and travel to cities around the United States, Europe, Japan, or Australia to acquire pieces from famous artists.[29]

In her study of elite tattoo collectors, Irwin describes a common aesthetic of tattoo imagery that the collectors often gravitate toward, as they are popular within the subculture: "images of monsters, demons, beheadings, severed hands, and aliens."[30] Christine Braunberger points out that once women become immersed in this subculture, they become "revolting bodies."[31] Braunberger states, "As symbols demanding to be read, tattoos on women produce anxieties of misrecognition."[32] Historically, heavily tattooed women were associated with the biker subculture, gangs, or prostitutes. Even in the 1970s, when tattooing was much more associated with the biker culture, women bikers still were steered toward "tattoos for the ladies," as many shops announced on a separate section of the flash art displays on the walls of the shop. Yet in the decades since then, women have moved away from the "tattoos for the ladies" sections and have begun to collect their own imagery of monsters, which the public still finds shocking on the female body. Because of this violation of gender norms, the women become monstrous in their violation and become the recipient of public scorn. The following sections look at common public reactions and self-defenses that heavily tattooed women encounter, shaping the narrative of their tattooed identity.

"You're Such a Pretty Girl, Why Would You Do That to Yourself?"

> It is a lot more acceptable for men to have excessive amount of tattoos. I think it's normal for girls to have the lower back or one on the shoulder. That seems to be deemed okay, but when you start getting into the full sleeves or the full bodies it's like, "Oh My God, you're such a pretty girl, why would you do that to yourself?"
> —Dawn Harris

The message that heavily tattooed women receive from the public is loud and clear: They are mutilating their bodies and making themselves ugly. Yet, in an interesting twist, the women reframe tattooing from their

Figure 2.3. Meghan Muzerie is a heavily tattooed model in Houston, Texas.

own perspective—tattoos are beautiful, they are marks of individuality. Or else they resist the pressure for normative beauty—it's *my* body, *my* choice. In this quote above, Dawn Harris, a tattoo collector from Houston, Texas, expresses the negative social sanctions from the public that all of the women I interviewed report receiving. I interviewed Dawn during a visit to Webster, Texas, where shop manager Jennifer Wilder connected me with quite a few women from her shop Abstract Art, including customers, friends, and partners of the male tattoo artists. At the time, Dawn was twenty-eight-years-old and working at the Apple Store, where she was able to show her tattoos at work, although

they elicited attention. In fact, she observed, "Pretty much everywhere you go, especially around here, [people notice]." Dawn is an attractive woman, with straight black hair cut in a rockabilly fashion, straight bangs just above her eyebrows. She has two old-school roses just below her collarbone and was already getting extensive work on her arms, which extended from wrist to shoulder. On her left arm, she was getting a Japanese geisha zombie head touched up during one of our talks. I interviewed her as she got tattooed; she showed no reaction to the pain she was receiving. This led the tattooist working on her to observe that "women sit so much better than men." Tattooists and collectors alike, whom I encountered, made this observation. Dawn's arms were covered in medium-sized designs that were brought together with shading and background filler images to make the sleeves appear of a more solid ink design. Her images were "old-school," like those one would encounter on flash sheets in the front of a street shop during the sailor years: nautical stars, a skull, a spider in a web. But her left arm was becoming covered in Japanese-style work, with red flowers and black water wave bars in the background. For Dawn Harris and her friends, they believe their body art is beautiful; however, they know that many in the general public would beg to differ. To many observers, it is inconceivable that a woman would purposely make herself "ugly," and this disbelief compels many people to breach the lines of appropriate public self-presentation. Strangers often touch the tattooed person without warning and continue to ask questions such as, "Are those real?"

Often tattoo artists warn customers against getting tattoos that they find highly visible or controversial. Before 1980, several of the women tattooists would warn women clients to avoid large, bold tattoos because of such public, negative treatment. In his research on Chicana tattooing, Xuan Santos found that several Chicano tattooists in East Los Angeles often "refused to tattoo Chicanas in areas of the body that are visible to the public eye . . . and encouraged women to tattoo on a private body region."[33] For the most part, women conform to feminine limitations. The tattoo collector Eileen Megias pointed out that many Cuban women in Miami keep their ink gender appropriate, unlike herself:

They have the appropriate tattoos. There are tattoos that are acceptable if you're a Cuban girl. Tattoos that are to enhance your sex appeal, like the

one on the lower back, or on your hip, or maybe something small by your ankle. They are in prescribed places and subject matters, like a butterfly is okay. Your boyfriend's name may be strategically placed on your butt. That kind of thing. But definitely no large graphics, and definitely not a lot. Men have their manly tats that they are allowed to have, no hibiscus for a Cuban man. Lot of names in script, or a memorial portrait of their baby, or dead brother, or a big 305 across their back. It's always to maintain the line—what makes you an attractive man or an attractive woman. It's just wrong to mess with those female assets; you're not supposed to ruin them.

In this quote, Eileen demonstrates the ways in which tattoo imagery reinforces normative gender roles, which are more restrictively reinforced in the Cuban culture that Eileen has experienced in her family and community. Imagery patterns are often established within subcultures, and for Latina/o, Black, and Native American women and men, script and memorials recognizing family members are common. She presents two gender-divergent tattoos designed for men (a big 305 on the back, which is the area code for Miami and represents hometown pride) and for women (flowers). Eileen Megias was a student of mine at Florida International University. While I was busy making sure all of my tattoos were tucked under my suit, I was grateful to walk into the classroom and see her sitting in the front row, with her bold, black tribal tattoos covering a good percentage of her arms, visible in her short sleeve shirt. She had short hair, was more masculine presenting in appearance, and had a big, assured smile on her face. She was older than some of the classmates, and her life experience was easily demonstrated in her confidence as she spoke up in class, voicing well-thought-out opinions, and, of course, in her ability to look different from the mostly hyper-feminine Cuban women students in the classroom. Eileen was also a lesbian, and she brought her partner to my office one day to be interviewed, freely discussing their identities as heavily tattooed lesbian women in the gender-normative environment of Miami. It was difficult for them, and they hoped to soon move to a city that was "more tattoo friendly."

For women, part of becoming heavily tattooed is to negotiate this decision within our beauty culture. In order to collect large, public, and so-called ugly tattoos, the women have to defend their choices on

a daily basis. This is often a difficult position, even for the most confi-dent. Greta Purcell, a participant from Spokane, Washington, describes this fear:

> Women are afraid of what people will think, extremely afraid. Young girls are really, really afraid of what people will think. And so they get their tattoos really hidden. Maybe somewhere where even their underwear would cover it. I just don't understand the shame.

Katherine Irwin agrees that women face additional pressures when they become heavily tattooed because of the beauty culture norms. While men become more masculine with their extensive tattoo work, even invoking a hyper-masculine image that can be misconstrued as criminal, women "are sometimes accused of being 'masculine,' 'ugly' or 'slutty.'"[34] Many heavily tattooed women reclaimed their inked status as being one of alternative beauty. In her article "Beauty Secrets," the tattoo collector Lee Damsky describes this reclamation of "ugly" tattoos as a means of alternative beauty construction:

> Later that year, I got a tattoo of Medusa on the back of my neck in an attempt to find empowerment in ugliness. In Greek mythology, Medusa was a creature so ugly [destructively powerful] that anyone who looked at her was turned to stone. I thought that embracing this symbol of ugli-ness and inscribing it on my skin would be the first step in accepting my body and claiming it as my own. Determined to abandon the cult of beauty once and for all, I resolved to be ugly and proud.[35]

Many of the tattoos reflect this sentiment by taking a portrait of a beau-tiful woman, such as Marilyn Monroe, or a traditional pinup, and turn-ing her into a zombie. Others collect images of beautiful Hollywood stars or pinups as a symbolic stand-in for the beautiful woman with which they identify.

"It's My Body, and Tattoos Are Beautiful to Me"

In spite of the world questioning their desire for extensive body art, heavily tattooed women are drawn to this particular style and must

endure the offensive questions, unpermitted touches, and outright scorn. Collectors love tattoos because they find them beautiful, self-expressive, and represent independence.[36] When women consciously reject beauty culture, it can be liberating. Women express that they are reclaiming their bodies and developing a heightened self-confidence. Becoming tattooed often makes women feel "closer in line with their own self-image."[37] Collecting beautiful tattoos on body part that one is critical of also creates a sense of reclamation. The tattoo collector Reva Castillenti from Tampa, Florida, describes her experience:

> I think it helped out with my personal body image a lot. I was pretty uncomfortable in my own skin, and then after I started getting tattooed, it helped. Before, in high school, I would never wear a tank top or a shirt that has a little bit of cleavage showing, it was completely taboo. . . . Because you don't want to show someone your fat rolls and be like, "Look at my love handles." But put a tattoo on it. Now they're not looking at your fat anymore. . . . So I think it was a means of reclaiming myself.

Another participant showed that tattoos also promote pride in the body and increased self-care. Bernadette Martinez explains:

> I take better care of myself now. I have to take care of myself to heal. And I am going to have to heal for a long time if I'm going to do both arms solid. So it made me be healthier. I work out a lot more, because I have this beautiful tattoo, I don't want my arms to be flabby. It's been a positive change in my life. Because now I work out, I eat healthy, and I take care of myself a lot more.

The tattoo collector Talia Robertson poignantly describes a situation that boldly placed her heavily tattooed status in sharp contrast to the beauty culture—her wedding. Weddings are the most prominent moment of enforced beauty culture, and women pay large amounts of money on their dress, hair, and makeup (but men are spared such expense).[38] On such occasions women are often expected to hide their tattoos. Indeed, there are products such as heavy concealer makeup, or even skin-colored cloth, which are made specifically to cover tattoos.

However, Talia Robertson saw her wedding as an opportunity to show off her beautiful artwork, and personality, to her family and friends:

> My wedding dress will be designed to show off my tattoos. I'm looking for something that cuts very low in the back so it will show what I have on my back. And I want spaghetti straps or something that is going to show my arms off. The goal for a fall wedding is to have my half sleeves finished by then. So that's why I started this so soon and I'm going straight to this other tattoo. I want that to be a part of my outfit for my wedding day. So it's going to be in-your-face. And all of our friends and everybody know, so I'm not really worried about them accepting that or anything. My parents will probably be the ones that have the issues, but his parents are fine.

Especially upon getting married and raising a family, women are expected to be "other oriented." Women become the default caretaker of their spouse and children and face social sanctions if they prioritize their own interests above that of their family. Yet tattoos are something for oneself. Kerri Newman, a tattoo collector in Spokane, Washington, and mother of five, states, "It makes me feel like I'm doing something for myself. I do so much for my family; this is what I have decided for me. It makes me feel like I have a piece that's mine alone. It's just something that I've always wanted." Kerri has tattoos that represent her children, as well as other subjects close to her heart. Gaynell Simmons, an African American woman who was visiting Miami Beach for work when I was able to interview her at Kolo Tattoo, started her tattoo collection at age forty-three because her children had always come first. For decades, she had desired to start her tattoo collection, but her children had always been her financial priority, and her desire for body art was always delayed. During this work visit to Miami, she began visiting Kolo Tattoo each Friday after work, to collect another small tattoo that represented her identity: a Gemini symbol, a theater mask, a heart, a Japanese design, and a yin-yang symbol. The owner of the shop, Cyndi White, had developed a friendship with Gaynell and invited me to interview her before she returned home to Maryland. Cyndi was especially impressed that Gaynell had sacrificed a great deal of her own interests and pursuits in order to support her children materially and

emotionally. For the first time in her life, she was taking this trip to focus on getting the tattoos she had desired for so long. Her consistent approach to getting a small tattoo each week, on payday, was also highly unusual for frequency, but it provided the time for Gaynell and Cyndi to get to know each other. While Cyndi was a new mother with her infant son in the shop, Gaynell's children were adults, and the women bonded over their shared motherhood.

Becoming heavily tattooed changes women's bodies and, potentially, their social relationships. Women overwhelming express their tattoos as a form of self-empowerment, especially because of their potential for self-expression. The visual content of their tattoos are often symbolic of important issues within women's lives, the topic to which I now turn.

"What Does That Tattoo Mean?"

The process of becoming heavily tattooed means letting go of social expectations of normalcy in appearance. This decision represents a certain authenticity to the self.[39] The question of what imagery people select and why is one of the most often asked and researched. The short answer is that people choose any imagery possible, with the aim of a vast array of self-expressive purposes. People get certain images tattooed on their bodies because they have personal meaning. The imagery and reasons follow certain themes: identity, family, hobbies/interests, pop culture, and transitional life moments. In an article entitled, "Managing Meaning and Belonging: Young Women's Negotiation of Authenticity in Body Art," authors Sara Riley and Sharon Cahill's participants describe their body art as a pathway to "being your own person."[40]

Many of the participants had tattoos that represented their identity. Ethnic identity was a popular theme. The tattooist Angel Garza had imagery that represented both sides of her multiracial heritage:

I have the Mayan pieces on my forearms, because half of my family is Spanish and Native, from the middle of Mexico and Central America. And on my upper arms. . . . I've got a big Chinese water dragon on the left arm. And the Chinese good luck bat, on my upper right. On my mom's side of the family they go back to China. And I got the Hello Kitty on my wrist because I like Hello Kitty.

Even though Kerri Newman collected her tattoos to represent her own identity, she still ended up with imagery that represented how important her five children were in her life, thus reflecting the centrality of motherhood to her sense of self:

> I had my two daughters names, which wasn't the smartest thing in the world to do, since I wasn't done having kids. I had four kids and I was done. So I came in and she tattooed this, it's my four kids' with their Irish birthstone tree and flower. My father passed away, so I had a tribute on my foot, because I wanted it near my kids. But I had a problem, because I had a fifth kid. So I had to squeeze them in also.

Even when family members' disapprove of the decision to collect tattoos, the participants still collected imagery that represented those family members. Even though Eileen Megias's Cuban grandparents were upset by her decision to become tattooed, they appreciated that the imagery represented them:

> My family was happy because most of this arm has to do with my grandparents. This virgin is the patron saint of Cuba, I inherited my grandmother's statue of the virgin. The anchor is for my grandfather. That made them really happy. When trusted family friends would come over, they would say, "Show her the tattoo you got for me."

Carmen Guadalupe does not enjoy strangers questioning the meaning of her tattoos, as she feels they are personal and private, not the basis for a casual conversation. Her tattoos resonate deeply with her heritage and family. Ironically, as she was a former soldier, military oriented tattoos did not appeal to her in the least, even with the strong connection between the military and tattoos historically. Carmen waited until she was out of the military before she began her tattoo collection in earnest. She describes how her tattoos connect her to her mother and the difficult time they faced while Carmen was in Iraq as a soldier:

> To me it's personal, because I got it to represent my mom. Women go through so much pain with their children. And by me going off to war—and my mom—the pain it must have caused her. I'm an only child. The

pain my mom must've gone through, while I was out there in Iraq. It's like what the Virgin Mary went through with Jesus on the Cross. So it's a representation of her strength, and the strength of the mothers around the world. I think they suffer the most.

Tattoos representing and honoring family members are popular imagery for both men and women, and they provide a genre that may be equally utilized by both sexes. From the "Mom" in a heart tattoo based on flash sheets, to portraits, script, or symbolic imagery representing family members, the family provides an endless topic for tattoo art. For Carmen, her tattoo goes further than a symbolic mom in a heart and represents their heritage, relationship, and her experience of serving in the war. Because of this deeper meaning to her tattoo, it becomes a personal image that she does not want to share superficially with strangers.

Transitional life moments were times when many of the participants chose to get a tattoo to commemorate the memory. In his study of tattoo collectors, Paul Sweetman also found that interviewees became tattooed in order to make transitional moments into a permanent reminder of "particular periods or events."[41] Rolene McClanathan described her "transitional moment" tattoos:

> It seemed to work out where all my tattoos happened around times of transition in my life: leaving bad relationships or having my son. All of my tattoos are very intimate as far as points in my life that I have progressed through, or transitional moments. My first tattoo was the chaos symbol. I had left a really bad domestic violence relationship, and that was my way of celebrating leaving the chaos.

Margo DeMello reminds us that there is a particularly gendered motivation for collecting tattoos. In her study of the tattoo community, *Bodies of Inscription*, DeMello states that

> women . . . are much more apt to explain their tattoos in terms of healing, empowerment, or control. I have not had any straight men report to me that they acquired a tattoo as a means of regaining control over their life while undergoing a crisis.[42]

A more common motivation for both women and men in selecting tattoo imagery is to commemorate particular interests, hobbies, passions, or popular imagery. Heavily tattooed people often pride themselves on their custom design tattoos, distancing themselves from more casual collectors who may select images from flash sheet sets on the wall. The popularity of particular tattoo images go through phases, like any other art world: fairies in the 1980s, tribal tattoos in the 1990s, and in the 2000s, large Japanese style designs—such as koi fish and cherry blossoms—were popular. Several of the participants had imagery based upon popular culture references, especially film and music. Judith Davis collected references to movie characters that she enjoyed:

> I really like pop culture. So, I am probably going to be covered with weird shit. This is going to be a half sleeve of the Marx Brothers. This is a monologue that Groucho Marx says in one of the movies. I'm saying something with my tattoos. It's not just artwork, or something cute. It's my personality on my arm. So you don't even have to talk to me to really get me. You just look at my tattoos.

Tattoos often "sample" from popular culture, just like music does; for example, cartoon characters, popular actor portraits, or corporate logos often make their way into tattoo artwork. Some lawyers and legal scholars have commented on issues pertaining to potential copyright violations by such tattoo art, including when tattooists copy tattoo designs straight from a photograph or tattoo magazine; however, such lawsuits have not yet started to be filed.

While some tattoo collectors feel their personal tattoo art is too close to the heart to share with strangers, others may be putting their interests on their sleeves in a way that could provoke both those with common interests and those who object to the imagery to comment. Judith Davis in her quote above is stating that she is making herself transparent with her tattoos, which act as a filter or a message to the public about her interests and passions. Those who share her subcultural references might be provoked to comment, and presumably, Judith may invite a conversation with a fellow enthusiast. Tina Ferris, a tattooist in Florida, was interested in classic movies and photography, which she commemorated in her extensive leg tattoos. She states:

The portraits I have are black and gray, and they are influenced by classical movie stars: James Dean, Marlon Brando, and Marlene Dietrich, some of my favorite actors from when I was younger. I did a lot of photography when I was younger; and James Dean did a lot of photography also. He would shoot with the photographer that used to take pictures of him. Actually, the portrait that I have on my leg is of him with a camera, taking a picture.

Because heavily tattooed women can express their numerous interests, family connections, and heritage, it is easy to see how they can quickly become covered in artwork expressed over a lifetime. Sailor Cher, a piercer in St. Augustine, Florida, walked through her tattoo collection as if down memory lane:

Of course, my first one was for my mom. Here is my anchor from my career in the Navy. This one was for my children. I've got a lot of daughters, so instead of getting all their names, I just had the rose tattoo as a reference to the Tennessee Williams play, *The Rose Tattoo*. This is my wedding band right here. My husband and I have matching tattoos, and when we hold hands they match up. When we were married, we actually put our wrists together, "And with this tattoo, I thee wed." So, I guess that's important. . . . I like to play pool. I drink appletinis. The one on the back of my leg is my menopause tattoo; the day after I became officially menopausal I had the Sailor Jerry pirate girl[43] with the bloody saber tattooed. . . . What else? In my previous life I was a pirate, so that's one. The little heart on my ankle I share with my daughters, they all have that same tattoo. And they have their birth order in them. We had that done on Mother's Day together. I've got more on my back, I have a *que sera sera*, "What will be will be." . . . And then of course there's my bat-winged penis. Okay and that has no significance whatsoever. And to counter that, I have the angel wing cherry pie.

Sailor Cher started her extensive tattoo collection at forty-two, after she retired from the navy, where she worked as a reporter. When I interviewed her at Ms. Deborah's Fountain of Youth Tattoo Studio, she was a fifty-six year old piercer, a mother of five daughters, and a grandmother. She had her salt and pepper hair shaved into a mohawk and

extensive tattoo work covering her from feet to chest, with full sleeve tattoos visible, yet also wore a pearl necklace, red fingernails, and a full face of makeup. In the tattoo studio and at the convention Marked for Life, where I would also see her, she was much admired by the younger women, as she represented an alternative image of an older woman. Sailor Cher flaunted her alternative beauty and sexuality.

"I Want to Be Covered"

All of the participants in this study planned on continuing to collect tattoos until they had a bodysuit—literally being covered from foot to neck. By now, they were dedicated to this particular style of self-expression and had no plans to change their direction. None felt complete, and all of them had plans for further tattoos. First and foremost, they wanted to finish works in progress. Second, they wanted to continue following themes that reoccurred through their body art. And finally, they aimed to collect new pieces that they had been thinking about for some time. For example, Carmen Guadalupe planned on getting more tattoos representing her Mexican heritage: "I'm going to get a sugar skull on my elbow, to represent the Mexican side of my heritage. And my mom's portrait will go here. I still have a castle to put here, because it goes along with her background." For Jennifer Muniz, a tattooist in Miami, Florida, she wanted to explore a new theme in her tattoo collection:

> I really like movies a lot. So I want to do a movie homage on the side of my leg, from my thigh to my ankle. *Natural Born Killers* is my favorite movie. And *A Clockwork Orange, Donnie Darko*, a bunch of cool stuff. *Frankenstein*, I'm just going to throw all the movies on the side of my leg. With some film reels in the middle or something, it'll be cool.

The veteran tattooist Patty Kelley described her future plans for tattoo work she found humorous:

> I'm going to get both arms done, eventually. This is going to be all meat-eating plants. That should make all the vegetarians very nervous, plants that pay back. There are dozens and dozens of variety of meat-eating plants. And the rest will be fruit.

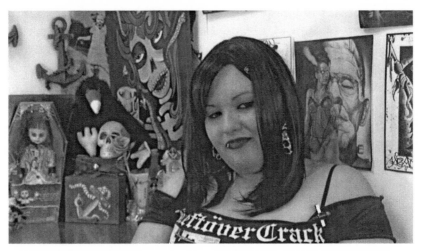

Figure 2.4. The tattoo artist Jennifer Muniz specializes in creating custom monster tattoos, like the dolls behind her.

Genevieve Arnold planned on collecting another nature-themed tattoo:

> I liked how the scorpion tattoo looks. I want to have more insects. The insects are aesthetically beautiful, there are so many different insects and they're all so interesting, different shapes, colors, and sizes. I like that the scorpion has sort of a threatening quality, but they're whip-tail scorpions, so they're not really dangerous, they are usually underground and hide.

While many family members cringed with each new tattoo that the women brought home, pleading with them to stop, they themselves were only becoming bolder in their confidence to carry their growing art collection with them throughout their lives. All of the participants loved being tattooed and nearly all planned on continuing the journey. For some, they are content to collect one or two tattoos and stop. For heavily tattooed people who consider this one of their passions, it is hard to end the project of collecting tattoo art to represent continued interests, passions, and life milestones. This becomes one of their favorite means of self-expression, and there is always so much more to express. Further, the women appreciated the look of solid tattoo work covering the body (a "body suit").

Many of the participants said that they wanted to be "covered." While the majority of people with tattoos may have one or two small images that they are content with, heavily tattooed women overwhelmingly want to have as much skin tattooed as possible while still avoiding the face and, perhaps, the hands and feet (that is, the "public skin"). In Miami, Andria Chediak had begun her journey of becoming heavily tattooed by her mid-twenties. Even though most of her tattoos could be covered with a T-shirt at that point, she intended to cover most of her body. Andria stated:

> I have always wanted them. And not just little ones, I've always wanted full coverage. For me, it's just my own satisfaction; they all mean something to me. They're all an experience to me. And I just love the way it looks. Some people get plastic surgery, some people get lots of piercing. People change their hair. I get tattoos.

Andria Chediak explicitly compares tattoos to plastic surgery or changing one's hair, which are part of normative beauty projects with which women engage. Throughout this research, I have wondered if heavily tattooed women have more positive self-esteem and love of their bodies, as they are not constantly comparing themselves against the beauty norm against which women who engage with normative beauty rituals may compare. For women who get plastic surgery or spend a great deal of time on hair, makeup and fitness, their journey is endless, as one can never have a beautiful, flawless, airbrushed body in the real world when comparing oneself to the glossy magazine ideals. Beauty must constantly be maintained. Facelifts need to be redone, the aging process continues. And age is the enemy of the beauty project—with its emphasis on perpetual youth. Pursuing beauty is like being on a treadmill; there is always more work to be done, more money to be spent. The procedures are superficial, literally on the surface of one's skin, a costume, under which the body is hidden. But for heavily tattooed women, their journey is also endless, as there is more work to be done. When I take pictures of the participants, sometimes they are shy about having an incomplete tattoo photographed, similar to a woman without makeup who may shy away from the camera. When the participants look back at the photographs years later, they often comment on how "incomplete"

they were back then. "That was before I had my sleeve finished. Look how naked I appear." After each tattoo, they beam with delight, showing it off for the world to see. "Isn't it awesome? My new tattoo." They see their bodies as a constant work in progress. Whereas most people mark themselves by the age they demonstrate in photographs ("I looked so young then"), tattooed people have their ink progression to also mark the time ("that was before I had my arms done"). Therefore the desire to keep on with the project, be it normative beauty conformance or tattooing, can become a life's work. Do these groups—the tattooed and the plastic surgery recipients—overlap, both being body modifiers, or are they opposites on a binary? Of all the participants, only two mentioned getting plastic surgery (breast implants)—and one was Sailor Cher. In her piercing studio, a photograph of her—topless—adorns her wall, where she is showing off her new breasts, as well as her tattooed chest, pearl necklace and flawless makeup. Overall, tattooed women are not immune to beauty norms, but as they are going against the grain, they have the self-confidence and disregard for social pressures enough to accept themselves and follow their non-traditional bliss. They receive criticism and build defenses against it. In the end, I feel that the heavily tattooed women demonstrate a great deal of self-confidence and self-love in ways that those who aspire to be traditionally feminine do not. Women are especially valued for their youthful appearance, and the aging process erodes femininity, as older women are deemed less sexually desirable. Unlike the fashion exhibited through clothing, which can be muted as one ages, tattoos remain for life and provide a constant reminder of the women's alternative gender expression, which may become more surprising on their aging body, as tattoos can be associated with youthful rebellion. For women to embrace the possibility of aging gracefully, aging gracefully with tattoos becomes a statement of continued bold self-expression.

"What about When You're Eighty?"

Even though these heavily tattooed women did not regret their tattoos, they constantly encountered *other* people who argued that tattoos are regretful. The fear of permanency seems to be the motivation behind the question: "What about when you're eighty?" I find the question to be

an especially gendered attack on women. In our culture, the aging process is considered to be especially cruel to women; while men become "distinguished," women simply become old and invisible. Consider how aging actors, news anchors, and performers face differential treatment later in life based on their gender. Whereas older male actors may be paired with very young women as their romantic leads, female actors become quickly replaced as they age. Many women report "becoming invisible" later in life. Once they are no longer considered a sexual being, they are no longer considered at all. This type of ageist sexism underlies perception of heavily tattooed people. Yet this is not a worry that the tattooed women expressed to me, as they all seem excited about entering their old age as "the coolest grandma ever." But all of the tattooed women have encountered this derogatory remark at some point. Therefore, responses to it have become part of their arsenal. Talia Robertson told me her typical response:

> I had people say, "What are going to do when you're eighty? You know, what are your tattoos gonna look like?" I'm assuming they're going to sag, because everybody sags at that age. And I've had a lot of women say, "What are you going to do when you get pregnant?" because of my stomach tattoo.

These comments remind Talia of her social role as a future wife and possible mother. The message is clear: She should not ruin her future of being a good woman with her temporary wild ways. Women are expected to fade in appearance and become more socially conservative as they grow older. However, all of the participants looked forward to having an interesting body in their later years, even if it is wrinkled or sagging. For these participants, they did not expect to fundamentally change as they aged; instead, they expected to become even more comfortable in their bodies. They are not going to have a turnaround and become conservative, regretting the life they have led. Samantha Holland studied older women who were eccentric in their dress and body art for her book *Alternative Femininities*. She writes, "Body modifications work against the idea of women becoming less visible as they age" and that an older modified woman would stand out more than a similarly adorned young woman because of the expectations for the different

generations.[44] The participants often expressed hope that there would be more acceptance of body art by the time they were eighty. None of them were bothered by the idea of having faded or sagging tattoos, since that simply marked more of their life journey on their skin. Renee Little stated: "I'm going to be the eighty-year-old woman baking cookies, covered in tattoos." Several of the participants already were grandmothers, like Sailor Cher. During our interview at her piercing studio in St. Augustine, Florida, Sailor Cher recounted her experience of being a tattooed grandma and hoped her example would lead to more acceptance:

> I've been asked about being a tattooed grandma. My grandchildren don't know anything else. I mean, isn't everybody's grandma tattooed? That's how they feel. And I think it makes them more tolerant of people that are different. So it has actually been a good thing. As far as my children, they are all tattooed and pierced. It's a beautiful thing, and they appreciate it.

None of the participants expressed any concerns regarding the aging of tattoos. To the contrary, the tattoos seemed to provide the participants with a positive outlook on the process of aging in general.

Conclusion

> The oldest woman that I ever tattooed was about seventy-six. She came in, and she wanted a little heart. And I was like, "Wow, why did it take you so long?" And she was like, "Honey, my husband just died, and he never wanted me to have a tattoo. And darn it, now that he is gone I'm going to do what I want!" And then she got her first tattoo. It was one of the best experiences I ever had.
> —Kari Barba

Kari Barba told me this story in her Long Beach, California, studio. Several of the tattooists had reported working on elderly women clients who reported reaching a point in their lives when the felt that they could finally do as they wanted. For many people in general, they wait to get their first tattoo, or additional tattoos, because they are weighing out the negative social sanctions that may accompany their decision. Tattoos still carry the burden of stigma that originates in the historic

associations from the early part of the century: circus performers, criminals, sailors, drug addicts, and bikers. For women, the pressures of the beauty culture further stigmatize tattooing as masculine and, therefore, ugly for women.

The women I interviewed described their experiences of becoming heavily tattooed, the selection of artwork, and some of the social responses that they elicit. Strangers and family members alike often do not understand why "such a pretty girl would do that to herself." But those interviewed described their tattoos as beautiful, accentuating their bodies in ways that made them feel more in line with how they saw themselves. As the Seattle tattooist Jacqueline Beach stated, "I can't imagine myself without them. I don't know myself without them." When the participants retold their tattoo narratives, it provided an insight into their personality, interests, and histories. One could look at their permanent artwork and know important details about their lives. All of the participants wanted more tattoos; most of them realized that they would probably continue until their bodies were mostly covered. "I want to be covered," was a popular sentiment among the interviewees. Yet the more they continued on their journey, the more social sanctions they received, such as the infamous tattoo question, "What will you do when you are eighty?" The responses from the participants indicated that they were happy about their choices in body modification and looked forward to a future in which they could feel that they were true to themselves.

3

"I ♥ Mom"

Family Responses toward Tattooed Women

Born in Primrose, Nebraska, in 1926, my father had rarely even seen tattoos, being so far from either coast, where sailors might appear. He was fifty years old when he had me—his third child—born to his third wife, an immigrant from Hong Kong and his former student from the rural state university at which he spent his career. Neither of my parents had the background to understand how their daughter, coming of age in the 1990s, came to be immersed in the subcultures of radical politics and punk rock. I knew better than to immediately tell them about my beginning tattoo collection. But it was not until I became friends with Charissa, my tattoo artist friend, at age nineteen, when the subject of tattooing became a real conflict in our family life. The first time I brought Charissa home should have been an indicator of the chasm that tattooing would create between myself and my family. I kept my tattoos hidden from my father—except for one brief moment. At eighteen, I showed my dad that I had two tattoos. He accepted it, but he certainly hoped it was a phase that would soon end. From the age of nineteen onward, I never again showed my father my skin. I would visit Spokane only during the temperate months, which, luckily, was most of them. I rotated through a few long-sleeved shirts, nervously hoping the inked portrait of my father would not peak out the neck of my shirt. Sometimes when it got hot in the unair-conditioned house my father lived in, I fantasized about coming clean. But he was neurotically phobic of snakes, unable to bear the sight of them on television, let alone his own daughter's arms. Even if he knew, I would be unable to relax in a tank top, and so I sweated out the summer, choosing not to upset him during our brief annual visits. He just wouldn't understand.

Of all the participants I interviewed, it was the Asian American women who would go to the greatest extremes to hide their ink

collections from unaccepting parents since Asian cultures harbor harsh associations of tattooing with criminality. I had an ironic reversal of that situation. While my White father could not endure the sight of tattoos, my immigrant mother, who lives in sweltering Las Vegas, Nevada, was more accepting. When I visit, my mother will often encourage me to hide my tattoos when we visit extended Chinese family members. However, once my tattoos are covered, she will often tell them about my tattoos—in Chinese, which I don't understand—and soon enough, she is pulling at my shirt sleeve, telling me to show them my ink. I am able to lounge around in my tank top during visits to my mother's place, but with each additional tattoo, she scrunches up her nose and asks, "Not another tattoo, is it? When are you going to stop that?" But she understands the reasoning for the snake tattoos on my arms—I was born in the Chinese year of the Snake—and so they show pride in my heritage.

Knowing how contentious and diverse family reactions to tattoo collections can be, I asked my interviewees, How did their families view their body art? How did these reactions reflect already-established family dynamics? Were permissive parents more accepting than authoritarian ones? Were reactions harsher among older family members, such as grandparents? And were they, therefore, more accepted among siblings, cousins, or children? How did disclosing one's tattoos affect family relationships? This chapter examines the reactions that the participants have received from their family members, broken down by generation and relationship: parents, grandparents, partners, and children. The chapter also looks at the ways in which the role of being a heavily tattooed woman and a mother intersect.

Family Responses to Tattoo Disclosure

The most important indicator of parents' willingness to be supportive of the participants' tattoo collecting was their adaptability to the changing dynamics of the parent-child relationship. This adaptability provides a foundation for more stable, close ties over time.[1] Rigid, authoritarian parents often strain this emotional cohesion and provoke increased tension with their children.[2] Such parents hold an idealized image of their children's futures that is often incongruent with an alternative

self-presentation. The people interviewed expressed conflicts over their tattoo collections with parents, grandparents, partners, and teachers (and other parents) at their children's schools. How do these conflicts affect participants and their relationships? Are they pushed to hide their tattoo collections at family functions or at their children's school events? While there is little written about family conflict over tattooing in particular, the social science literature on other topics can provide useful theoretical models for family conflict and adaptability in general.

Interviewees experienced a wide range of family responses to their tattoos, which were reflective of already established patterns of emotional interactions. Families that were flexible, respective of a child's autonomy, and emotionally warm and loving experienced the most positive responses toward the tattooing project. Families that were authoritarian, rigid, and emotionally distanced fared much worse when it came to responses of family members toward tattoo disclosure. The participants were able to anticipate the response based on the history of interactions and thus could decide on their level of disclosure. Generally speaking, negative responses came from older generations and from Latino and Asian American families, while younger generations and Whites were more accepting.

In another study of tattooing practices, participants were more likely to become interested in tattoos because they had tattooed family members who had exposed them to the practice and were accepting of it.[3] Some of the participants in this study had been exposed to family members' tattoos early on, and it influenced them. These tattoos provided them with the awareness that tattoos existed, were an option, and were somewhat accepted by the family. Being tattooed became more normalized, rather than something completely unwelcome. While some family members may have tattoos, others may still be opposed to them. I interviewed Loryn Heffner in Tampa when she was a twenty-year-old college student studying both drawing and fabric art. She already had quite a few tattoos and remembered that her first exposure was through her uncle:

> I was three or four, sitting on Great-Uncle Tommy's knee. He was doing the pony game, and I noticed that he had a hula girl from his wrist to his elbow, green colored. It just stuck in my brain, this naked hula girl. Later

on I asked him, "Did you get tattooed in Hawaii in 1949?" He said, "Yes, Sailor Jerry did that." So it was pretty cool.

While Uncle Tommy had a sailor tattoo, Loryn's mother was less approving. Loryn described her mother's perspective:

My mom is super Christian, a little old church lady. She's adorable. I love her, totally. She always thought that people with tattoos were bikers and sailors and vagrants. So to have both of her children becoming tattooed is really difficult for her. At least it was for quite some time. I guess she's accepted it, more so, now.

For Loryn's mother, the uncle's tattoo fit into her stereotype of the wearer being a sailor and collecting a memento while serving in the navy. However, her children collecting tattoos did not fit within her preconceived notion of propriety. I interviewed Loryn at a tattoo studio in St. Petersburg, Florida, while Renee Little, an apprentice tattooist at the time, worked on her. Loryn was getting a tattoo of a Band-Aid on her foot, where she had recently sustained an injury and wanted to commemorate the fracture with this permanent memento. One of her tattoos was a memorial for her mother's friend who had died of AIDS, a "radiant baby" by the artist and social activist Keith Haring, popular in the 1980s. On her ankle, she had a swallow that "was inspired by the Greek god Hermes, he was my favorite. It's a small bird, holding a letter. And according to the myth, small birds are the carriers of the soul to the underworld, the messenger." She also had another swallow tattoo in the style of traditional American flash art, based on Sailor Jerry's design, on her shoulder, a style similar to her uncle's. Another tattoo was a skeleton on her other shoulder, also done by Renee, around the time of Halloween. She chastised herself for collecting holiday-themed tattoos but also said that it was a design that Renee liked to do, and collecting an art piece in the style of the artist is something that collectors like to encourage, especially when they are friends, as these two were. Loryn felt that her tattoos represented her own personal museum collection:

To be honest, I find tattoos to be incredibly aesthetically pleasing. It's like having your own personal museum. Loving art as much as I do, I

hope to eventually be a curator of a museum. It's like having my own personal collection of fabulous art that I will always have with me. And it is also something permanent—in the world where everything fades away. So many things are not stable. This is mine and nobody else's. It is a wonderful feeling.

Amanda Forgue, a twenty-four-year-old in Pearland, Texas, was introduced to the world of tattooing when her father gave her a tattoo magazine. From the very beginning, she knew she wanted to be covered in tattoos, even though she didn't quite know which designs she was interested in:

When I was fourteen or fifteen my dad bought me my first tattoo magazine, and that was it. As soon as I could get tattooed, that's what I was doing. Yeah, he has a tattoo, a big anchor on his forearm, which he got in the navy. And so that's kind of what started everything.

Even though her father introduced her to the world of tattooing, he still was not happy about her becoming tattooed: "Oh, he minded, he definitely didn't want his daughter getting tattooed. But he's better with it now." Therefore parents can have an appreciation—or at least be open to body modifications—yet still resist the idea of their children becoming modified. In the next section, I explore the variety of responses that the women received from their parents over their tattoo collections.

Parents' Reactions

For the women interviewed, the younger they were, the more significant their parents' responses to their tattoos were, as they believed that these tattoos could have a profound effect on their lives.[4] One study found that parents in general were accurate about "80% of the time in their knowledge about adolescents' daily experiences," and this could be extended to their knowledge of their children's tattoos.[5] Tattooed adolescents often went to great lengths to hide their tattoos from disapproving parents, even while living in the same household. For women who were older and living on their own, it was simply easier to conceal tattoos from disapproving parents. In general, the women were more

open with parents who were accepting. One study found that family members who "disclose more to all other family members also appear to be more satisfied with their relationships."[6] Kimberly Updegraff and colleagues conducted a study on parental involved with teenager's peer relationships, and their findings concur. Updegraff et al. report on the importance of open communication between parents and children for healthy relationship development:

> Expressing one's beliefs and ideas, learning to understand each other's viewpoint, discussing problems honestly—may be beneficial as adolescents strive to establish intimate friendships.[7]

The scholarship on the family clearly states that parents who are warm and accepting are able to establish closer and more respectful relationships with their children over time compared to those who are rigid or authoritarian.[8] For parents, allowing their children to develop independently, even when their behaviors and beliefs are disagreeable, is healthier for the children's development. "Forging strong emotional ties" is an important step leading to "adolescent family life satisfaction."[9] Open communication was central in establishing these close, emotional ties. Another study found that the more accepting parents are, the more disclosure children are willing to make.[10] The tattooed women I interviewed often told their mothers before telling their fathers. Both mothers and fathers provide a range of responses to their daughters' tattoo collections, from total acceptance to complete ostracism. Family reactions to tattoo disclosure reflected already established pathways of communication and control. For the most part, the women could anticipate their parents' responses because they already knew their parents' feelings toward tattooing and their emotional openness. Cody Kushman, a tattooist in Long Beach, California, had one of the most positive family responses:

> Well, I think I have the best family in the world. I have tattooed every single one of my family members, all of them. My family is rad about it. I didn't even think about it [acceptance]; it's just the way you were brought up. My parents are so open that I didn't even think about asking to get a

tattoo. I just came home and was like, "Look at my tattoo." My mom said, "Oh, it's cute." Everybody is so proud.

Two of the participants shared their tattoos with their mothers, and subsequently, their mothers decided to acquire their own tattoo artwork. This provided an important bonding moment for the two pairs. Man's Ruin, a Roller Derby player from south Texas, states:

> I took my mother to get her first tattoo when she was forty-five. . . . She got a chain of roses around her ankle. . . . I think she was having a midlife crisis and actually got a tattoo because of it. She thinks she's so cool because of it. I thought it was cool; I took her to get it. I sat there with her, and she complained the whole time that it hurt. I'm sure it did. But she got it, and she likes it.

Jacquee Rose, age 22, and living in Cocoa Beach, Florida, had one of the most accepting mothers of all the participants. They already had a very close relationship, as Jacquee's mother Amelia had raised her as a single

Figure 3.1. Jacquee Rose is pictured here with her mother, Amelia Joseph, who is kissing her daughter's tattoo, which depicts Amelia.

mother, and they were living together at the time of the interview. Jac-
quee had gotten her mother's portrait. "She's my mother, my best friend,
just somebody that I respect completely. She's a wonderful human
being and that's why I have her tattooed on my arm." Her mother was
impressed by this gesture: "It makes me feel good that you're proud of
me." I was able to interview both of them in their two-bedroom apart-
ment in Cocoa Beach, Florida, where Amelia was a hairdresser:

> My mom loves it. My mom has a few small tattoos; she received cosmetic
> tattoos on her face. So, for me to sit there and watch my mom get her face
> tattooed, that was really cool. She did it on the same night as the grand
> opening of a shop I used to work at. It was awesome to watch my mom.
> She got tattooed at fifty. She said, "I want to do this for me."

Jacquee's mom, Amelia, discussed her philosophy on child rearing,
which has contributed to the closeness that she shares with her daughter:

> A child is becoming a person, and you need to let them become their
> own person. They are not yours forever, so you are lucky if you have
> a good bond with them. Heart to heart and mind to mind. I certainly
> would not want my daughter to hurt herself, but she's doing something
> that as you can see, is beautiful, and it's making her feel confident. It's cer-
> tainly going to make me feel happy. And like I said before, at first I was
> hurt because I thought maybe she was hurting herself. But as you start to
> experience these things, you start to feel more comfortable and say, "Oh
> wow, that does look great." And her tattoos are beautiful, and I'm proud
> of it, like when she got a portrait of me on her arm. It really is an honor
> for her to do something like that. And at first I didn't feel that honor. I
> felt, Oh my God, ya know—are you nuts? But then when you sit back and
> really absorb what's really going on, it's absolutely gorgeous. And it will
> be there forever, and so it just makes me feel warm inside to know that.

Even though Amelia is a loving and accepting mother, she still had a
hard time accepting that her daughter was becoming heavily tattooed
and wanted to become covered. She hoped that each tattoo was Jac-
quee's last and felt that heavily tattooed people looked "too cartoon-y."
But Jacquee continued to immerse herself in tattoo culture, first by

dating a tattooist for a decade, then later on becoming an apprentice, and then a tattooist on her own. "I just hope she stops," Amelia says. "I'm not going to stop," Jacquee laughs. It is not Amelia's permissiveness or unconditional love that encourages Jacquee to continue getting tattooed, as some authoritarian parents may argue. As she states, Jacquee intends to continue collecting tattoos no matter what the response. But having a mother express unconditional love and acceptance can only enhance a nurturing relationship. Amelia's parenting philosophy is the perfect example of the healthy developmental model that Carolyn Henry discussed in her research. Henry explores family developmental models that point to an increased need for accommodation and flexibility within the family environment for children to assume increased responsibility for themselves and their behaviors.[11] In Lauraine Leblanc's landmark study of punk girls and their relationship to their families, she found a few accepting parents who stood out in a sea of disapproving parents:

> Some did find that their parents were open-minded and accepted their daughter's unconventional appearance or lifestyle, as did Lisa: "My parents are really open-minded, so they were just like "Well, if that's what you like . . . you pay for it. Pay for your hair dye." That's it. . . . Sadly, these girls' experiences were very much the minority of cases.[12]

In Leblanc's study, some of the participants' parents were open-minded and accepting; however, the majority were not. Many parents disliked their daughters' tattoos and/or punk rock aesthetic. Some were able to tolerate it, while other parents rejected their daughters, thus allowing appearance to significantly alter their relationship.

Similarly, in my research for this book, the majority of the participants' parents were unhappy about their daughter becoming heavily tattooed. Some parents did not want to know about, or see, the tattoos. Still others completely rejected their daughters over their transgressive acts, finding the behavior absolutely unacceptable. Such harsh responses came from parents who were strict and authoritarian. Such authoritarian parenting actually models "aggressive, noncompliant behavior."[13] In Leblanc's study, many of her participants recounted heartbreaking stories of family rejection over their adoption of a punk aesthetic. Some

parents did not want to be seen with their children anymore in public. Rudie, one of Leblanc's participants had such an experience:

> My mom, she used to walk three feet behind me all the time. And one day I said, "Would you come on?" And she was like, "No, I don't want anyone to know I'm with you." I was like, "Damn."[14]

Many of Leblanc's participants, minors living at home, would run away to escape such authoritarian control. These girls felt pushed out, and some even ended up on the streets.[15] Leblanc's participants' punk aesthetic was often more "extreme" and harder to hide than the tattooed participants of this study. Unlike Leblanc's participants, participants in this study are adults. Man's Ruin was kicked out of the house by her mother when she was a teenager, albeit very briefly:

> My mom kicked me out of the house when I got my first real tattoo, the cat on my back. It was for a day, and then she let me back in and said, "Don't get anymore." I said, "Okay." Then I got these tattoos, and she freaked out again. My dad never really says anything, just stupid comments.

For Yvonne La, a Korean American tattooist in Southern California, it was a moment of truth when she came out to her parents. Her profession was only one aspect of her life that she hid from her disapproving parents. But it was enough for her to fear rejection. Ironically, she only had one tattoo herself, though she had been tattooing for over a decade. She had more personal aspects to reveal of who she was as a person:

> My parents expected me to go to college and do the whole doctor thing. So I was on my way to do that. And then, I finally decided that I was going to do something for myself, which was tattooing. My father tries to understand, but he would just rather not talk about it. And my mom, she's horrified, as a matter of fact. I mean, it was such a big deal when I told them: I told them that I was dropping out of college, that I was a lesbian, and that I was tattoo artist, all at the same time. I dropped the bomb on them. . . . My mom cried for at least a year—she seriously just cried. And she didn't know which one was the worst of them all. . . . In the end, it actually made us closer because I did not have to lie anymore.

I got to a point where I was tired of lying, and they wanted me to be a part of their lives. And so I threw it out there. My dad was great, he said, "Well you're my daughter, and I've always loved you and I'll always love you no matter what." And he was like, "Just do me a favor, don't tell your mom. She doesn't need to know." And then one day I told her, and I even showed my tattoo to her, and she just lost it. "I can't believe you did that to me. Why would you do that to me?"

Yvonne's family moved to the States from Korea when she was a small child. In Korea, as in other Asian nations, tattoos are associated with criminality and, thus, are stigmatized. In Japan, for example, tattoos are banned in many pseudopublic places because of their association with the *yakuza*, or organized crime members, even as the art form has gained popularity among younger generations and Japanese-style tattooing has garnered significant international attention. However, tattooing is much more underground, and therefore less visible, in Asian countries compared to the West. Therefore Asian immigrant parents, with American-born children, have fewer references to the practice than their White peers. Asian cultures are often more family oriented, requiring individual decisions to be weighed against family reputation, unlike the individual orientation of Western cultures. Asian parenting models are often authoritarian and value economic success (never artistic expression). Many Asian American children complain of their parents' cold, controlling mannerisms when compared to the affectionate permissiveness of their White peers' parents. Of all the participants, the Asian American women were the most likely to completely hide their tattoo collections from their parents. Yvonne had been withholding a great deal of her identity from her parents, fearing rejection and increasing her own stress. When she finally spoke to them about her issues, it was her father who was more open, rather than her mother. In the end, Yvonne felt her honesty brought her family closer together, as she no longer had to hide important aspects of her life. Her parents valued their relationship with her enough to not end it over their thwarted expectations.

Why were Asian American women most likely to conceal their tattoo collections from family members at all costs? Because Asian families were the most likely to completely banish a child for becoming

tattooed—ending all communication. Bringing shame upon the family is often enough to provoke such banishment. Evelyn Park, a Korean American originally from Washington, DC, told the most heartbreaking tale of family rejection:

> I wanted my parents to *see* me. I did not feel seen by them. Sometimes I still don't, and I tried in many ways. I told my parents things they never wanted to know about me. And I realized over the years it was like I was trying to say, "I'm here, ya know. I am your daughter. I'm here, this is who I am, this is who you created." And I guess in a way this is a very permanent, very visual way of being like, "Look at me." So I guess you could probably boil it down to those two people, much less the rest of the world. Well, the first time I told them, it was August, and I have to wear a hoodie to lunch. "Aren't you hot?" "No." I broke the news to them. We were sitting in this Korean restaurant on 32nd Street. I'm like, "Mom, dad—I have something to tell you." And my sister's like, "Shut up, wait till I'm gone." I was like, "I have tattoos." It was as if they couldn't comprehend. "Big ones. Colorful ones." When my father gets angry his pinkie starts to twitch. So his pinkie is twitching and my mother is moaning, "Oh my God, oh my God." She was probably praying or whatever. "What did we do wrong? What did we do wrong?" And they didn't ask to see them. It was just an idea—that their daughter had these large tattoos. It took a long time for them to see them by accident. I think my mother has always been sort of curious, she hates it, but she's always been curious. Finally, I told them I wasn't going to cover myself anymore. They had bought me a plane ticket to come up for Christmas. I just warned them, "Listen, when I get out of the shower I'm not going to freaking scurry to my room." And they canceled my ticket. I haven't seen my father in almost three years. [Crying] Obviously it's something that still hurts me. In a way, it was a big thing. I still don't regret having them, but I do realize that it changed my life completely. There are certain things in my life that are the way they are because I have tattoos.

Out of the sixty-five women I interviewed, the women of color in this study faced sanctions from their families that were somewhat different than those faced by White women. For the forty-nine White women, this was often the first time they were associated with behavior that

results in social sanctions. Alternately, tattooed White women had more social freedom to be seen as creative and artistic individuals. For women of color, however, they were already contextualized within a social context of perceived criminality or foreignness by the dominant culture. For immigrant families, their perception of tattooing often stems from stigmas in their native countries. Many immigrants are vigilant about proper behavior in their adopted land. Therefore generational conflicts can arise between immigrant grandparents, or parents, and American-born family members. Immigrants may interpret tattooing as a negative impact of Americanization. In Xuan Santos's study of Chicana tattooing in Los Angeles, he found a community double standard of tattooing based on gender:

> A Chicana expressed the Chicana/o community's double standard imposed on women with tattoos: "Even though I am so excited to get my first tattoo I know that it will create many problems. It is perfectly fine for men to get a [tattoo], but if a chick [woman] gets a tattoo people . . . are likely to say that she is a *puta* [whore] or a lesbian. My brothers have tattoos and my parents are OK with them, but when my parents saw my female cousin with her tat they gossiped about how slutty she looks. I am afraid that my family and community will see me differently and I just wonder what consequences this will bring me (Bartola, age 25).[16]

Many of the participants of color in this study expressed more extreme family reactions to their tattoos than did the majority of White participants. In American culture, individuality and self-expression are important markers that identify a person as coming into her own being. White parents may not like the direction in which their children develop, but they often understand the need for space and autonomy. In many Asian and Latin cultures, the family unit is primary, with familial hierarchy and obedience being more highly regarded than self-expression. Tiffany Garcia, a Chicana tattooist in Long Beach, California, describes clashes with her father over expected behavior rooted in cultural beliefs:

> My dad is very old-fashioned Hispanic Catholic, and he hates them more than anything, he can't stand the way they look, and he doesn't have one. He thinks they're associated with gangs and everything negative. So

constantly he's giving me a hard time about the tattoos. . . . So with my dad's side of the family, I am the black sheep. I did everything wrong: I am gay, I am tattooed, and I am just not living the way I'm supposed to be. And I don't worship the Virgin Guadalupe, you know all that stuff that they do so. Yeah, I guess it's just the way they view it.

For immigrant families, the culture of the immigrant parents and that of the American-born children is often experienced as a conflict.[17] The parents struggle to transmit their culture to the children, yet the children resist, as they want to be American.[18] Furthermore, children are often more fluent in the dominant culture than their parents, providing them with power in a way that can alter the parent-child relationship. A balanced family acculturation process, in which both cultures are brought together and the multicultural aspects of the family are welcomed, provides the healthiest outcome in this situation.[19] Indeed, for many of the participants, it was their cultural identity that they represented in their tattoo artwork. In their way, they were expressing the cultural pride that could potentially bring them emotionally closer to their parents over this shared bond. While parents may not be accepting upon first encountering their children's tattoo collection, they gradually move to a place of increasing acceptance over time. When given a choice, "more than anything else, parents want to stay part of their son's or daughter's life."[20]

Grandparents' Reactions

Grandparents were even more intolerant of tattooing than parents. Born during the first third of the 1900s, grandparents' references toward tattooing were based on outdated images of sideshow performers, sailors, and criminals. Jennifer Wilder was raised by her grandmother and heard these views on a daily basis:

And she is hard-core Methodist. She's never smoked, drank, or cussed in her life. And so this is not right to her. . . . She said she would quit loving me if I got a tattoo. And she hasn't, she hasn't quit loving me. . . . You know, she's eighty-four. So it's a whole different ballgame for her. . . . She feels that I've lost a lot because of it. She feels that there are a lot of

opportunities that have passed me by or I will never get because of it. And she might be right. But then again, do I really want those opportunities if they weren't going to accept me?

Grandparents expressed the most intolerant and abusive comments about tattooing. If participants were hiding tattoos from any family members, it would most often be grandparents. Renee Little, the tattooist in St. Petersburg, Florida, demonstrates:

> It was about five years into having tattoos, since my grandmother didn't know they were there, because I was very dedicated to wearing sweaters around her. She saw them—and about had a heart attack. She did not allow herself to see all of them. She was like, "Oh no, I don't want to see. I don't want to know." My grandfather told me he would kill me. That's the Romanian side.

Man's Ruin, the tattoo collector and Roller Derby player in Texas, also received a harsh response from her grandmother:

> My grandmother can't stand 'em. She thinks they are trashy. She actually offered to pay to get 'em removed. She said she didn't care how much money it would cost, she would pay to get them removed.

For Catholic Latinos, tattoos may be associated with "*Satanismo*," as Frankie Scorpion's mother dubbed it. Jacquee Rose's Cuban grandmother attempted to cast off Satan's grip on her granddaughter once she saw the tattoos:

> My sixty-four-year-old Cuban native grandmother is very anti-tattoo. So when I see her, she does the typical Catholic thing: rubbing holy water and praying to Jesus that he takes away my Satan tattoos.

The accepting grandparents were more rare, but they stood out as counterpoint examples of what was possible for their generation. Carmen Guadalupe, the Mexican American tattoo collector from Miami, understood that her grandmother was accepting, as her mother is, and therefore decided to share her tattoo art with her:

My grandma is very old-fashioned, but she's open-minded. When I showed the tattoos to her, she was like, "Oh, what pretty flowers." She was questioning the skulls though. I guess she thought it was weird. But she didn't really think anything was wrong with it.

Other respondents had supportive, open-minded grandparents with whom they felt comfortable sharing, yet they were the minority. However, as we have seen, the tattoo stigma is more pronounced with older generations. Therefore we can expect that the youngest generations would be most accepting, with lovers and children constituting the most supportive of all family members.

Partner Reactions

Many women come into tattoo studios after breaking up with intolerant boyfriends and husbands, finally free to make their own decisions regarding their body. For some partners who have distaste for tattoos, this conflict can cause strain within the relationship. Jennifer Taylor, a twenty-five-year-old pretty blond, White mother from Florida, has an intolerant boyfriend:

I was just saying how I plan on getting a lot more. I'm going to get a lot more when we go to New York and stuff like that, and he's like "No you're not." Not like, telling me that, but it was like, "Yeah, I am." That was kind of the end of it. He couldn't say anything else.

Jennifer and her boyfriend did not understand the extent of this conflict until our interview forced the discussion. The extent of his distaste surprised her. She was taken aback by his opinions of her appearance. He was surprised that she wanted to continue becoming heavily tattooed. She told me of her future plans for an old-school traditional Americana sleeve tattoo, as well as zombies, shrunken heads, and other gruesome-looking imagery. Often, those who espouse more traditional gender roles hold negative opinions of women's tattooing. Jennifer was a friend of one of my students, Nathaly Charria, who was assisting me with the research. Nathaly and I met up with Jennifer at the house of her boyfriend's parents, where we conducted the interview in the backyard,

next to the pool. Jennifer had appeared uneasy and whispered to us about this argument she had just had with her boyfriend. He was inside the house, hence, the reason we were outside, to gain some distance and privacy for our conversation so that her words would not be inhibited by his lurking, angry presence. We could see this realization of relationship conflict brooding within Jennifer, who had previously not encountered this side of her boyfriend's disdain. To her, it symbolized a lot more than the tattoo art—it symbolized his judgment and control over her body and actions—in short, her life. While writing this piece about Jennifer, I found her on Facebook and wrote to follow up on her story, as I could not imagine that this relationship had lasted. She informed me that, years later, she has many more tattoos, a second child, and was engaged to a tattoo artist! It seems a positive end to the story.

Most of the participants were, of course, involved with partners who loved tattoos. Some were tattoo artists themselves, while others were married to tattoo artists. It is common in the tattoo world for a tattooists' partner to collect their work and almost be a stand-in portfolio. Historically, this would be a male artist who had tattooed his wife. Some of my participants fit this mold, or they had been with tattooist husbands from whom they were now separated. This was the case of Hispanic Panic, a Roller Derby participant, married to Johnny Williams. I interviewed them in Johnny's shop, Abstract Art, in Webster, Texas. His shop manager, Jennifer Wilder, had originally invited me. As they sat on the couch for the interview with their two small children, Johnny talked about the first time he saw a punk rock woman when he was a small child himself and was immediately smitten. He knew he wanted to be with a woman like that. Hispanic Panic laughed, "So you ended up with me." She was, of course, covered in tattoos, many of old-school design— skulls, sailors, anchors, and roses—and she was pierced and had artificially colored hair. She had also been drawn to this style as early as she could remember. Together, they shared their interest in tattoos, punk rock, and alternative cultures. For him, this means classic car culture, and for her, it was her dedication to Roller Derby. She even had her Roller Derby name—Hispanic Panic—tattooed across her knuckles.

For other participants, the woman was the tattoo artist who had worked on her husband. The most positive couple among the participants would surely be that of tattoo artist Telisa Swan and her husband

Figure 3.2. Karla Williams is pictured with her tattoo artist husband, Johnny, and their two children.

Allen. Telisa worked in Sofia Estrella's shop, Ms. Deborah's Fountain of Youth Tattoo Studio, in St. Augustine, Florida. During the long process of collecting my back-piece tattoo from Sofia, spanning much longer than the research process itself, I visited this studio on numerous occasions. Telisa Swan tattooed my father's portrait on my back, before Sofia started on the back piece representing the Hindu goddess Saraswati. Telisa's specialty was in portrait work, and she had covered Allen in portraits of famous rock stars. During visits to town, I even had occasion to stay at their house and spend time with their family. Once she had moved on from the Florida shop, she moved back to Moscow, Idaho,

and resumed ownership of a tattoo studio she had run years previously, housed in an old movie theater. Swan Family Ink became a family business, where her three children tattooed alongside her; Allen worked as an instructor of Pa-Kua (martial arts) out of the building as well. They were often together at tattoo conventions, the studio, or at home. And whenever they were together, they were affectionate and loving, praising each other and generally modeling a healthy, happy relationship. While we cannot choose members of the family we are born into, we do choose our partners—and it makes sense that they would be interested in the world of tattooing as well. For a minority, their interest in tattooing developed after their relationship was established. However, for the most part, the partners of the heavily tattooed women knew what they were getting into and were excited by it.

Heavily Tattooed Motherhood

Jennifer Taylor told me a story about taking her two-year-old daughter to the beach in Miami. I can see the image of them together: Jennifer, young and blond, with various tattoos across her bikini-clad body,

Figure 3.3. Frankie Scorpion (left), Phoenix (center), and Shannon Brown (right), are all heavily tattooed mothers. Phoenix and Shannon are also tattoo artists.

holding her small daughter with curly blond hair, full of life as she runs around on the beach. Jennifer seemed at odds with the public's perception of motherhood—strangers assumed she was the babysitter, which fit better with their perspective. Hispanic Panic and Man's Ruin also discussed this happening during their interview at the tattoo shop in Webster, Texas. Hispanic Panic had previously lived in Missouri, where her treatment was even worse than what she received in Texas:

> HISPANIC PANIC: I couldn't go anywhere without somebody saying something or looking at me funny, or thinking I'm some kind of criminal, or that I stole my kids. I am a really good person, and I'm a really good parent, you know. The tattoos have nothing to do with that. But it's automatically like, you're a bad parent. You have tattoos, oooh.
>
> MAN'S RUIN: Yeah, someone thought I was the babysitter. Like, "Who would let her babysit their kids?"

The association of motherhood with "purity" places the image of the heavily tattooed woman at odds with the role.[21] The assumption that the tattooed person is irresponsible and reckless is at odds with the concept of a parent as selfless caretaker. Because of this cognitive dissonance, strangers may not be able to rectify the two stereotypical images, and they may make assumptions such as, "She must be the babysitter? But then again, who would hire such a person for such a responsibility?" This was a common experience. For many participants, being out in public with their small children might provoke glares or inappropriate comments. This distain toward the tattooed parent can extend to institutional discrimination, especially when one interacts with the educational system.

Many tattooed parents encounter discrimination when they pick their children up from day care, attend PTA meetings, or join homeschool gatherings. Charissa Vaunderbroad, the tattooist in Spokane, Washington, homeschools her son and attends educational gatherings with other parents. It is in these situations that Charissa often feels the need to hide her profession, and her tattoos, from the conservative mothers of the group:

The other thing is being a mom. It's kind of hard to be a PTA soccer mom with tattoos. My son was going to a tutoring center, and I kept my tattoos covered; they didn't know what I did for a living. They thought I was a stay-at-home mom. Most of the women there stayed home with their children and homeschooled them. I kept it in the closet that I was a tattoo artist. One day, a woman I had tattooed showed up at the tutoring center. She announced that I was her tattoo artist and showed her tattoos to the group! These women didn't really know, at that point. My hair was brown and I looked fairly conservative. It was like an outcry. People's faces were horrified, shocked. . . . Some of the mothers no longer hung out in the room with me.

The majority of homeschoolers in the United States home school for religious reasons. Alternatively, liberal families make up a smaller percentage of homeschoolers, which provides divisions ripe for conflict when the groups come together, as Charissa's story demonstrates. Juleigh Howard-Hobson recounts her experience as a homeschooling mom among conservative mothers in her article, "They Don't Teach This in School." She states:

In this mostly conservative world of homeschooling . . . mothers with tattoos are not "normal" and can't be entirely trusted. They wonder, If I'd get a tattoo, what other sordid things have I done or would I do? Could they have been mistaken about me?[22]

In contrast, there are tattooed parents, similarly positioned, who are hungry to meet similarly situated others. Sierra Furtwangler and her husband Heron are heavily tattooed artists and musicians, very active in their child's schooling, in Spokane. They have become friends with other alternative-looking parents at their child's school, which makes them feel less isolated:

Usually there are a couple of parents that are also tattooed, in the same kind of situation. They seek me out. There are some parents that have a child in her class. They are a bit younger than my husband and me. At the parent-teacher meetings, they come sit by us and stuff.

Parents are sensitive to the fact that their child's experience at school may be affected by tattoo discrimination directed toward them. Teachers, or the parents of other children, were often guilty of discriminating against the children of tattooed parents. Often parents were made uncomfortable by a teacher's hostility during meetings about a child's progress in school. If a teacher has such bias against the parents, this could affect the child. However, more teachers are beginning to collect tattoos themselves. Other participants mentioned bias stemming from the parents of other children. Several parents mentioned that while their children could stay at their friends' houses, those friends were not allowed to do the same. Sparkill-icious, the Roller Derby player in Spokane, is the crew leader for her daughter's Girl Scout troop:

> The people that have treated me the worse are those from my daughter's school. I have to say, I'm the crew leader of the Girl Scout troop. Some of their mothers, at first, I was the cookie manager of the trip this year, and some of the mothers would come over, and just be terrible. I am like, "I'm doing this for your children, you know?" It affects how you feel on the inside. They treat me differently than anybody else.

Parents were concerned about the impact of such rejection on their children but tried to turn such experiences into teaching moments about tolerance.

While parents may discriminate against heavily tattooed mothers, children do not—indeed, they love tattoos. While Jennifer Taylor's boyfriend was intolerant of her tattoo collection, her two-year-old daughter loved her body art:

> She calls them "too-tats," and I guess she is kind of into them. But I think most kids are into temporary tattoos. Pop Tarts came with temporary tattoos in the box, and she loved those. It was like free advertising on children; it said "Pop Tarts" and had little pop tarts on it. And she was really excited about showing everyone her too-tats.

When asked about how her children reacted to her tattoos, Hispanic Panic pointed out that they lacked a reference point to her without tattoos:

My kids don't even know any different. They think it's normal. They've been around tattooing their whole lives, so they think people that don't have tattoos are weird, actually.

However, when Hispanic Panic's son wore temporary tattoos to school in second grade, his teacher made him leave the classroom and come back in a long-sleeved shirt, concealing the sticker tattoos. Her son told me, "I had to go to the nurse and get another shirt. I got in trouble for it with the principal. It was a really hot day, and I had to wear long sleeves." Such reaction from the teacher is excessive, but it demonstrates the remaining stigma. While many children love to play with the fake tattoos that they find in the cereal box or in the vending machines, an intolerant teacher may feel this is a gateway experience. The teacher is expressing to the child that being tattooed is deviant—even temporarily or for play. Like any prejudice, children are taught to judge others, and these lessons usually begin with parents and with the educational institution. If a child does not have a non-tattooed parent to compare the tattooed parent to, such prejudice would have to be learned from outside of the family.

Conclusion

Family has had an important impact upon heavily tattooed participants, both by providing the initial influence and exposure to tattoo culture or by fueling stigma against the practice. Some participants recall tattooed uncles, fathers, and other extended family members who had traditional sailor tattoos, which they found intriguing. This increased the likelihood that family members would at least tolerate, if not embrace, the participant's future tattoo collection. However, even when fathers did have their own tattoos, they were still not happy about their daughter's collections. Occasionally one of the women would influence her parent to get a tattoo—or, as some have dubbed them, "mid-life crisis tattoos." Others came to their fondness of tattooing later in life, lacking such early childhood exposure or impact. But parental styles and perspectives were often a consideration for heavily tattooed participants.

Once the women were able to start their tattoo collections, they often faced the dilemma of whether to tell their family members or to hide

their growing ink work, with increasing difficulty. In a minority of cases the women knew their family would be completely open and accepting to their modification. For the vast majority, they suffered some kind of negative reaction from parents, grandparents, or extended family members. Eventually the majority of these family members would come around to accept, if not appreciate, the artwork. A few suffered extreme rejection, including banishment.

How family members reacted was an indicator of family relations in general. Usually, this was not the first family conflict, and it often followed a previously established pattern of interaction. In the family literature, these interactions between family and friends are crucial for establishing early developmental "feelings of adequacy and well-being."[23] For rejecting families, there were often elements of abuse in their responses toward the tattoo collectors. They often wanted to scrub the images off, poured holy water on them, or wanted to have them surgically removed. Parents felt that their children were desecrating their bodies and making them ugly, even though the participants felt that the tattoos made them more beautiful. Families that were warm, emotionally close, and accepting of the personal development of their family member were the best models for healthy family dynamics. Within the literature on healthy psychological development of the family, flexibility was crucial. Flexible and accepting families proved to be the best possible model for psychological development in this study. For families that had this flexibility, open-mindedness, and acceptance, their bonds between the tattooed family member and the rest of the family were able to easily adjust, and family members maintained close, emotional ties.

4

"Covering" Work

Dress Code Policies, Tattoos, and the Law

Covering is work.
—Kenji Yoshino (2006)

My first teaching job was in Miami, Florida. Wandering through the air-conditioned mall, shopping for my first batch of appropriate work clothes, there were barely any long-sleeved shirts to be seen, especially anything remotely resembling my style. While the weather outside was often humid, I needed long sleeves to cover my arm tattoos. Some of my colleagues told me I should go ahead and show my tattoos; after all, wouldn't it appeal to the college-age demographic? Perhaps it would appeal to some, but not all. And I was more concerned about appearing professional in front of my new colleagues, especially since this first job was only temporary. I could not imagine enduring the stares my tattoos would provoke. It's okay, I sighed to myself. At least in the summertime, when I am not working, I can wear what I like.

In this chapter I discuss the predicament of heavily tattooed employees within their workplace environments. Do tattooed persons have legal rights regarding their self-presentation at work? The chapter first examines the role of the law, in particular Title VII of the Civil Rights Act of 1964, which covers discrimination based on a few protected classes—which, of course, does not cover tattooing or style of dress (even when based upon a religious, ethnic, or racial identity). Next, I examine the protected classes of sex, race/ethnicity, origin, religion, and disability to understand how the law defines discrimination. I then present the experiences of tattooed people in the workplace as well as an overview some important legal cases in which body modifications have been at the forefront. I look at the impacts of dress code requirements, the idea of the authentic self and expression, and how tattooed

people think about their future job prospects as well as tattoo plans in relation to their social roles. Many people object to the use of the word "discrimination" when referring to tattoos in the workplace because the behavior is chosen and it is legal for companies to have "no tattoo" policies. However, the definition of the word "discrimination" is "making a distinction in favor of or against, a person or thing based on the group, class, or category to which that person or thing belongs rather than on individual merit."[1] The key concept of discrimination is "distinction." Discriminating against a particular category or type of person is only illegal against the few categories included in Title VII; everything else, such as being overweight, unattractive, or tattooed, is fair game. But even though a type of distinction can be legally used, that does not make it non-discriminatory. Therefore, in this chapter I use the word "discrimination," especially since I am making the argument that such behavior should be challenged. Finally, the chapter examines ways in which tattoos could be protected by extending certain laws and provides examples of legal protections for appearance that are in effect in other countries, as well as in some U.S. cities.

Title VII of the Civil Rights Act of 1964

The most powerful law that employees can use to fight discrimination is Title VII of the Civil rights Act of 1964, which prohibits discrimination on the basis of race, color, religion, national origin, or sex. Another powerful law that protects employees is the Americans with Disabilities Act of 1990, which prohibits unjustified discrimination against the disabled and requires (reasonable) accommodations. These laws demonstrate useful examples of how accommodation can be enacted. For most discrimination cases, plaintiffs often make their case utilizing several laws. Discrimination based upon appearance can be covered under Title VII.[2] For example, there have been cases of individuals claiming their tattoos were religious and therefore protected under religious protections. Another example includes African Americans claiming that dress codes that ban cornrow or dreadlock hairstyles are racially discriminatory. Unfortunately, these cases are rarely successful, as the courts do not protect the expression of an identity, only immutable characteristics. Cultural behaviors, such as speaking a particular language, wearing

religious dress, or wearing a beard for religious reasons, have not faired well under U.S. law. As anyone who belongs to an ethnic, religious, or sexual minority group knows, cultural practices are intrinsically linked to that identity, and, therefore, not protecting these behaviors provides a hardship for those members.

Dress Codes

Many workplaces and schools enforce dress code policies. Schools with dress codes train youth about what is appropriate to wear. The criminologist Robert Garot in his book, *Who You Claim*, examined how dress codes developed as school administrators attempted to combat gang symbolism at one particular high school.[3] The symbolism of dress style and behaviors was constantly changing on this particular campus, so the administration was continuously updating the dress code to reflect their evolving understanding of the gang symbolism. However, they were banning symbolism, rather than addressing the root causes of gang membership and violence. Garot argues that the use of the dress code by the school administration was a way to exert power and control: "Dress codes provided a sanction for tyranny, which at best led to student alienation."[4] Furthermore, Garot points out, although there were always students in non-compliance with the dress code, enforcement was arbitrary, leading to further student alienation.

Arbitrary enforcement of dress codes is not only limited to schools but also to the way many companies operate. Some companies may have written dress policies that they distribute to their employees upon being hired, others may not have a written policy at all. Such arbitrariness often is what leads to conflict for tattooed employees. For some, they were not directly told about a prohibitive policy or their visible tattoos were tolerated for a while until a customer or other employees complained later on during their employment. Tattooed employees may be given an ultimatum to cover their ink, or they may be terminated on the spot. These regulations may remain unenforced until activated in a particular circumstance. Many service-sector jobs have dress codes that adhere to a "clean-cut" standard that includes gender-normative haircuts (excluding cornrows and dreads), clean-shaven or trimmed facial hair, and no body modifications beyond earrings (for women).

Starbucks only began allowing some visible tattoos in October 2014, after having maintained a long ban on ink previously.[5]

Dawn Harris currently works for an Apple Store outside of Houston, Texas. The business has a progressive reputation, similar to Starbucks (which still maintains a ban on artificially colored hair, watches, wristbands, and rings). Dawn is allowed to show her tattoos at work, which was in contrast to her previous job:

> My old company was an office-based job, and I was behind the scenes, where it was okay for me to wear shorts and T-shirts and not have to cover them up. It was made very publicly known to me that I would never be in the front of the company, visible to the customers' eyes. On my job now, I'm on the sales floor a lot of the time with the customers, and some people look at me kind of weird. Some people just want to stop and talk about my tattoos.

Like Dawn, many tattooed women work for employers whose dress code policies varied, thus always making them a bit weary of reactions. Dawn's experience demonstrates how tattoos can limit ones' promotion within a company. In her case, tattoos were considered acceptable only in the backroom. Therefore, even when tattoos are "allowed," be it in the backroom or at all workstations, it can still affect promotion. Tattoo acceptance in the workplace can also vary by geography, as tattoos are more popular and ever present in certain parts of the country and neighborhoods or within particular subcultures. One survey asked three thousand managers if they had ever passed someone over for a promotion or a raise because of their appearance, and 43 percent admitted they had.[6] Thus, not only do tattooed employees have to ask if tattoos are allowed by the workplace dress code, but they must also wonder if visible tattoos will affect their future promotions even if they *are* allowed.

Military Dress Codes, or, Army Regulation 670-1, 3-3

As discussed earlier, the military is strongly associated with tattoos. During the early part of the twentieth century, sailors made tattooing popular, as they collected tattoos during their travels around the world. When sailors would come into port towns for R&R, they would flood

into tattoo shops (as well as taverns and brothels), lining up for the simple designs from flash sheets on the walls. For sailors, these designs represented pride in their military careers and a bonding experience with their fellow sailors. Most of us have seen the military insignia tattoos on the forearms of veterans, fading to green, as those early inks tend to do.

Two documentary films capture the spirit of military tattooing. The first, *Hori Smoku Sailor Jerry: The Life of Norman K. Collins,* directed by Erich Weiss, documents the life of the early pioneer tattooist Sailor Jerry.[7] He opened one of the first tattoo shops in Honolulu, which serviced sailors by the boatload. He was famous for combining the old traditional flash drawings of popular military themes, found on the walls of tattoo shops, with the artistic flair of Japanese-style tattooing with more vivid color, shading, and larger pieces that fit the body. The documentary presents archival footage and interviews of other senior tattooists who describe these early days of tattooing, where sailors would stand in long lines outside, as they rotated between bars, brothels, and tattoo shops, "stewed, screwed, and tattooed," as a popular tattoo logo represented in these flash images attests. Collecting such tattoos became a large part of sailor culture, a way to express one's identity. In the documentary *Tattooed under Fire*, the director/producer Nancy Schiesari presents one shop, River City Tattoo, in Ft. Hood, Texas, in which nearly all of the clientele are young soldiers getting ready to deploy or have recently returned from their most recent tours.[8] It is an emotionally moving tale of the psychological trauma of war and the ways in which the soldiers use tattoo art to represent their experiences and start to heal. The tattoo artists in the shop are de facto therapists, listening to the tales of their clients, the fears, tragedies, and sorrows of their war experience. Overwhelmingly, the clients are young white men getting military-themed tattoos or tough imagery such as skulls or grim reapers. A few women are represented, and their tattoos focus more on family, those they want to carry with them when they are far away. The movie documents the importance of differentiating oneself while being forced at the same time to conform to a uniform appearance of a generic soldier. The clients go to the limits of the regulations, as in the case of one young man who brought his tattoo design onto his neck but kept right under the rim of his uniform collar, to be within army regulations.

The tattoos were their one indulgence, the one thing they could take with them that couldn't be taken away. It gave them a way to express themselves and be unique while living in an institution that tries to suppress individuality.

With the military being so closely associated with tattoos, it may surprise some that the military has long waged a battle to regulate tattoos to various degrees over the years. These rules fluctuate, and individuals can be exempted on a case-by-case basis, presumably as the needs of the military expand and contract. Army Regulation 670-1, "Wear and Appearance of Army Uniforms and Insignia," 3-3. "Tattoo, Branding, and Body Mutilation Policy," was published in 2005 and updated on September 15, 2014. The document states in part that tattoos cannot be extremist, indecent, sexist, or racist. Besides content, location on the body and size are also regulated: Nothing can be tattooed on the face, and no more than four tattoos can be visible below the elbow or knee. Further, band tattoos that encircle a limb and sleeve tattoos below the elbow or knee are not allowed.[9] Other branches of the military enforce more stringent regulations.

Violating these regulations will bar someone from being recruited (unless they are waived). Service members who are not grandfathered in can face sanctions, including discharge. As we can see, the military is attempting to present a uniform appearance for soldiers, while the soldiers are attempting to bring some individuality into their appearance. Ironically, many of the tattoos that are covered up under these regulations and uniforms express military pride and memorials for deceased service members.

Appearance-Based Gender Discrimination

Heavily tattooed women may face gender discrimination that is intertwined with their heavily tattooed appearance. Since tattoos are considered masculine, men who have tattoos many be considered acceptable, but women who have many tattoos may be deemed inappropriate in their gender performance. If men and women face differential expectations in regard to tattoo visibility, then that could be considered gender discrimination. Potentially, tattoos could be deemed acceptable for male employees but not for females. The courts have allowed for differential

appearances tied to gender norms. Yet this seems like a stretch, considering that women now outnumber men as tattoo collectors. But cases have demonstrated differentiated rules of body modification for men and women. For example, in *Kleinsorge v. Island Corp.* (2000), two men filed a lawsuit against their employer, who had prevented them from wearing earrings. The men claimed that this was sex discrimination. Ultimately, their claim was denied because the judge stated that "gender differences in standards of appearance are permissible."[10]

Under Title VII, gender discrimination is traditionally acknowledged when women are excluded from a type of employment because of their sex. Distinctions of gender-differentiated appearance have been acceptable under this law, so long as women are not placed into a position encouraging sexual harassment, for example, by wearing a provocative uniform. However, the idea that a required feminine appearance itself may be oppressive and unwanted is a departure from the long-accepted judicial understanding of gender discrimination.[11] This double bind of needing to be feminine or not overtly feminine may affect the heavily tattooed women in different ways. Heavily tattooed women often face having their tattoos touched and encounter invasive questions about their body modifications by strangers. What if these types of interactions take place within the work environment, instead of in the public sphere? Such behavior in this context can be much more threatening and have a greater impact on career trajectory—in terms of perceived sexual harassment or encouraging improper interactions with customers.

Through the use of dress codes and prohibitions against visible body modifications, women may find themselves pressured to conform to a gender norm at odds with their many tattoos. This expectation that women will put effort into creating a feminine appearance can be a burden for those who define their femininity in an alternative manner. Several scholars have written books based on the premise that the prettier women are, the more successful they will be in life, including making more money on the job, attracting better mates, and being healthier and happier. The economist Daniel Hamermesh argues in his book *Beauty Pays* that, "across the entire economy, good-looking workers earn more on average than their otherwise identical but less well-endowed colleagues."[12] Hamermesh even develops monetary figures for

his case, for example, bad looks being equated with $140,000 less in salary over a lifetime career, compared to an average-looking worker.[13] Nancy Etcoff, using theories of evolutionary psychology, argues that it is merely human nature that people will go toward the more beautiful in her book *Survival of the Prettiest*.[14] And in *Erotic Capital*, Catherine Hakim encourages women to exploit their sex appeal in all aspects of life in order to get ahead.[15] Hakim has no qualms about condemning people who "choose" to not be attractive: "Being overweight is unnecessary and indefensible," she says, and "discrimination against overweight people can often be justified."[16] Therefore we can assume that Hakim would argue that heavily tattooed women purposely create a situation in which they will be perceived as unattractive and unworthy of career advancement. Only the legal theorist Deborah L. Rhode deems what she calls the "beauty bias" as a regrettable, but true, state of affairs.[17] These authors reflect the dominant social messages that women receive about how they should look, as enforced through economic and legal institutions.

Appearance-Based Racial Discrimination

Under Title VII, discrimination based on race, color, religion, sex, and national origin is prohibited. As we have seen with sex, Title VII has been used for appearance-based discrimination related to expectations of appropriate gender expression. It is similar with race. Many dress codes that may appear neutral may disproportionately affect particular racial, ethnic, religious, or national origin groups. These dress codes have an inherent bias toward Anglo, middle-class culture that may be uncomfortable for others. In his ethnographic book, *In Search of Respect*, Philippe Bourgois spent years with his Puerto Rican participants in East Harlem, documenting their survival tactics through petty criminal behavior.[18] As he analyzed their work environment as street-level crack sellers, he noted the undesirable working conditions they endured in the abandoned buildings without air conditioning and functioning bathrooms, the long hours of work, the risk of arrest, and less than minimum-wage earnings. At one point, he had a conversation with them about how they could "tolerate being minimum wage crack dealers" instead of just getting a regular job.[19] Through their conversation,

it became apparent that "the 'common sense' of white-collar work [was] foreign to them," as was the bureaucracy, the pleasantries of social interactions, and the dress code.[20] Bourgois reflects on their perspective:

> To my surprise, many of the crack dealers cited their inappropriate wardrobes and the imposition of demeaning dress codes as primary reasons for shunning legal employment. . . . It took me several months to realize how centrally this symbolic expression of identity articulates with power relations in the labor market. . . . [Caesar] had no idea when his clothes would elicit ridicule or anger. Caesar was hurt when his supervisor accused him of "looking like a hoodlum" on the days when he thought he was actually dressing well . . . he had no idea of which clothes to choose when he went to buy them.[21] . . . It is precisely in moments like this that one can see institutionalized racism at work in how the professional service sector unconsciously imposes the requisites of Anglo, middle-class cultural capital.[22]

Bourgois provides an extreme example of cultural and class alienation in his ethnographic work, but it points to the inherent cultural codes in both communities and how the office world is not a neutral environment but requires extensive socialization into a White, corporate world. This environment can be at odds with other cultural or religious practices. Yet, Title VII only protects immutable characteristics based on sex, race, color, national origin, and religion, not the expression of these identities.[23]

Many Title VII lawsuits that have claimed appearance-based racial discrimination have focused on hairstyles. In one court case, *Hollins v. Atlantic*,[24] an African American woman sued her employer for having a dress code that did not allow certain hairstyles, such as dreadlocks and cornrows. The woman felt that such restrictions applied only to her and not to her White colleagues, who did not employ similar hairstyles. Since this dress code was in effect differentially applied to different racial groups, she sued for racial discrimination under Title VII. Her claim was rejected. In another court case, an employee at a convenience store was told after four months of employment that his dreadlocks were considered unacceptable by the written policy, which states that hair should be "kept neat and clean . . . immoderate styles . . . such as

corn rows, braids etc. must be approved by a supervisor . . . dreadlocks and mohawks are unacceptable."[25] His company, Petro Mart, demanded that he change his hairstyle. However, the employee, Antonio Hegwood, responded that he had the same hairstyle during these four months of employment, and it had not yet been an issue. While Mr. Hegwood was not fired, his employer refused to pay him until he complied. The case has yet to be decided. Hairstyles that may be particular to certain racial or ethnic groups have no protection under Title VII as racial discrimination. The employers and courts argue that the ban on cornrows and dreadlocks apply to all employees, regardless of their race. Whites are not allowed to have a dreadlock hairstyle any more than African Americans. The courts and employers also argue that having such a hairstyle is not an inherent necessity for racial expression because other members of the racial or ethnic group do not all have such a style. Such hairstyles are not immutable characteristics. Even religious groups that require beards have not been protected under Title VII when their beard interferes with a workplace dress code or safety gear (such as face masks for firefighters). This no-beard policy also disproportionately affects African American men, who have a 25–30 percent chance of having a condition called "pseudofolliculitis barbae" (severe shaving bumps), which causes pain and skin inflammation with shaving. However, the courts have upheld that, if there is a business necessity for the clean-shaven appearance, then these policies have been upheld. I have looked over these protected classes and the ways in which the courts have upheld or denied discriminatory policies so we can better understand the context of heavily tattooed employees in the workplace environment. While immutable characteristics of protected classes cannot be discriminated against, the expression of these characteristics has not been protected. Since tattooing itself is, of course, not a protected class, and the act of becoming tattooed is voluntary, there is no defense or lawful recourse under these laws to protect tattooed individuals. However, these cases have still appeared before the courts in various forms.

Tattoo Discrimination in the Workplace

The women in this study were not representative of a general tattoo population, as the majority of them work in the tattoo industry

(thirty-one out of fifty-nine), where their ink is an asset, rather than a deficit, to their job performance. Because of this, some might have even become more heavily tattooed, feeling more insulated by the industry in which they worked. Furthermore, the majority of the participants were younger than thirty (thirty-five out of fifty-nine), and the next largest age group was thirty to forty (eighteen out of fifty-nine). There were five participants between the ages of forty and fifty, and there was one participant above sixty-five years old. With a group composed of younger members, many may not have had extensive work experience or its accompanying discrimination. There were eight students, five participants who worked in retail, four teachers, and one office worker, warehouse employee, and security guard. Nine had unknown jobs. The participants thought about the possibility of needing to hide their tattoos in work environments, and tattoo artists would advise their clients about visible tattoos (neck, face, and hands) and provide cautionary words about the negative impact they could provoke. While the participants in this study were more heavily tattooed than the general population, they live in a larger social context that is increasingly tattooed, especially for women.

A Harris Poll conducted in 2012 stated that one in five U.S. adults has a tattoo and that, for the first time ever, women are more likely than men to have a tattoo. On the flip side, one quarter of the non-tattooed respondents stated that people with tattoos are "less intelligent" (27 percent), "less healthy" (25 percent), and "more rebellious" (50 percent).[26] Another survey by *Vault.com*, a career information website, in 2003 reported that "42% of managers said they would have a lower opinion of a tattooed person. . . . And 58% said they'd be less likely to offer a job to a tattooed or pierced applicant."[27] Tattooed people are aware of the social stigma that accompanies their visible tattoos, and of course, this is most critical during the job search and interview, when candidates are being sized up.[28]

The Job Interview

Heavily tattooed people often face prejudice regarding their tattoos, either during the job interview or after, while on the job. The participants in this study have overwhelmingly expressed that they would

not go to a job interview with visible tattoos (unless they are unable to cover some public skin tattoos, such as those on the hands and neck). The legal theorist Katharine Bartlett writes in her article "Only Girls Wear Barrettes" that a good deal of "control over appearance is exercised at the hiring stage," when managers can decide if an individual "fits in."[29] At the job interview, a manager is making a host of decisions about a potential employee and may have many applicants from which to choose. If a manager does not select a tattooed applicant, it would be unknown to the person why he or she was not selected. Marisa Kakoulas is a lawyer, as well as a writer on tattoo culture, living in Brooklyn, New York, where I was able to interview her on the topic of tattoos and the law. She is often sought out to address issues regarding tattoos in the workplace. While she fights against this prejudice in the workplace, she also realizes the power of appearance enforcement that is given to employers through the legal system. Because of this, she advocates a two-pronged approach of strategically covering up tattoos until one is established in their profession:

> I think it would be great if we didn't have to deal with this. I think it should be fought, I think we should be vocal. But at the same time, I like the backdoor approach as well. I worked very hard in very conservative offices, and they had no idea I was heavily tattooed. But when they did find out, at that point I was making them a lot of money, and I showed my value. And so it didn't matter. But if I had shown up to the interview, showing my tattoos, I may not have had the opportunity to change their mind. So I believe in banging on the doors, and also sneaking in from the other side. And if we can do that two-prong approach to kind of change that discrimination, I don't think it's a bad thing to say cover up, if you have that in mind, if you want to change people's minds.

Sparkill-icious, one of the participants in Spokane, Washington, also worries about her employment options. "How am I going to find a job if people are going to judge me? Even if I'm educated, you know?" She elaborates on her anxieties over finding employment:

> I do school and student employment assessments, and you can't show any of your tattoos. I have to take my piercings out; I have to wear a business

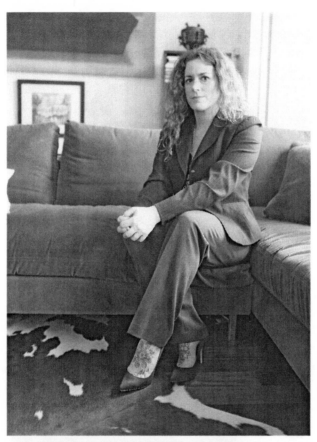

Figures 4.1a and 4.1b. Marisa Kakoulas is a heavily tattooed law-
yer in Brooklyn, NY.

dress and my hair down [to cover neck tattoos]. My business dress comes down to here, so with my hands, I've got to hold this one behind my back [with a hand tattoo, mimics shaking hands with one behind her back]. "Hi, how are you doing?" I'm taking "medical office specialist" at school right now. So that's what I'm doing until I get a job. Some of my other friends are getting jobs where people do have tattoos. So I'm hoping that happens for me. And there are a couple of hospitals in town that accept people with tattoos. So hopefully I'll be able to get a job there.

Sparkill-icious demonstrates the extensive planning and covering that she has to do in order to hide her tattoos and be presentable for both her work and school environments. When she first began collecting tattoos, she had not thought about her future job prospects, and now she wishes she had more foresight when she was younger:

> To be totally honest about this, when I was younger, I think that my tat-
> toos were more of an "F— the world" statement. I started getting tattoos
> when I was fifteen. When I was about twenty-one, it was more about
> "F— the world." And I didn't think about the future, and I didn't think
> about having kids and stuff like that and how that would affect me. . . .
> Now that I am older I am finding out that the world is so judgmental.
> It is really hard for me to find a job. I mean, I've been going to school
> for two years now, and I'm starting to get an internship. And I'm really
> afraid, what if I don't find a job, even after going to school for two years?
> And it's just because of what people think of my looks. In this society, I
> wished that I had probably kept my tattoos [off public skin], because now
> I do have two children. I want to have a really good job and for them to
> be proud of me.

Not only do her tattoos interfere with her job prospects, but they also affect her children, via her own economic security, as well as socially, in the schooling system. Sparkill-icious stated earlier that she faces the most extreme hostility toward her tattoos when she participates at her children's school functions. She was involved with her daughter's Girl Scouts, and the other mothers were not open to her presence. As some tattooists mention, "Tattoos are a permanent reminder of a temporary feeling." Sparkill-icious represents this adage by showing how

some of her earlier tattoos continue to affect her adult life, as well as the life of her children. While the women loved to express themselves with tattoo art and plan to continue their collection, some of them had regret over designs they had chosen while younger. Many of the women had cover-up tattoos, erasing an old tattoo by placing a new tattoo over it. Collecting tattoos was part of a life path that was not always linear and carefully chosen. Others had tattoos that they felt were more a part of their past than current life, but they chose to keep them out of nostalgia.

Covered Up

Because of such discrimination—experienced, anticipated, or perceived—most tattooed people know that there is a time and place to be covered up—and that place is work. Since this book is about heavily tattooed women, this chapter tends to emphasize professions that include more women. Some male-dominated blue-collar industries, such as construction or mechanics, may be more open to visible tattoos. Some service-sector jobs may openly allow visible tattoos, such as fast food or retail clothing stores, but then again, they may not. For example, McDonald's has a "no tattoo" policy and a uniform, so tattoos that would be visible while wearing the uniform are not allowed. Many chain retail stores do not want visible tattoos. Since this is an important issue for tattooed people to explore while they are looking for a job, there are lists of "tattoo-friendly" workplaces. Some of these workplaces are listed on websites,[30] for example, Whole Foods, Hot Topic, Border's Books, Burlington Coat Factory, IKEA, Home Depot, Petco, Fed Ex delivery, Target, Albertson's, Barnes & Noble, Forever 21, Best Buy, Staples, Lowe's, and Google.

Tattooed people have a variety of opinions about employment discrimination. These views can be roughly categorized into two prominent camps: those who think that "no tattoo/piercing" rules are acceptable, and those who do not. When I ask about their experiences of workplace tattoo discrimination, at least a few people will object to my word choice and say that is it not discrimination because it is a chosen behavior. Part of the discussion of tattoos in the workplace should be about changing the focus from tattooed skin to job performance, workers' rights, and job protection. We live in a world increasingly

marked by economic insecurity, job scarcity, low rates of unionism, and unprecedented corporate power. Historically, the courts have nearly always sided with the company when it comes to workers' rights of self-expression. A large part of protecting tattooed peoples' employment is to strengthen workers' rights.

The most practical thing that tattooed people do to protect their jobs is to cover up their tattoos at work (unless they are lucky enough to work in a "tattoo-friendly" environment). The participants in this study who work in tattoo studios have the liberty to express their personality through their body modifications and their dress. For those working in other environments, they have learned how to keep their tattoos covered. Elisa Melendez is a participant who struggles with tattoos in the workplace. She is twenty-two and has recently graduated from Florida International University with a degree in women's studies, the same department in which I was teaching. However, this was the first time we had met, as I lugged my video recording gear into her apartment in Kendall, a Cuban neighborhood in Miami, where I also lived. While we were talking, Elisa brought out some of her work shirts to demonstrate how her sleeves are not always long enough to cover her tattoos, which include a half sleeve of musical notes. She is a singer in a band, and music is her passion, a fact that she wants to commemorate and carry with her wherever she goes. Music is central to her identity. But this identity needed to remain covered at work, even though she also sports bright red bangs on her otherwise black hair. Elisa was working as a secretary in the university, and so she was already struggling as a recent graduate to separate herself from the students. Her dyed hair and tattoos added to that difficulty, as her appearance would be more associated with being a student than a department secretary. She explains:

Well, I'm a secretary at my college, working in the Social Sciences Department. And as a secretary you have to present yourself in a professional manner. I already look young and have the weird hair. So it's a struggle to separate yourself and have some sort of authority over the student population as the secretary of the department. So I have to dress in a professional manner in order to command that authority. So it is always the slacks and then every shirt has to be to the elbow. Sometimes there's

a little bit of poke through, but you know, no one really notices. But the problem is that if I stretched out my arm there is a little bit of a peek through. I'll let it fly when I'm typing. But as soon as I hear footsteps, I pull my sleeve down. Lately, now that I sort of feel more secure in my job position, I've started to care less, but I still do pay attention. Because you never know who could be walking by. It is a little uncomfortable to have to do this all the time. But I'd much rather do this than to have to wear a shirt all the way down to my wrists. Because I end up rolling up the sleeves anyway out of a force of habit. So I have to keep a look out.

Elisa's story, and that of Sparkill-icious, show the vigilance that those with visible tattoos must have at work. They cannot let their guard down and let their tattoos peek out because they never know who will be walking by. For anyone who has had to keep such a secret, one can imagine the stress that such covering work can impose over time. Another participant shared the following incident:

I had worked at a place that insisted my tattoo was covered at all times, regardless of the weather. The tattoo is a small black design, just above the crook of my arm and only about the size of half a business card. In class, my shirt rode up to show a tiny proportion of it. A student mistook it for an ink stain and laughed about it with a colleague—who promptly reported me. I was disciplined after that for my tattoo showing while I was teaching.

In this situation, we can see that even when one wears clothing to cover the tattoos, there can still be some "poke through," as Elisa called it, which calls for constant vigilance.

This vigilance becomes even more difficult, if not impossible, for those with tattoos on their public skin: hands, neck, face, and forearms. Katherine Irwin even predicts that those with such tattoos may find themselves unable to escape disdain and disregard.[31] Shannon Bell points out that

more heavily tattooed people have a harder time covering their tattoos, which may lead one to assume that they like it that way and enjoy the

> attention. From my experience and interactions with numerous other
> heavily tattooed people over the years, this is not the case.[32]

This point is an important one that I have found in my research.
When collecting tattoos, people think about placement of the design
and whether it is publicly visible. While they know that a tattoo will
draw attention if easily seen, all of my participants remarked on how
they had underestimated the amount of attention they would receive.
Some strangers in public are often compelled to comment when they
see visible tattoos. From participants' perspective, a tattoo seems
acceptable, as tattooing was a conscious decision to place a visible
image upon one's body. However, when heavily tattooed participants
were asked if they enjoyed the attention that they received publicly,
the overwhelming majority said, "No way!" They found themselves
compelled to cover up their tattoos even when they were not at work
but merely in public to avoid this constant attention. Just a minority
of individuals said that they did not mind talking about their tattoos
when approached by strangers in public. Rita Martinez-Rushka, a co-
owner of a tattoo shop in Miami was one of those who said the atten-
tion provided her with an opportunity to teach people about her faith.
She is a Hare Krishna devotee, with images of various colorful Hindu
goddesses and gods on her arms. When people ask about the imagery,
she is able to teach them a bit about a religion with which they are
most likely unfamiliar.

Kristen Wall was by far one of the most striking women in the
study because of the black and gray skull tattoo on her chest, behind
which her collar and rib bones were drawn in detail, creating a skel-
etal background. It was one of the most shocking tattoos of all of the
participants and the one that received the most outraged comments
on pictures posted to Flickr.[33] I interviewed Kristen twice, once when
she was eighteen and later, at age 20. Everywhere she goes, she attracts
attention because of the extreme content of her tattoos, as well as her
youth and beauty. She is the perfect target for the question, "You're such
a pretty girl, why would you do *that* to yourself?" Such questions fol-
low her on a daily basis. She is passionate and committed to her idea
of acquiring a tattoo body suit. But she also wants to earn a psychology
degree and work with at-risk youth as a therapist or social worker. In

the meanwhile, she suffers through service jobs where she had to cover her tattoos, including her knuckles:

> As far as getting jobs, if I want to work as a waitress or whatever, obviously I'm going to have to cover up. Which sucks, because we live in Texas. It is hot out, and I have to really button up with high collars and everything. Last summer I had a hostess job where we wore all black. I couldn't even wear short sleeves. I had to wear the long sleeves. Yeah, that sucks.

When employees spend time together outside of the work environment, it presents another challenge for covering up. Do you still have to wear the button-down shirt while partying with co-workers? Man's Ruin, a participant who gets tattooed at the same shop in Webster, Texas, as Kristen Wall, had dutifully hidden her tattoos at work, except when it came time for the company party. Man's Ruin describes the scene:

> For a while, I had to wear long sleeves. I was the receptionist, and they thought that I just had the tattoos on my thumbs. I told them, "Oh this was something I did when I was young and stupid," you know, just to tell them some story. And I went to one of their parties. It was a get-together. And so I came showing my tattoos by wearing a T-shirt, and they freaked out! They were like, "Oh my God, I can't believe it! You never showed us any of that?" And I reply, "Why would I? I would not have gotten the job if I had."

Man's Ruin shocked her colleagues with her full sleeve-tattoos, which she had been covering up in the hot Texas weather. Her co-workers felt deceived and could not believe that someone they had worked with for so long was, unbeknownst to them, heavily tattooed underneath her work clothes. These examples demonstrate how the participants struggle with their tattoos in the workplace. Let us now turn to a few legal cases filed by tattooed individuals who lost their jobs—and sued.

Tattoo Discrimination Case Law

The logic of the courts is that only discrimination against immutable characteristics based on protected class status can be banned; all other

behavior can be regulated by the employer, at will. The courts have upheld the rights of employers "to equally ban women and men from displaying visible employee tattoos and piercings as part of an employer's workplace prerogatives."[34] Courts have reasoned that employees can (and will) change their self-presentation style to "conform to workplace standards."[35] Nor are tattoos free speech, the courts have ruled.

Many tattoo and piercing court cases have attempted to use the defense that the tattooed individual is a member of one of the protected classes and that his or her body modification is a part of the expression of this class. One of the more prominent recent cases is *Cloutier v. Costco Wholesale Corp.*[36] Kimberly Cloutier was a cashier at Costco in West Springfield, Massachusetts. After she was hired, Costco revised its dress code to prohibit all facial jewelry (besides earrings). Cloutier refused to remove her facial piercings on religious grounds, later stating that she was a member of the Church of Body Modification. Cloutier demanded an exemption to the dress-code policy. Costco provided her with an accommodation by allowing her to remove the eyebrow piercing jewelry and use a clear retainer in its place. The courts decided on behalf of Costco, citing their accommodation and that an exemption to the dress code would cause an undue hardship for the company.

Sheldon Swartzentruber brought another tattoo case to the courts, *Swartzentruber v. Gunite Corporation* (2000), claiming that his tattoo was an important part of his religious membership.[37] His tattoo depicted a hooded figure standing in front of a burning cross. His religion? He was a member of the Church of the American Knights of the Ku Klux Klan in Indiana. Gunite Corporation, his employer, provided accommodation by stating he could cover his tattoo—and that he must—as it was offensive to his co-workers. Swartzentruber did not win his case.

Another tattoo court case, *Baldetta v. Harborview Medical Center* (1997), relied on the Americans with Disabilities Act, the Rehabilitation Act, and the First Amendment to allege discrimination against the plaintiff's tattoos.[38] John Baldetta was an employee at Harborview Medical Center who was also HIV positive. Harborview already knew of Baldetta's HIV status and was not found to have discriminated against him on that basis. Harborview did, however, forbid Baldetta from talking with patients about HIV. Later on during his employment, he arrived to work with a tattoo of the words "HIV-Positive," located on

a visible place on his body. His employers requested that he cover the tattoo, but he refused. He continued to display the tattoo in defiance of Harborview's request, and therefore the behavior became one of misconduct. Baldetta alleged that he was fired because of his HIV status; his employer stated he was fired because of his misconduct for continuing to show the tattoo. Baldetta did not win his case and appealed. During the appeal, the misconduct was reaffirmed. However, the courts found Harborview's gag order on Baldetta troubling, and this was found to infringe on his freedom of speech rights.

Tattoo discrimination may also happen in conjunction with sexual harassment, as the case of *Bussell v. Motorola, Inc.* (2005) demonstrates.[39] Meghan Bussell was a temporary worker for Adecco Employment Services and was assigned to work at Motorola, where she assembled and repaired radios and cellular phones. She claimed to have suffered from hostile work environment sexual harassment from her co-worker Bob Render, whom often spoke of his sex life in the workplace. At one point, Render lifted the back of her shirt up and pulled her pants down to view the tattoo located on her back and said, "nice tattoo." Bussell added this single incident to the ongoing misconduct of Render and brought her claim to court under both Title VII as well as the Florida Civil Rights Act. Because Bob Render did not also make a sexualized comment when saying "nice tattoo," the incident was not considered sexually harassing. The talk about his sex life was deemed inappropriate but not severe and pervasive enough to alter the work environment. Bussell lost her case.

As we saw with the military regulations, branches of the government, like private employers, can require a uniform and a highly regulated appearance. Some tattoo court cases have been brought by police officers and firefighters. In *Riggs v. City of Fort Worth* (2002), a heavily tattooed Texas police officer was ordered to cover up all his tattoos by the chief of police.[40] The police officer lost his case. The district court upheld the restriction of the officer's tattoos and wrote, "A police officer's uniform is not a forum for fostering public discourse or expressing one's personal beliefs."[41] Police officers in Connecticut were also banned from showing their tattoos while working, in the case *Inturri v. City of Hartford* (2006).[42] Three of the police officers had spider web tattoos on their arms, and their chief assumed this was a coded message

implying racial hatred, which the officers denied. They filed their case under the First Amendment and their equal protection rights under the Fourteenth Amendment. Again, the officers lost their court case, with the district court determining that the city had a legitimate interest in making the officers cover their tattoos. As we can see in these tattoo court cases, tattooed plaintiffs have lost their cases on all grounds utilizing Title VII, the Americans with Disabilities Act, and the First Amendment. The courts have sided with employers for their rights in regulating the appearance of their employees as they deem appropriate. Even behavioral expressions of protected classes, such as religion and race, have not been upheld. This example of tattoo discrimination case law does not bode well in arguing for a right to self-expression.

The Impact of Prejudice

The largest impact of appearance-based discrimination falls upon those who step outside the bounds of a normative appearance based on White, middle-class, clean-cut, and attractive standards. We see these normative images in magazine ads, on television shows, and in the movies. Protective legislations, such as the First Amendment and Title VII, are established to protect those who face potential discrimination. However, as we see with the examples in this chapter, these protections cover only the minimum of immutable characteristics. But as anyone in such protected classes can attest, behavioral aspects are just as much a part of the group culture as are the immutable characteristics. Members of racial/ethnic groups are often tested on how culturally competent they are by in-group members; simply having physiological characteristics is not enough. These laws see it otherwise. But what is the big deal about making people look "presentable"? The question is best illuminated by its reversal. What if a conventionally attractive woman were required to dress in a Goth style? What if a man were forced to wear a dress? What if a conventional woman were forced to wear overalls and no makeup? The ultimate question is, What if one were forced to conform to a style of dress and appearance that was very uncomfortable to them? Is that an appropriate sacrifice to make for a paycheck? For the participants in this project, they feel most themselves, and most beautiful, when they express themselves through their body modification, unusual

hairstyles, and the personal flair that makes them unique individuals and comfortably themselves.

It is important for the laws and workplace dress codes to continue to keep pace with the society in which they are a part. As we have seen with the Harris Poll cited earlier, about 20–25 percent of the population is now tattooed and, for the first time ever, more women than men are getting inked. Duncan Lewis, in his article "Workplace Bullying," defines bulling, in part, as an "an attempt to regulate the body. For example, victims may find their physical mobility constricted by having to work long hours in the office. Alternatively, they may be forced to move around frequently."[43] Participant Anna Surbeck exemplifies how this body-controlling behavior can be read as bullying:

This story happened in Portland, Oregon. I worked at a long-term care pharmacy that was not open to the public. I understood when I was hired that visible tattoos were not allowed. That was fine, I bought long-sleeve sweaters to wear to work. I expressed concern to my supervisor that this might be hard in the summer. She told me not to worry about it, that the rules were in the process of being changed to be more liberal. In May, several coworkers and I donated our hair in support of one of the pharmacy directors who had breast cancer. Now the tattoo on the back of my neck was clearly visible. A couple months later they changed the dress code to be more strict. Tattoos were not allowed. Morale was horrible at work. People with tattoos were really feeling like they were being singled out and picked on. I was not the only person who felt this way. The weather was hot in the summer, so I would wear a tank top with a large loose-fitting long-sleeved blouse over it. The AC didn't work some of the time. When I felt overheated I would go to the break room, remove my blouse and drink water until the heatstroke feeling subsided. A while later I was told we were no longer allowed to show tattoos in the break room. I was called into the office of the person who we supported by donating our hair (she was my supervisor's supervisor). Had I not donated my hair the tattoo on the back of my neck would not have been visible. She told me that I have to start using Band-Aids to cover my tattoo every day as others were being made to do. I tried Band-Aids and couldn't stand the feeling. I tried wearing scarves but they did not completely cover the tattoo. The next week I was fired. They did not even give me a reason why.

In this case, the courts would side with the employer, as the policy was stated at the beginning of the employment term and Anna was provided accommodations with the Band-Aids. But more important, this story shows the impact of discrimination, how workers feel targeted and bullied, and that they do not see a purpose in such regulations. In this case, the workplace was not visible to customers. A break room should provide a more lax atmosphere, in which employees can relax, but tattoos could not even be shown in this space. Also, we see the way in which the rule is imposed arbitrarily. The employer could have upheld the rule form the beginning, yet Anna was told, "It's okay." In the end, she was fired. In one study of workplace discrimination, Eliza Pavalko et al. found that the impact of discrimination has definite emotional and health costs that "are not trivial."[44] One of the largest costs of discrimination is the emotional toll of needing to cover one's authentic self, to appear to be someone he or she is not.

Authentic Self

An authentic self is how we perceive ourselves to be: how we identify, how we present ourselves—our self-understanding. Often, for most of us, we have to compromise our self-expression in order to fit into our social roles. There is also discrepancy between how we perceive ourselves and how others perceive us. For the participants, one of their most powerful modes of self-expression—tattooing—is often covered up so they can fit into their social roles. Imagine going to work dressed as someone completely different than yourself. Whatever your normal attire, imagine changing it drastically, to the point where you would be embarrassed and uncomfortable. What if you were forced to be covered in tattoos and show them everywhere you went if you are a non-tattooed person? I asked the participants if they could envision themselves without the tattoos. How attached is their self-identity to their tattoos? None of them could imagine themselves without tattoos; the thought was off-putting. Yet this is the disguise that many of them are forced to take on as they head to work. Katharine Bartlett wrote that "appearances matter a great deal in the workplace . . . dress and appearance have important, albeit complicated, autonomy and equality implications."[45] I have one friend who is so heavily tattooed she must go out of her way to find

the most conservative dress clothes she can find. She often posts photos online with comments like "Yes, I look like I am Amish or Mennonite in this outfit, but it's the only one that will cover all the tattoos—except the hands." Can you imagine dressing so far outside one's own sense of style as you go to work everyday? This is the predicament of many tattooed people.

Deborah Rhode, a legal theorist and author of *The Beauty Bias*, finds this level of appearance regulation to be harmful because of the stifling of oneself: "[It] restricts rights to self-expression. How individuals present themselves to the world may implicate core political values, cultural identity, and religious beliefs."[46] Elisa Melendez deals with this dilemma when she heads to work, covering up her individual personality under button-down shirts that just barely cover up her ink. She states:

> That's the problem with peekage, it implies mystery. If people think you're hiding something, they are going to want to know what it is. I like to tell people up front at my job, that I am not just a secretary. I'm a musician, I love rock music. I put it in their heads that I'm different. So then, if they ever do see it, they are not as shocked or offended by it because they already know. Oh yeah, she's a musician, she's a rock star in her spare time. Of course she would have tattoos.

In this quote, you can see how important it is to Elisa to be seen as a musician. Being disguised as a secretary during the day is a definite challenge to her self-perception. It creates the feeling that one is leading a double life. Elisa elaborates further:

> The tattoos are so much a part of me, but I have to wear a long-sleeved shirt every day. There are times when I just take off my clothes, and I look at myself in the mirror and I go, "*Ahhhhh*, there I am." It's as if I'm taking off the Clark Kent outfit, and I finally see myself as Superman. This is *really* me. I can breathe now. My skin can breathe, my art can breathe. That is always a good feeling.

Deborah Rhode argues that many of these appearance discrimination instances, especially when examined individually, may appear insignificant. However, "their cumulative effect is anything but. Such

prejudice violates merit principles, undermines equal opportunity, exacerbates stigma, erodes self-esteem, restricts individual liberty, and reinforces disadvantages."[47] Many non-tattooed people do not understand the drive that many heavily tattooed people have for this form of self-expression. When I asked my participants if they plan on getting more ink, all of them said, "Yes!" They had many ideas for their future body art: finishing sleeves and other large pieces, designs that they had been thinking about for years, and other visual memories they wanted to commemorate. They were willing to suffer through the cover-up process at work to follow their tattooed dreams but wished they did not face so much social prejudice when they stepped outside of their homes. Kristen Wall told me, "My thing is I'm not going to stop getting tattooed. If I have to cover up, that's just what I have to do."

Toward Workplace Tolerance

How can justice be achieved for heavily tattooed people in the workplace? It would make sense that there should be a reduction of appearance-based discrimination and that workers should be judged on their job performance more so than appearance. How can this be achieved? There are a few legal strategies and examples that could contribute to this theoretical foundation.

To begin, the First Amendment is an important tool, as its aim is to protect dissent and free speech, which could include freedom of self-expression. Steven Shiffrin writes in his book *Dissent, Injustice, and the Meanings of America* that "the First Amendment has a special regard for those who swim against the current, for those who would shake us to our foundations, for those who reject prevailing authority."[48] Is getting a tattoo a form of self-expression and "speech"? In the news there have been cases of teenagers being banned from their high schools for wearing T-shirts with particular slogans that authorities found offensive. Several cases of T-shirt slogans got people in trouble in 2012. In Cincinnati, for example, a student at Waynesville High School was banned from wearing a T-shirt with the slogan "Jesus is not a Homophobe" to his school; he subsequently sued. In May, a woman wearing a T-shirt that said "If I wanted the government in my womb, I'd fuck a senator" was kicked off her American Airlines flight. A twenty-one-year-old employee with

the Girl Scouts was told to turn her T-shirt inside out because it had the slogan "Pray to end abortion," on it. She refused—and resigned the next day. In New Jersey, students were banned from wearing a T-shirt with a memorial picture of their recently deceased friend. (School officials at first banned the shirt because the deceased teen was assumed to have committed suicide and the school did not want to promote suicide. However, the death was ruled accidental, and eventually they let the students wear the shirt.) These incidents show that wearing political T-shirts can result in banishment, and the First Amendment is called upon in such cases to support freedom of expression. This example can be parallel to having tattoos in the workplace, where self-expression is demonstrated not only through one's fashion but also through body modification practices. Certain cities and states—Cleveland, Rhode Island, and Massachusetts, for example—have banned tattooing practices but have faced lawsuits from the American Civil Liberties Union, which has defended the practices as "a unique form of personal art" that is "no less a form of expression than parades, marching, displaying swastikas, wearing armbands, saluting or refusing to salute a flag, singing or other artistic endeavors"—all of which are protected by the First Amendment.[49]

Another potential protection for tattooed employees could come from labor unions. Under a union contract, a union can include dress codes within their negotiations and provide protection for employees during a grievance procedure. An employer would not be able to change the dress code without consent of the union, as it would be an unfair labor practice.[50] However, unions have been tremendously weakened over the last several decades. Therefore, part of the fight against tattoo discrimination is to empower the workforce and increase worker protections. Unions could provide part of this defense, turning the focus away from the appearances of workers and onto their job performances. Lucille Ponte and Jennifer Gillian make this argument in their article "Gender Performance over Job Performance":

> What has long been missing from the mix is a focus on individual qualifications and workplace performance. It is striking that in so many of these dress and grooming cases, the discharged or demoted employees were successfully performing their jobs. Then one day their world was

> turned upside down because the employer decided to change the rules of the game with a new or revised policy, or to enforce some long moribund policy, or to conjure up some unwritten code. . . . It seems a fair bargain to allow employers to expect employees to do their jobs if, in turn, employees get a reasonable chance to reflect themselves in their grooming and dress including body modification.[51]

But employers may protest that they are simply following the wishes of the customers. After all, the customer is the priority, and customers prefer clean-cut employees, without tattoos or dreadlocks. This type of argument was utilized to uphold segregation, by requiring appearances that are more common among certain (racial) groups over others. These arguments continue to be used to discriminate against gay, lesbian, bisexual, and transgender (GLBT) teachers. The discriminatory preference of customers cannot be upheld, or else we open our workplaces to rampant discrimination. Such arguments were used by the airlines to hire beautiful women who were placed in revealing uniforms and to uphold particular height and weight requirements. In the class-action gender-discrimination suit *Frank v. United Airlines* (2004), the women flight attendants were required to weigh less than comparable male flight attendants.[52] They won their settlement of $36.5 million. In *The Beauty Bias*, Rhode states that appearance discrimination is only justified when appearance is the product being sold—as is the case with sex work and other forms of erotic entertainment.[53] In *Beauty Pays*, Hamermesh argues:

> Indeed, because the disadvantages experienced by protected groups are produced by the preferences of the majority behaving as consumers, members of the majority are precisely those who should be made to bear the costs of protecting the minorities whom they have disadvantaged.[54]

Even if customers are unaccustomed to tattoos, they will get use to them, just as they have adjusted to change in the past. Discrimination in itself is not enough of a defense to continue the practice. Law can set the progressive standard to which the public must eventually conform. Having visibly tattooed people in more professions can begin to help reduce the stigma that tattoos are not professional. Once tattoos can

be more visible on white-collar professionals, perceptions can change. One of the first steps to further removing the stigma of ink is to allow it to be visible in places where it is unexpected (perhaps already present, but covered).

A legal model can follow that of accommodation for disability and religion. In the Americans with Disabilities Act, the protected qualified worker is required to be given accommodation, unless it results in undue hardship for the business. Employers are prohibited from discriminating against a qualified applicant as well as from asking about disability before a job offer is made. With religion, employers cannot discriminate and are supposed to provide reasonable accommodations for the religious practice. Religious harassment and segregation are not allowed in the workplace (e.g., an employer cannot assign a religious minority to work in the backroom to avoid customer contact). Reasonable accommodations for religious practices include flexible scheduling and dress (without an undue hardship on the employer), and employees cannot be forced to participate in religious activities as a condition of employment (unless it is a religious organization, school, or corporation). These accommodation models provide an example for protective labor laws that re-direct the focus from an individual's appearance, ability, or religion to that of their job performance. It is important to remember that labor laws were won through the struggle of social movements that demanded such rights; they were not granted without pressure. Therefore, in order to extend further labor protections, social movements with people's participation is crucial.[55]

In the United States as well as in other countries, there are examples of municipalities that have established stronger protective laws that limit appearance-based discrimination. In the United States, six cities and one state have banned weight discrimination: Michigan; Binghamton, New York; Washington, DC; Urbana, Illinois; Madison, Wisconsin; Santa Cruz, California, and San Francisco. Considering the levels of obesity in this country as well as the harsh social stigma that overweight individuals experience, these legal protections are rarely used. For example, in Urbana, Illinois, where the statute has been in effect for more than eighteen years, there has never been a weight discrimination case, and this is usual for the other cities. San Francisco may face four cases a year. Often, when these laws are invoked, the plaintiff

utilizes several laws in conjunction. If employers make a bona fide claim that employees need to be under a certain weight, this is still defensible on their part. Washington, DC, is the only municipality that prohibits all appearance-based discrimination, while the other municipalities only refer to weight discrimination. Each municipality applies this law to businesses with a certain number of employees; for example, in San Francisco the company has to have five or more employees. These laws provide an example of ways that appearance-based discrimination can be regulated. However, we see that these laws are rarely, if ever, utilized and often have very narrow parameters.

Other countries also have legislation banning appearance-based discrimination that can provide a model. The 1995 Equal Opportunity Act of Australia's state of Victoria prohibits discrimination on the basis of a number of criteria, including: gender identity, lawful sexual activity, marital status, physical features, sex, sexual orientation, and personal association. In the United States, gender orientation and sexual orientation have yet to make it as protected categories. Lawful sexual activity would include prostitution, which is legal in the state of Victoria. Victoria's Equal Opportunity Act also promotes teaching GLBT workshops in companies to promote a more GLBT-friendly work environment. Furthermore, the Victoria Equal Opportunity and Human Rights Commission sets out its proactive agenda:

> The Commission believes that a major shift in attitude towards the elimination of discrimination can only be brought about by recasting the debate as a responsibility on everyone to actively eliminate discrimination rather than, as currently, a passive obligation not to discriminate.[56]

As we can see, this is far more proactive than we can imagine anti-discrimination laws in the United States to be. Yet Australia is not the only country to have laws protecting appearance.

German law established in 1949 states that "every person shall have the right to free development of his personality insofar as he does not violate the rights of others or offend against the constitutional order or the moral law."[57] Furthermore, in Article 5, it states that "every persona shall have the right to freely express and disseminate his opinions in speech, writing and pictures. . . . There shall be no censorship."

Additionally, men and women "shall have equal rights."[58] Article 5 should be significant for the protection of body art and self-expression, especially with the inclusion of "disseminate his [*sic*] opinions in . . . pictures." The labor code in France covers a host of protected categories, which includes "external appearance." Under French law, "No person can be eliminated due to their . . . physical appearance."[59] As we can see in these examples from the Australian state of Victoria and the nations of Germany and France, it is possible to legislate against appearance-based discrimination and take a proactive stance. The Victoria Equal Opportunity and Human Rights Commission states that it is the responsibility of everyone to actively eliminate discrimination and that it is a burden for society as a whole to address, not the targeted group members.

Tattoo-Friendly Workplaces

While it is legal to discriminate against people with tattoos in the United States, not all workplaces do so. With over 20 percent of the population tattooed, some employers realize that some of their customers are also tattooed, and they want to appeal to this demographic. Tattoos are part of popular culture: They are visible on television, in advertisements, in films, and in music culture. There have been at least ten television reality shows about tattoo studios, indicating the wide public appeal of artistic body modification. Some employers may be tattooed themselves, and others just do not care whether their employees are tattooed as long as they are good workers. As we have seen, tattooed individuals are keeping track of "tattoo-friendly workplaces" on the Internet. Seeing other visibly tattooed people employed is important to heavily tattooed individuals, and they may proactively support those businesses. When Eileen Meigas and her girlfriend Rachel traveled from their home in Miami to Jacksonville, Eileen just could not get over how many employees in the mall they visited were tattooed:

> We were at this mainstream America mall in the middle of Jacksonville, and I just kept turning around. Rachel asked, "What the hell is wrong with you?" I said, "*Look.* Did you see they have ink? There is ink everywhere!" It was a lot of girls working their crappy mall jobs, but they had

short-sleeve shirts and weird ink popping out all over the place. There were girls with neck tattoos and everything. And I said, "Look, you can be employed in Jacksonville and have some ink. We should move here, this is great." So now we're considering going to college in Jacksonville.

Just by being in an atmosphere where tattoos are normalized, Eileen and Rachel were willing to change their lives and move across the state in order to live in that accepting environment. Another worker described how important it was to her that her workplace was accepting of her ink:

Emily Huston, a librarian in Florida stated, "I am a pierced and tattooed librarian who is blessed with a library that does not have a dress code. We are all adult enough to dress appropriately for work. I don't flaunt my tattoos and piercings; I don't hide them either."[60]

For tattooed employees, being able to comfortably express one's individuality and style is a big relief. We can understand why, given situations, already described, in which tattooed employees have been fired even after months of showing their tattoos at work without incident.

Self-employment, of course, provides the most tattoo-friendly work environment, and many study participants dream of this kind of freedom. In the case of Antonio Hegwood, who was fired from the service station for wearing dreads, that was his dream: "Maybe I'll start my own business," he said, looking ahead. "That way I can wear my hair any way I want."[61] Women have lower rates of self-employment than men,[62] but, interestingly, as we have seen, many of the participants in this study are indeed self-employed women. They own or co-own their own tattoo studios where, of course, their tattoos become an asset to the business, rather than a liability.

Conclusion

Covering up one's tattoos and, symbolically, one's authentic self takes a toll on one's spirit and even health. Study participants have found a meaningful way to express themselves through their body modifications; however, in the workplace, that authentic self-expression needs to be covered in order to conform to workplace dress codes. This issue is

symbolic of conformity in the workplace, as well as in society. While one may want to be expressively unique, one must conform to acceptable public behavior and appearances in order to maintain the social order, which rests on such conformity. In this chapter, two issues are central to the idea of workplace dress codes: the right to express one's authentic self, and the enforcement of the letter of the law in employment-discrimination cases. Socially, there is the feeling that people should be able to express themselves, which is especially tied to the concept of free speech and rights. The participants in this study have often encountered people, both inked and not, who encourage them to "just be yourself. If they don't accept you, then screw them." However, this ignores the structural power of the economic system on which individuals depend for their livelihoods, especially in times of recession. Many of the study participants negotiate their self-presentation on a daily basis.

As we have seen, the legal system is framed on specifying particular protected classes and protecting only their immutable characteristics, not their expression. Therefore these laws are of little use in defending the right to be tattooed. Further, the courts overwhelmingly uphold the rights of employers in most cases, rarely the employees. This demonstrates the power imbalances inherent in the economic and legal frameworks and where individual, tattooed employees stand within them. Tattoos simply are not protected in the world of work. Indeed, they can cause individuals to lose their jobs, thus providing a potential liability for employment. One direction that the tattooed employee dilemma points to is that of strengthening workers' rights, which is especially important (and difficult, but necessary) in today's economic climate. There should be a shift from the total control of the employees' presentation to an emphasis on their work performance. Finally, the legal system should reflect today's multicultural and visibly diverse society by widening the rights of self-expression and demonstrate an understanding of diversity.

5

"Is the Tattoo Guy Here?"

Women Tattoo Artists' Experience Working in a
Male-Dominated Profession

Many of the women-owned tattoo studios that I walk into remind me of high-end hair saloons: gentle music plays, canvas paintings are on the walls (instead of tattoo flash—i.e., sheets of tattoo designs) in a tidy, clean environment with a friendly employee behind the front desk, ready to talk with customers about potential tattoo or piercing work. Portfolios of artists' work line the front counter, demonstrating the skill level and artistic expertise of each artist. Stations are either in loft-style open spaces or, so much the better, separated into private rooms for work on large tattoo pieces or on private body parts for hours on end. These studios specialize in custom artwork and large-scale pieces for regular clients, although none of the shops are above doing walk-in work for small designs on lightly tattooed people. These studios contrast with the stereotypical street shop employing primarily men, specializing in small designs straight from flash sheets, with aggressive music and voices blaring. While the high-end custom studios and the flash-oriented street shops demonstrate the range of businesses across the United States, gender dynamics also contribute to the feel of the tattoo studio. How did these spaces, with different ratios of men and women artists, alter the experience of the workers and clients? Does the tattoo industry provide a different perspective of women working in male-dominated professions? In this chapter, I examine the experiences of twenty-five female tattoo artists in the United States. In particular, I focus upon their entry into the profession through their apprenticeship experience, working conditions, and gender dynamics of the workspace. Additionally, the chapter examines the interactions between tattooists and customers in relation to gender stereotypes and expectations. While women currently make up between 10 percent and 20 percent of

tattooists nationwide, women are entering the profession in increasing numbers and dramatically changing the feel of the industry. The experiences of women within the industry are important to consider, as they will be at the forefront of changes within it.

Women and Employment in Non-traditional Fields

Women working in the tattoo industry find themselves in a situation comparable to that of women in the skilled trades (e.g., carpentry), craftwork (e.g., woodworking), service industry (e.g., hair saloons), and fine arts (e.g., painting). Such professions require a great deal of skill but are also service oriented. For tattooists, it is the client who dictates the final design and placement, unlike fine artists, who may be able to exercise more control over the final product, unless they are creating commissioned work. Additionally, tattooists are only paid by the piece, based upon an hourly rate; therefore financial security is dependent upon securing new customers as well as returning clients.

Women in Skilled Trades

Why do women want to become employed in male-dominated "blue-collar" professions (e.g., carpentry or construction)? It is possibly because worker satisfaction is often higher in these higher-paying jobs than in lower-end service-sector employment. Studies have shown that men employed in male-dominated professions have the highest work satisfaction, followed by women in these professions.[1] These jobs are highly valued, are rewarded socially, and provide workers with challenge, excitement, and security, especially compared to female-dominated occupations.[2] But in male-dominated occupations, not only do men hold positions of power and authority,[3] but the cultural atmosphere is also decidedly masculine,[4] which may be uncomfortable or chilly for women.[5] In such an environment, harassment toward women may be common, as a manner of testing their endurance for surviving in a masculinized, hostile environment. Since the 1970s, women have been entering non-traditional professions in exponentially increasing numbers; however, eliminating the token status of women has not necessarily eased harassment.[6] Men, positioned as the dominant group

within such professions, may find themselves threatened by the perceived encroachment by women and continue to combat the newcomers by exerting their dominance and solidarity among themselves.[7] If we compare the tattoo industry against other skilled blue-collar and craft industries, we can find similarities and differences that are significant for women to understand when they enter the profession. Tattooing can be comparable to blue-collar industries because of its historic, working-class association and its craft-oriented skill set, often learned through apprenticeships, rather than through higher education. But it also differs in important regards—blue-collar industries are formally regulated through unions and certification; however, tattooing is not regulated as such. Therefore, while formal means of combatting sex discrimination exists for such industries at these points of regulation, the same is not true of the tattoo profession.

Women in the Art World

Within the art world, there is a strong distinction made between fine art and craft. Fine art is that which you would find in art museums, such as oil paintings, decorative sculptures, and installation work. Craftwork has been defined as artistic work that has a practical purpose, such as woven blankets, baskets, or pottery. Is tattooing an art craft or fine art in itself? Howard Becker explores such distinctions in his book *Art Worlds*.[8] Over the last two decades, several art shows in museums have been dedicated to the medium of tattoo art, usually portrayed through photography. Many photography books dedicated to this field have presented the work in a high-art format—challenging the assumption that tattoo work is not fine art. However, many tattooists themselves call their work a skilled craft, providing wearable art more akin to craftwork than fine art. Yet many tattooists have done recreations of classic paintings, like those of Picasso or Van Gogh, on the bodies of clients, definitely challenging the distinction of tattooing from high art.

Aspiring to be a fine artist is not an easy endeavor. For many idealistic students, they may first step onto this path by pursuing a bachelor's degree in art. Having such a degree is one way in which to demonstrate artistic ability, but it is not a requirement for the profession. Indeed, "in the arts there are no official prerequisites or credentials to distinguish

artists from non-artists, professionals from amateurs."[9] To establish oneself in the field requires the "construction and maintenance of an artistic identity."[10] A college degree can cost a significant amount of money, but such a degree does not guarantee a job in the field. Many might find themselves employed as art teachers or as a clerk in an art supply store or in a photography studio—and those would be the ones lucky enough to find a job in a marginally related field. For the vast majority, they may find themselves working in the service industry or in an office environment—or they may simply be unemployable.

Tattooing provides a means of making a living as an artist. Over the last several decades, there has been an increase of tattoo artists receiving art degrees, and many of these are women. These artists may take their portfolios, containing both paintings and tattoo work, into tattoo studios, seeking to establish an apprenticeship with a local artist. In the skilled trades, an apprenticeship and subsequent certifications are required to work in the field, but apprenticing in a tattoo shop is a tradition, not a requirement. Some artists may skip this step entirely and establish their own tattoo studios by acquiring a business license and other minimal health and sanitation regulations required by the local government. Tattooing requires no degree, certification, or other industry requirement. Many tattooists may begin their career tattooing their friends out of their homes; however, this is illegal, unethical, and stigmatized within the profession. Such tattooists are called "scratchers," and they are pitted against the professional artists working in studios. While tattooists provide scathing critiques of "scratchers," many of them, especially women who have had a hard time finding artists who would allow them to apprentice with them, have taken this route themselves. Without an industry-regulated apprenticeship program, attending art school and then establishing a formal apprenticeship at a reputable tattoo studio is the proper manner of entering into the industry. Cindy Lael, a late-career tattooists living in northern Florida, talked about the ways in which many women are now following this path:

> A lot of women are getting into the business after they have completed art school. I have seen the most amazing artwork from ladies who have only been tattooing a couple years. I don't think they could have learned that from just apprenticing, sitting in the shop and waiting for people to

come in. They have got to have advance art training. If I'd known or had the insight when I first got started, I would've gone to art school and gotten a better education, too.

She continues:

I had an art background and was an artist. So I was amazed that you could do work on someone and they could carry it, look at it, and enjoy it every day. Instead of doing a painting or drawing and have 'em get tired of it after a couple years and put it in the attic or sell it at a yard sale or whatever. I knew that if you were a tattoo artist, your art would be thought about every day. It wasn't just a spur of the moment thing that you could just dispose of.

Art school provides training in technical artistic ability as well as art history education, but it does not include any courses about tattoo artwork in particular. Outside of the few museum shows about tattoo art, the relationship between the art world and the tattoo world has often been contentious. Art galleries overwhelmingly reject tattoo art, whereas tattoo artists often consider their work to be on an equal footing with that of fine art.[11] The tattoo artist Mary Jane Haake "caused a furor by proposing tattoo art for her senior thesis at Pacific Northwest College of Art in the early '80s." She brought examples of her tattoo work to the presentation—on live models.[12] While the art world continues to banish tattoo art from their realm, tattooing provides a means to a livelihood not often granted to fine artists.

While tattoo artists need to have a firm grasp on skillful drawing and shading techniques, learning to handle a tattoo machine—to operate it, fix it, and repair parts—is another skill set altogether. The machine holds a needle bar that contains many onetime-use needles. Powered by a motor, the needle bar moves up and down quickly, puncturing the top few layers of the skin hundreds of times in a minute. The needles are dipped in ink, but the ink does not go on the inside of the needles; rather, the ink is on the outside of the needles and simply falls into the punctured skin. Excess ink on the skin's surface is wiped away with a paper towel repeatedly, as the artist keeps an eye on the progress of the lines and shading. Inks are added in order from the lightest color to the

Figure 5.1. Shorty and Kody Kushman flip off a picture of old-time tattoo artists posed next to a sign that says, "I do not tattoo girls." Shorty and Kody both work for Kari Barba, a tattoo artist who has apprenticed many female artists.

darkest, so as not to contaminate the other colors. The ink needs to be placed on a specific layer of skin; if the ink is too deep or too shallow, the tattoo will not hold its appearance properly over time. Working on human skin is quite different, of course, than an artist's canvas. It is a medium that takes practice in order to become accustomed to it.

Tattoo-Shop Culture

In his social history and memoir, *Bad Boys and Tough Tattoos*,[13] Samuel Steward portrayed the tattoo culture of the 1950s, which he joined after he transitioned from being a college English professor to a tattoo artist. Steward entered the seedy underground world of tattooing by acquiring his own small tattoo, hidden from sight. However, after showing it to friends, he found that it carried a heavy stigma. His friends were horrified that he would mark his body in such a way and gave an endless list of reasons explaining why they would never do such a thing. Indeed, Steward points out that one of the root causes for the associated stigma

was that "a good forty percent of its practitioners in those days was composed of ex-cons or conmen, drunks, wife-beaters, military deserters, pushers, (and even two murders)."[14] But Steward—or Phil Sparrow, as he was known in the tattoo world—was not put off by the deviant crowd; indeed, he was attracted to it. He bought a correspondence course in tattooing but admitted that he did not really learn the craft until he spent time with the old master Amund Dietzel in Milwaukee, where he learned that "tattooing seems to be one of the few remaining skills that must be passed from a master to an apprentice."[15] Phil Sparrow opened up one of the first tattoo shops in Chicago. Sailors made up a significant portion of his clientele, lining up outside of the shops, dozens at a time, to acquire tattoos that were given out as fast as possible in a factory-like procession. Gang members, bikers, and gang-member wannabes made up the other significant portion of his clientele. Indeed, upon moving to California, he was discovered by the Hells Angels, and became, "in a sense the 'official' tattoo artist for them."[16]

Women occasionally entered Steward's shop, but they were mostly the wives and girlfriends of men, often getting the man's name tattooed on their bodies. Steward tattooed many Hells Angels women with the "Property of . . ." tattoo. After complaints from husbands and parents, he stopped tattooing women without getting permission from those family members first. But, as Steward states, "the lesbians were another matter. Whenever they came in they frightened the sailors and many of the city-boys out of the shop."[17] From Steward's description of his clientele, during the time period ranging from 1950 to 1970, the tattoo shop was a rough, masculine environment, where women were either out of place, literally being marked as a man's property, or banned outright. Wives of tattooists, however, always had a place in the shop, and the occasional girlfriend of a client would venture into this hostile environment. The transition from this male-bonding environment to shops owned by women demonstrates a significant shift in the tattoo-shop culture over the last half of the century. But it was not until after the 1980s that more than a handful of women began working in the industry.

Fast-forward to the 2000s and 2010s, with women-owned tattoo shops on the rise. Contemporary tattoo shops do not resemble those earlier street shops with drunk and unruly sailors loitering outside. But some of those early tattoo-shop elements are still present. The shops

range from basic street shops, servicing walk-in customers looking for quick, simple designs, to high-end shops, specializing in large-scale custom designs. One of the most obvious signifiers of the different types of shops is the display of flash on the walls, presenting small images of classic tattoo designs (eagles, roses, pinups). In contrast, custom shops usually do not exhibit flash; instead, they decorate their studios with fine art paintings. Many of the women-owned shops that I visited were custom shops that no longer display flash or otherwise resemble the street shops of the past. In St. Augustine, Florida, Ms. Deborah's Fountain of Youth Tattoo Studio is located on the edge of Old Town, an area where tourists can visit parts of the city built hundreds of years ago. The studio is in a large, Victorian house, painted purple, with a Zen garden in the front yard, welcoming customers into the lobby. Once inside, clients will find a seating area with portfolios, fine art on the walls, and a selection of jewelry from the piercing studio. Each tattoo station takes one of the rooms in the house, providing privacy for the artist and client, as well as separation for the different music selections playing. Artists often gather in the kitchen/computer room, as they work on their custom drawings or grab a bite of food picked up from local restaurants by the receptionist. The atmosphere promotes a home-like feeling, and the participants in this study who work there often express that they feel like a part of a tattoo family. New generations of tattooists are creating a different physical environment that contrasts with that of the old-school street shops—and women are at the forefront of this change.

Women in the Tattoo Industry

For women entering such a historically hyper-masculine space, they must negotiate the ways in which they present themselves, and their workstation, in such an environment. They may find their workplace bombarded by male co-workers, a situation similar to women in many professions.[18] Besides the physical environment, the ways in which men and women socially construct each other in a decidedly gendered manner also affects the environment for both workers and clients.[19] Because the tattoo industry has been constructed as a masculine arena, behaving in a masculine manner works well within the environment, whereas femininity may create dissonance. This can foster an environment of

sexual or gender harassment, where women's bodies are overly visible and sexualized.[20] Other women enter the profession through their boyfriend or husband, and this situation tends to offer protection from harassment.[21] When women attempt to find an apprenticeship in an established shop, this creates an imbalance of power that can contribute to sexual harassment, as shop owners may pressure women apprentices in uncomfortable ways.

Tattoo Apprenticeships

> Seventeen years ago, to break into the business, you called a shop that was run by men and said, "Hi, I'm a girl and I want to tattoo." They go, "Oh you can't tattoo, it's a man's world and we're not hiring." And the guys tried hard to keep all those girls out of the business.

Missy Kramer demonstrates the male gatekeeper attitude of the industry at the time when she entered the profession. While many blue-collar professions have a formal apprenticeship process, the tattooing industry has an informal process. Aspiring tattooists are often art students or self-trained artists who have proven their artistic ability. Whereas in the old-school days of tattooing tattooists did not necessarily know how to draw, as they relied extensively on stencils, contemporary tattooists overwhelmingly have proven their artistic abilities. With portfolio in hand, they may approach various shops in their town, asking for the opportunity to apprentice. In a mid-sized town like Spokane, Washington, there may be upwards of forty shops in the city. Not every studio will be open to taking on an apprentice, in fact, making the pitch as a potential apprentice will be an exercise in toughening oneself to constant rejection. Shops do not want to take on the burden of training a new person, nor do they want to develop the abilities of someone who might one day compete with them. In the old days of tattooing, the business was cutthroat, and competition among the few shops was ruthless. Artists in the same town did not share any camaraderie; indeed, they often attempted to sabotage one another. While some of that animosity has died down, the explosion of tattoo shops in any given town fuels competition. Thus one really must have an in with a studio,

or be impressive in some manner, in order to land such an opportunity. And, once that opportunity is landed, the road ahead is difficult. Apprenticeships are hard work, time-consuming, and not financially compensated.[22] Similar to boot camp, apprenticeships can be headed by tattooists who can be more or less aggressive in their aim to break down any already-established bad habits and to rebuild the apprentice as a technically competent tattooist. Jacqueline Beach was lucky enough to garner an apprenticeship under veteran tattooist Vyvyn Lazonga in Seattle:

> I did have to have another job so that I could support myself. So it took two years of part-time training, and now I have a little over two years of full-time tattooing. So I did train with her for two years. And that was five and a half years ago, and that started my journey, which eventually brought me to Vyvyn and an apprenticeship with her. But I came to her as a client first to get my first big tattoo, because that was kind of one of those things. You are never going to get an apprenticeship unless they know you are committed to tattooing, and to be committed to it you are going to get the work done. And I first came to her as a client, and we did a big dragon piece that went all the way down my leg.

Starting out as a client is a common way to approach a tattooist, in order to demonstrate one's commitment to the craft and to establish a relationship with the artist. After commissioning a large tattoo piece, one may inquire about a potential apprenticeship. An apprentice has very little power within the studio and is at the beck and call of the shop owner, creating an unequal power relationship that can foster potential discrimination—or advantage.[23] Traditional apprenticeships require apprentices to begin with unglamorous labor: cleaning, answering phones, taking out the garbage, and fetching coffee or food. Apprentices are expected to watch the tattooists working during their downtime in order to learn, and they are also expected to draw regularly. Eventually, after months of such labor, they are slowly taught the technical aspects of tattooing. Apprenticeships are mostly unpaid, and often apprentices pay thousands of dollars for the learning opportunity. Ideally, apprenticeship positions would be full-time, however, understanding the

financial difficulties of such a situation, mentoring tattooists will often offer apprenticeships on a part-time basis. One apprentice, Suzy Todd, who was training under Vyvyn Lazonga, describes her apprenticeship:

> It's five days a week, Wednesday through Sunday. I get Monday and Tuesday off, which leaves very little free time. Two days a week I'm a freelance artist out of my home, to make money, because here, I'm not making any money. So, while this is going on my husband is trying to support us, but things get tight, every now and again and I have to find a new way to bring in some income, which isn't very much, per month. [For the apprenticeship] I do a lot of cleaning. I clean up after Vyvyn, her station. I clean everything after she's done, I clean the shop. I sweep and wipe down counters. I watch the front desk. I check emails. I answer the phones. I make needles for Vyvyn. I am working on art projects, every once in a while. She has given me a goal of making a flash set [tattoo designs], which I have been working on, every time I get a free chance. But there is so much shop-related stuff that I need to do that it's kind of hard to get to it.

The mentor can have a great deal of power over the apprentice, and this can affect the training, networking opportunities, and future prospects of the apprentice.[24] Cynthia Epstein points out that "a protégé relationship may be more important to the woman than a man, and that a male sponsor may make an extra effort to promote a female protégé because he is aware of the difficulties she faces."[25] Networking within the tattoo industry can take place at tattoo conventions, where artists gather together to see each other work, learn about new developments in the industry, and collect a different group of clients than those who make it into their studio. Yet a mentor would need to make a conscious effort to introduce her or his apprentice to other artists and provide other such opportunities. Additionally, the scarcity of female mentors can have a negative affect on the recruitment of women.[26] As more females enter the business, they can provide more opportunities for apprenticeships for additional women.

Historically, however, most women have entered the tattooing profession through their husbands and boyfriends, and this pathway continues for a large percentage of female tattooists. Of the participants in

this study, this was true of both veteran and novice tattooists. Ms. Sofia Estrella started her tattooing journey nearly forty years ago, and it began because of her relationship with a tattoo artist:

> Well I ended up marrying [a tattooist] so I had an apprenticeship through that relationship in the shop, from getting the coffee to cleaning. I was just learning. He would give me little drawing to look at and things to take home and color with colored pencils, and little flash that we had back in the day. Because back then there wasn't a lot shared information like there is today.

Maytee Bringas, a tattooist of sixteen years in Miami, Florida, described how her husband provided the opportunity for her tattoo apprenticeship:

> I worked in an office before and I would come to the shop and just be here all the time. I started drawing again, I used to draw and paint in junior high. But I never thought anything of that. I never thought I would end up doing what I'm doing now. It's amazing. . . . At first it was a little hard because he was against the whole relationship and working-together thing; he thought maybe it would be a bad idea. But I just kept on bugging him. I was very persistent, "Give me a chance, you know." So at first I tattooed my friends. . . . Then he gave me the opportunity for a tattoo apprenticeship.

Women enter the profession not only via their male partners but through other family members as well. Having family members who run a tattoo studio, like other family businesses, provides opportunities for relatives who might not have otherwise considered such a profession. The tattooist Charissa Vaunderbroad grew up in a tattoo shop, along with her sister. She took up the profession, but her sister did not. Vaunderbroad describes her childhood:

> It became normal to have children at the shop, so I grew up there while my mom was always tattooing. When I was out of school there was always a space for me at the shop, where I could draw and play with tattoo stuff, I had toys and so it was just like a normal childhood. But you

spend your time, instead of in front of the TV at home, with your mom while she tattooed.

While there seem to be decreasing numbers of family-owned tattoo studios, the flexibility of scheduling at such studios assists with child-care concerns and thus could be helpful for women with children.[27] An artistic child, Vaunderbroad began apprenticing with her parents as a teenager, after her father offered her the opportunity:

> That's when my apprenticeship started. My dad taught me more stuff about machines and certain styles. . . . And then my mom taught me how to work with a little more delicacy, a little bit more finesse. . . . So I got an apprenticeship from both of them through my teen years and was tattooing full-time by the time I was seventeen.

Family shops provide a great opportunity for employment, as well as for spending time together. Some of the female tattoo artists interviewed also raised children who became tattooists, thus creating a new generation of tattoo artists trained by women. Debbie Lenz from Ohio was one such artist:

> One son was sixteen when he started tattooing, and he always said he wanted to be a tattoo artist. And he was like my husband: He's a fantastic technical tattoo artist. He jumped straight in, not afraid at all. . . . My other son Drake, who is a year older, waited a year after Jack. . . . He was a nervous wreck. He was like me with my first tattoo; he would be shaking, saying, "I don't know if I could ever do this." And now he is phenomenal.

Mid-career Women Tattoo Artists

In the first half of the century, just a few maverick women—wives of tattooists, or tattooed sideshow performers in the circus—began tattooing. Since the 1970s, however, women have entered the tattooing profession in exponentially growing numbers. Women who entered the business in the 1970s, when there were very few shops in any town, faced "the old-timers that frowned on girls in their business, much less tattooing out of their shop."[28] During the 1970s to the 1990s, women

tattooists flourished, producing the first wave of contemporary pioneers of women in tattooing: "Sheila May, Vyvyn Lazonga, Calamity Jane, Ruth Marten, Jamie Summers, Jacci Gresham, Mary Jane Haake, SuzAnne Fauser, Kari Barba, Juli Moon, Patty Kelley, Pat Fish."[29] These pioneer women were able to go on and provide apprenticeships and shop employment to a host of younger women also entering the business in later years. Vyvyn Lazonga, from Seattle, Washington, describes her philosophy of mentoring women:

> I would hire women because it seems to work out better. We are able to share and communicate, we all kind of give-and-take, instead of trying to compete, which is really nice. It's like a big relief. The people that I hire are older and more experienced. They know how tough it is out there in the world of tattooing. We all kind of appreciate each other, and it's quite a contrast from how it was in the early nineties.

Vyvyn described the difference she has felt between working with men and women tattooists. Having previously worked in men-only shops, she felt that those atmospheres had been fueled with competition and cutthroat behavior. In contrast, she found the atmosphere working in a shop with other women artists more congenial. Researchers on gender dynamics in the workplace have demonstrated that in some cases:

> Women were more likely to understand work through personal connections and relationships, to express personal loyalty to their bosses, although not to the firm or the client. By contrast, men's attachments to work and their loyalty appeared to be more fleeting and strategic.[30]

Vyvyn is not alone in this assessment. As tattooists, most of the women have worked in shops staffed by men only, or a majority of men, and have been able to compare their own experiences in different environments. Tattooing can be a cutthroat industry, as new shops spring up and further saturate areas with established shops. Generally, when one completes her apprenticeship, her training shop will either keep her on as an artist or suggest that she establish her own shop in a different area. It is considered bad form for an artist to compete locally. Yet this happens all the time. This dynamic can also have a gender influence,

as Karla Erickson and Jennifer Pierce point out: "Many women constructed narratives of investment to describe their jobs, while most men did not, suggesting that loyalty as a structure of feeling has not only become personal, but feminized as well."[31] While such dynamics happen between all genders, the expectation of loyalty from women tattooists who one has trained may sting that much more when violated. When women constitute a significant portion of workers in the shop, it alters the atmosphere in ways different from atmospheres in shops dominated by men's presence. Another pioneer artist, Kari Barba, established herself in the business several decades ago, and she has opened up four shops in southern California, many of which employ women:

> We do have a lot of women in the shop; I think we have more women than any other shop. We had one shop that was completely staffed by women. That was pretty fun. It was the Melrose shop. And it wasn't that I choose it that way, it's just the way that it happened. We kind of laughed about it because we had six girls working there and no guys. So it was pretty funny.

Barba is a role model and icon for women in the industry, so it is no accident that her shops attract women artists. Her artists talk with admiration and respect for her position in the industry, and they have pride in being in such a historic shop. Having such pioneers in the industry provides role models, recruitment, and a space for women to flourish in the business. While Barba may not see it as an intention design herself, it is no accident.

"Is the Tattoo Guy Here?": Customer Interactions

While gendered harassment and discrimination have lessened in the workplace, stories still abound about customer reactions to women artists, both negative and positive. These reactions overwhelmingly stem from old stereotypes of tattooists being overly masculine and deviant. As women tattoo artists constitute only 10–20 percent of all artists, these stereotypes continue to flourish. The most common reaction is for customers to view men as tattoo artists and women as "shop girls," or

girlfriends of the artists. Amanda Cancilla described common customer reactions she has experienced:

> I am the only female tattoo artist at the shop. . . . Clients would come in and think I was just a counter girl. Most of them were surprised to find out I was actually an artist. Some of them told me straight out that they would never let a girl tattoo them, and it would crush me.[32]

Another artist describes a similar reaction:

> I often hear the question, "Are the guys who do the tattoos here?" Then I smile and politely inform them that they are talking to one of the "guys" and hand them my portfolio.[33]

Many artists are hurt by these rejections, but they respond with the sentiment that sexist customers are undesirable, anyway. If customers are unwilling to be open to women tattoo artists, then the artists themselves desire better, more accepting customers. Kari Barba described one of her own experiences:

> Once, in the beginning, a guy had come into the shop and was looking through the photo album. He chose the artist through the photo album and when he found out it was a girl, he didn't want to get tattooed. He changed his mind. He was like, "No, I don't want to get tattooed by a chick." And I am like, "That's fine. Go ahead and get somebody else." And he was like, "Well, I want the person who did this." And I said, "Well that's a chick, ya know." . . . And then he tried to beg me to do it. And I said, "Well the thing is, here you tell me you don't want to get tattooed by me and then you find out it's my work, and you expect me to go ahead and sit down and be comfortable tattooing you." So, I didn't tattoo him and sent him out the door.

Many of the artists had similar stories in which customers' stereotypical gender expectations made them unable "to see" women as tattoo artists. Constance Eller, in Spokane, Washington, described a situation in which she was tattooing a man and the customers came into the shop

and asked the customer a question about tattooing! Another veteran tattooist, Patty Kelley, told another story:

> When I did have a boyfriend . . . he was a carpenter. And I would bring
> him to these conventions, and every time—without missing a beat—they
> would talk to him about tattoos. Not to the tattooist. They would talk to
> the carpenter about getting a tattoo. He would say, "Well, I'm just a boy
> friend, so you need to talk to her about the tattoo." I had to kick him out
> of the booth.

While some co-workers and clients discriminate against women working in the industry, others prefer them. Some customers may believe that the tattoo will hurt less if done by a woman because she will have a "gentler touch." Many of the tattooists reported that they have heard this expectation from clients; however, they are often disappointed with the painful outcome. Women clients may feel more comfortable working with a woman, especially if the tattoo is on an intimate part of the body. Tattooists report that women clients sometimes have possessive boyfriends or husbands who do not want them being touched by male tattooists. Men may also feel more comfortable working with women, as they don't expect to demonstrate as tough a façade as they would in front of other men. First-time clients may feel more emotionally supported. Cindy Lael from Florida describes receiving such reactions:

> I had a lot of people that were relieved that I was a woman because they
> felt more comfortable. Especially if they were modest, and they did
> not want a big burly biker guy mauling them, and back then, a lot of
> that was the scene. They just felt more comfortable with a compassion
> ate woman. They felt I would be gentler and more sympathetic, which I
> think I was, compared to most burly men. And actually, a lot of the men
> felt more comfortable because they could sit there and admit "Hey! That
> hurts." You know, where maybe they couldn't do that in the big burly
> macho shop.

Customers who prefer women tattoo artists can also be projecting gender-normative expectations, where they expect the artist to work in a stereotypical female manner (i.e., be gentle, compassionate, friendly).

Because of their relatively small numbers, female tattoo artists may be able to attract a great deal of business from customers with such preferences. Miss Blue, a tattooist in Ohio, describes her situation:

Actually, it has been wonderful, because there aren't a lot of female tattoo artists. And it's been a very positive response from clientele. Women are more comfortable to get tattooed by a female. Especially if it's in a little risqué area, on the hip or lower back even, they would be uncomfortable to go to a male artist. And guys are comfortable to come to me as well, 'cause then they don't feel they have to be like all macho, necessarily. And we can have girl talk, so to speak, even with the guys, so it's like being a hairstylist or a bartender. You know, you get personal with these people. You are sitting with them for a long time, sometimes. And you really get to know them, and sometimes people feel a little more comfortable with a female. It has actually been really great. I haven't had anybody go, "Oh you're a girl. You must not be that good." So I guess I've been lucky because I've heard of that happening to other people.

One Chicana artist in East Los Angeles found herself in high demand because she is so rare:

A lot more Chicanas come here than men, and I'm spread so thin. I know that women feel safer with me since I will understand their needs and will be respectful of their desires. . . . These fuckers [male tattoo artists] don't understand the special needs of women. Some of these dudes like to see naked bodies exposed, even if they aren't tattooing that area. . . . It almost seems like some of the Chicanas feel unsafe.[34]

Tattoo artists both utilize and fight against normative gender expectations when discussing how customer and co-workers react to their presence. On the one hand, many do not want to be presented as a *woman* tattooist but, rather, as just a tattooist. On the other hand, the reaction of many customers is stereotypical of gender biases, and this can be both beneficial or a drawback. If their gender repels some customers, it attracts others and, therefore, can balance out in the end.

Gender stereotypes do not end with the studio interaction between client and artist; they also extend to those who see a tattoo and assume

that a man did it. For example, women have done all of my tattoo work, but when I find myself talking about my body art to observers, they are often shocked to hear it was all done by women. Non-tattooed individuals foster even more of a gender-stereotypical understanding of tattooing because they lack exposure to the subculture. They have simply never considered women tattooing. This was a typical experience for tattoo collectors. One artist wrote that her clients have "gotten surprised responses from people when she tells them she was tattooed by a woman."[35]

Most of the tattooists report that they have admired and looked up to other women in the industry. Those who have worked with other women in the industry have felt that this was a positive experience for their career development and perspective. But one does not have to be a woman in order to support other women in the industry. Many progressive men in the business also are fully supportive of women and understand their struggles working in such a male-dominated environment. Good supervisors are supportive of women in the workplace "either by tolerating them and treating them the same as men or by welcoming them and encouraging them to participate."[36] The last several decades have resulted in rapid changes in the industry: an exponential growth of shops, technical developments in ink and machines, artistic development of designs, an increase of college art degrees, a dramatic increase of women working in the industry, and tattoo collecting becoming mainstream.

Tattoo Conventions

Another development in the tattoo industry during the last several decades has been the proliferation of tattoo conventions. Before 1976, there was no discernable "tattoo community," outside of a particular shop.[37] Tattooists guarded their secrets and were cutthroat toward possible competition. The very first gathering of tattooists was organized by Eddie Funk at the National Tattoo Club of the World in 1974, the precursor to the National Tattoo Association.[38] Old-timers like Eddie Funk and his colleagues Lyle Tuttle and Bowery Stan still make the rounds at the tattoo conventions, well into their eighties, socializing and taking

pictures with the new generations of tattooists and collectors. These old-timers do not tattoo anymore, except for Lyle Tuttle, who will routinely tattoo one lucky person a day with his signature at conventions, but these men provide the life of the party with their hard-drinking and storytelling ways. They bring the history to conventions, a world where it seems that history is fast disappearing with each wave of new artists on the convention floor. By the early 1980s, tattoo conventions were being organized by big-hitter tattooists like Ed Hardy.[39] Sofia Estrella's first convention was in 1982 on the RMS *Queen Mary*, moored at Long Beach, California:

> National Tattoo put on the convention. I met everybody I never imagined. The women who stood out in my mind, granted it was thirty years ago, were SuzAnne Fauser and her friend Diane Mansfield, Pat Sinatra, Patty Kelley, Debbie Lenz, Kandi Everett, and Peaches from Florida. There just were not that many women tattoo artists at that time. The men included Ed Hardy, Henry Goldfield, Greg Irons, Philadelphia Eddie, Lyle Tuttle, Cliff Raven, Horiyoshi. It was the first time I had ever seen all those Japanese body suits exposed. That's where I met Jonathan Shaw, who I ended up working for in NYC, for about a year. I went with Paul Rogers, so for the first time, I was exposed with him, and he was such a big figure, which people thought I was somebody. But in fact, I wasn't anybody, until after that convention, which changed my life and my way of thinking in the tattoo world. I saw possibilities, travel, money, a different kind of glamour and fame. There had been a few tattoo conventions before this, but as far as I am concerned, this was one of the first international tattoo conventions where everybody that was anybody showed up. It was huge. Ironically, there was also a dermatologists' convention at the same time on the ship, so those were very interesting conversations to say the least. What a mix.

In this passage, Sofia Estrella demonstrates the importance of conventions for aspiring tattooists. This was one of the first significant conventions, and she was able to attend at the beginning of her career, when she was still an apprentice, with her husband-to-be, Paul Rogers. Because she was able to come under the wing of Rogers, a well-established artist,

Figure 5.2. Sofia Estrella is a veteran tattoo artist, working out of her studio in St. Augustine, Florida. She is working on the author.

she was given respect that she felt she had not yet earned as an artist in her own right. But this connection at a public convention gave her career a boost. She met Jonathan Shaw, with whom she was able to work with later in New York City as a guest artist in his shop. She was exposed to the big names in the industry and cutting-edge artwork, such as the international styles of the Japanese body suits. This exposure changed her perspective on the industry and showed her the endless possibilities of this craft.

For many of the women, going to their first conventions made a great impact on their perception of their career choice and the possibilities before them. This was the case for mother-and-daughter tattooists Constance Eller and Charissa Vaunderbroad:

> CONSTANCE ELLER: Well, at my first tattoo convention in Kansas City, I was realizing at that point that I really knew what I was doing. Collecting together with other tattoo artists and realizing what a great brother- and sisterhood we have was significant. It doesn't mean you love all your family [laughter], but you acknowledge they're there.

CHARISSA VAUNDERBROAD: When I was seventeen I was able to attend my first tattoo convention in Houston. I think it was Tattoo Rendezvous and there were phenomenal artists. There was Little Vinnie Myers, Guy Aitchison, Wynonna, and Patty Kelley. There are all of these tattoo artists that I never got to see before. And so they come by my booth. They were fascinated with the tattooer teenager. And they would be like, "Oh how cute. She's not wiping away, so we can't see. Wipe it, wipe it." It was really nerve-racking because I couldn't really justify my art at that point. And so I sat with a lot of them and asked questions. They would show me how to draw things, and we passed the piece of paper back and forth. That's how I learned most, in this dialogue with other artists at conventions.

Tattoo conventions are important in the industry for artists to network, see new developments in the industry, and work on new clients otherwise inaccessible geographically. It also provides exposure to work by other artists as well as opportunities to be featured in tattoo magazines. For women, this exposure is especially significant.[40] Whereas, for Sofia Estrella, attending the early tattoo convention with her partner Paul Rogers gave her a boost of credibility with other well-known artists, for other tattoo artist wives, they may fade into the background and not gain such exposure. Maytee Bringas apprenticed as a tattooist with her husband, Phat Joe, and at conventions, she felt she was in his shadow. Later on, when she was able to network with other women artists in the industry, she began to feel more included in the community:

When I was an apprentice, I didn't know much, I was just learning. When I would go to conventions with my husband, he would stand there and speak with all these tattoo artists. All these guys have all this experience under their belt, and they start talking about tattoos. I felt like I'm just in the background, quiet. I was just listening and learning. And now you can talk to other women tattoo artists and feel you have the knowledge. Yes, at conventions, I see many women and, like I said, I love it 'cause you don't feel left out.

At regular tattoo conventions, women continue to be a minority. By looking at people behind the booth, one cannot tell if they are tattoo

artists, piercers, shop assistants, lovers, or friends hanging out. But women at conventions are indeed a minority of artists and may have difficulty finding each other or creating a space for community. The veteran tattooist Deana Lippens, with thirty-two years of experience, created her own tattoo convention for women artists called Marked for Life, which takes place each January in Orlando, Florida.[41] Participants had attended other tattoo conventions, but Marked for Life held a special place in their heart, and their schedules, as they returned each year to see their friends, old and new. Deana Lippens single-handedly organizes Marked for Life each year; therefore, the artists represent both her personal acquaintances in the industry as well as up-and-coming new artists who she has discovered and invited to attend. Sofia Estrella has been attending the convention since its inception, as her shop is located just a few hours from Orlando:

> We are at a women's convention. This convention was established about thirteen years ago. I've known Deana for about twenty years, well, my whole career, pretty much. I think I met her on the *Queen Mary*. She put this together so women could get recognized, join together, and learn some things because it was hard to learn things back in the day. We all are very busy these days trying to run our businesses and our family. We don't get out much to see each other, except once a year, so for us, it has become a social event. It's about getting out, meeting some sisters, seeing what's going on, what everybody's doing. Good luck to Deana and to what she's been doing. And I hope she can continue to do it. I've been supporting it a long time. Meeting women, old and new women that I've seen around at different shows that I have never got the chance to say hello to because they're so many people. This is a more intimate show. It's nice and the ladies are all wonderful, wonderful sweet loving ladies.

Besides the opportunity to network with other artists, both men and women, and to keep updated on new developments in the industry, the convention circuit provides other opportunities as well. Artists are often elite tattoo collectors themselves—collecting ink from artists they admire, mentors, and friends during this time together. Maytee Bringas

attended her local South Florida Tattoo Expo and was excited to get a chest piece by her idol, Josh Ford. She explains, "He's the one that did my hand tattoo. He also did the other side of my neck. So he is someone I really respect and admire." For such visible tattoos, artists often seek out those with the best skills in the industry. It is common to see artists receiving ink when they take a break from tattooing their own clients. If they are unable to schedule a session on the convention floor, they often party at night in hotel rooms, tattooing each other and drinking in a more relaxed space. This aspect of convention life is not officially sanctioned, but it is underground and tolerated. Just as "scratchers" are disparaged in the industry, so is tattooing out of one's home, hotel room, or at a tattoo party. However, tattoo artists themselves occasionally participate in this behavior and differentiate themselves from "scratchers" by noting that they are professionals who continue to observe cross-contamination prevention in whatever space they inhabit.

Tattooists often attend their local tattoo conventions because it is easier than attending national conventions, without the air travel and expense, and they have their local customer base to call upon. They can also take this opportunity to visit local tattooist acquaintances that they otherwise do not see, even when living in the same area. As Sofia mentioned, artists are caught up in their own life and do not often visit other area tattooists. But local conventions provide an opportunity for them to come together. However, tattooists are probably most excited about the opportunity to travel far and wide while practicing their craft, as Sofia has:

> I love Mexico. I love Europe. I will be in Iceland next month. New Zealand, I love New Zealand. Spain, Morocco. It doesn't matter. I love them all. I love all the places I go.

Sofia spent years commuting between her own shop in St. Augustine, Florida, and a guest spot at a shop in Reykjavik, Iceland. At the height of her commuting, she would travel every month or two between Iceland and Florida. She has since established a residence in Ecuador and continues to own and operate her shop in Florida. To assist her, she has brought her son on board to manage the shop. Tattoo studios sometimes

become family businesses. The veteran tattooist Patty Kelley from California has also enjoyed her share of traveling the world:

> Tattooing brings me all kinds of fun stuff. Travel has been my favorite. I wish I could do it more often. You know, that's what I really love about tattooing. And I didn't before, until I got divorced, because he never liked to travel. All of a sudden, the world opened up. My first trip to Europe was to Amsterdam and Moscow. The last trip I made was to Saipan. And the trip before that was to Cambodia and Borneo. This is all tattoo related. Ahh, the travel is what I'm really taken with. It's a great job. See the world. And tattoo it [laughter].

Besides traveling to conventions around the globe, tattooists often feature each other through "guest spots" in their studios. These guests may be acquaintances, friends, mentors, or artists that they want to get to know better. Guest spots allow an artist to work out of someone else's studio for an undefined amount of time. Some artists may schedule a series of guest spots in various places and spend a certain amount of time simply traveling around. Some artists may make this a way of life, without having a shop out of which they work exclusively. Reflecting on her long career in tattooing, Vyvyn Lazonga talked about her favorite memories of working out of other well-known women's shops while establishing stronger friendships with them:

> And women that I worked with . . . I worked at SuzAnne Fauser's shop once, when she went on vacation. That was pretty cool. And I worked with Julie Moon in the early nineties, a little bit. We kind of palled around and stuff for quite a while. That was fun.

Tattoo conventions provide the face-to-face professional exposure for artists in the industry, be they old-timers or new to the industry. They also provide an event for the media to cover, and it brings more public attention to the industry. At conventions, news stations often report on the event to the local community. But it also provides a place for tattoo magazines to collect stories and images of tattoo artwork, artists, and other featured events. It is often at tattoo conventions that tattooists

have the opportunity to have their artwork published or their personal tattoo collections photographed.

Tattoo Magazines

Tattooists were isolated from one another before the advent of conventions and tattoo magazines, which first began to emerge in the 1970s. Tattooing was still underground and marginal, and artists were self-taught and unwilling to train outsiders in their craft for fear that they would become tomorrow's competition. The artistic nature of tattooing in the early days was primitive, beginning with few colors, crude stencil tracings, and minimal talent. Only in the last three to four decades has the artistic abilities of tattooists grown exponentially with the advent of new inks, machines, styles, and professionally trained artists. In the 1970s, there was only one tattoo shop in any given city, and artists did not have a sense of their rival artists, except to know that they were few and far between. They would hear about each other from mutual clients, often while working with a client while covering up another artist's inferior design with their own design. But by the end of the 1970s, artists started developing a fledgling community through conventions and magazines.

Tattoo Magazine was one of the first tattoo magazines, established in 1984 and purchased by Paisano Publications in 1987. Paisano itself was established in 1970 and published motorcycle lifestyle magazines like *Easy Rider*. That is where Constance Eller first saw her future mentor:

> SuzAnne Fauser, she was the first female tattooist I saw a picture of in *Easy Rider Magazine*. She was doing a tattoo, and I thought, "Ah there she is! She's just like me." So we found out that we were very similar. And we were sisters, as well as Pat Sinatra and Patty Kelley. They have always kind of been some of my heroes that I would see from a far. I knew we had a sisterhood going.

Considering the connection between tattooists and bikers in the 1970s and 1980s, it was a natural development for Paisano Publications to branch out into tattoo magazines, with *Tattoo: Savage* and *Tattoo:*

Flash, both established in 1993. Another company, Art & Ink Publications, publishes both biker and tattoo magazines as well: *Outlaw Biker Magazine, Tabu Tattoo* combining tattoos and nudity in classic pinup style, and four other tattoo magazines, *Skin Art, Tattoo Revue, Tattoos for Women,* and *Tattoos for Men.* In 2000, *Prick Magazine* hit the scene, with its newsprint style, offered free to readers, and paid for by advertisements. In 2004, the more high-end *Inked Magazine* came on the scene as well. And while most of the magazines are very much focused on White people, *Urban Ink Magazine* presents itself as the only magazine for people of color.

All of these tattoo magazines have a similar formula. They feature articles on tattoo artists, presenting their artwork, location, and history in the industry. Articles feature major tattoo conventions and pictures from the events. And of course, the bulk of the magazines are filled with pictures of tattoos. Advertisements run throughout the magazine, selling tattoo-related products. In the back of some magazines there are classified ads for sexual services and tattoo machines for sale. Many tattooists are opposed to magazines selling machines, as that encourages "scratchers" over professional artists (who either build their own machines or buy from reputable dealers that sell only to professional tattooists). For example, on the Fallen King Irons website (www.fkirons.com), they clearly state, "All sales to professional artists only. For tattoo kits please click here." The link sends viewers to *ToysRUs* (www.toysrus.com). Tattoo kits are cheap packages of machines, needles, inks, and other accessories that a novice would purchase to get started in the craft—very much frowned upon by professionals. Overwhelmingly, women are featured on the cover of the magazines as scantily clad sex objects, with the focus on their bodies and large breasts, even more than on their tattoo art. Often, women appear without shirts, covering their breasts with their hands, even when they do not have visible ink on their torsos. The magazines uphold traditional gender stereotypes: men are active, serious tattooists, while women are sexual decoration—even when they are presented in articles as tattooists themselves. The presentation of men and women artists is vastly different, with the women often unclothed in ways that men are never represented. For the women artists I interviewed, this presents a double-edged sword. While their gender and

sexuality might provide them with more access to magazine coverage, their image may be more sexualized than serious.

Miss Blue had artwork featured in a magazine early on in her career:

> I did a couple of pieces, submitted them to a tattoo contest, and won awards. I was fresh out of my apprenticeship. And then a picture of those tattoos actually ended up in a tattoo magazine, which was awesome. Then at this convention, Marked for Life, last year, I got my picture in a tattoo magazine. It isn't my work, but it's my face so, that was nice too.

Being featured in tattoo magazines is something that the artists valued, often displaying the media coverage prominently in their shops, in their portfolio, or framed on the wall, as Maytee Bringas did with her featured cover page. She states:

> I was on the cover of *Prick Magazine*. My friend knows one of the editors of the magazine, and I have a photographer friend who took some pictures of me a while back. . . . I thought it was a good idea to promote her pictures and the shop. And I thought it would be fun. So we submitted the pictures. They did an interview with me.

Vyvyn Lazonga, an artist who has earned her reputation as an old-timer in the industry, has been featured many times in tattoo magazines. But now she writes her own column for *Skin & Ink Magazine*, "to inform and educate the public." Magazines and conventions provide networking opportunities and exposure for tattooists' artwork, which can increase their prominence in the industry as well as their bottom line. For many of the women working in the industry, finding other "sisters" in magazines is one way in which they have fought against their isolation and found friendships with like-minded others.

Conclusion

Women tattoo artists have faced occupational stigma: rejection from tattoo-shop owners for apprenticeships, rejection from clients who do not want to be "tattooed by a girl," and invisibility in the representation

of the profession. Similar to women in other non-traditional professions, women face both barriers and opportunities as they enter such professions. The literature on women in blue-collar industries, which focuses on individual professions, can provide insight into the various ways women encounter obstacles in their professions. But women working in the tattoo industry have not been examined within this body of literature. The experiences of women included in this chapter can provide insight into the larger realm of women and non-traditional employment. While women do not yet have equal numbers in this industry, their impact within it has been striking in just the last several decades.

The majority of study participants entered the business through their husbands or boyfriends who were already established as artists. These relationships provided them with some shelter from discrimination and harassment from other artists as well as clients. Others entered the profession through the apprenticeship process, which can provide additional barriers, as individual shop owners can operate as gatekeepers. Some shop owners may be more supportive of women in the industry. Others may harass women apprentices. Supportive shop owners may provide a refuge for women. Further, the structure of apprenticeships may disadvantage women more than men, as they are either unpaid or may cost thousands of dollars, in addition to requiring a time commitment of upward of two years. However, with financially supportive partners, some women may be able to take advantage of these training opportunities. When women find themselves in the tattoo studio, many customers may assume that they are girlfriends or counter assistants. Customers may ask the women, "Is the tattoo guy around?" Many female tattooists prefer to let their artwork speak for itself in their displayed portfolios. But some artists have reported that their gender is a (negative) surprise to customers who expect a man to perform the work. Other clients, however, prefer women tattoo artists because they are more comfortable working with them. Many participants in this chapter have been working in the industry for over three decades. Those who entered the profession in the 1970s and 1980s reported more harassment in their early careers than those who entered the profession in the 1990s or the 2000s. This demonstrates not only an increased tolerance but also a growing desire for women to hold a significant position in the industry.

6

Tattoos Are Not for Touching

Public Space, Stigma, and Social Sanctions

Social Interaction around Tattooing

Ever since I acquired visible tattoos on my arms, they have attracted public attention. This situation is often of significant import to my daily life, as it dictates what I wear and whether or not my tattoos are covered. A sweater is always at hand, in case of an emergency need to cover up. I actually shun "tattoo attention," as I am more introverted in general, whereas other tattooed people may be more open to the experience. While I love the aesthetics of sleeve tattoos, I do not love the attention that public ink provokes. This is difficult to understand for non-tattooed individuals, who assume that ink is acquired specifically for the attention or, at least, that those brandishing public ink can hardly rebuff the attention—after all, it is their fault for wearing tattoos.

When I asked study participants about reactions from strangers on the street about their tattoos, they explode with their responses: "Yes! People come up and touch my tattoos on the street all the time! And I hate it!" While they definitely had anticipated some response, the level of attention they received from strangers, many of whom would actually reach out and grab them, was unexpected. While family members' responses could be anticipated and postponed through covering, it was not until the women bared their tattoos in public that they encountered the reactions from strangers that would be a staple of their public life forevermore—unless they covered them. This chapter presents the experiences of heavily tattooed women as they interact with strangers in regard to their tattoo collections. It is understandable that publicly visible tattoos can elicit attention; however, none of the participants expected the extent, or the nature, of the attention received. Their encounters in public spaces share common themes that are explored in this chapter.

Erving Goffman's studies provide a foundation for understanding the "ritual" of public behavior, in both its socially appropriate and inappropriate outcomes. In *Interaction Ritual*, Goffman centralizes the importance of "one's face" as a

> sacred thing, and the expressive order required to sustain it is therefore a ritual one. The sequence of acts set in motion by an acknowledged threat to face, and terminating in the re-establishment of ritual equilibrium, I shall call an *interchange*.[1]

This threat to face, ultimately, provides the conflict that the tattooed women enact when they encounter strangers who have a response to their tattoos that breaks through the wall of "tactful inattention." In *The Presentation of Self in Everyday Life*, Goffman states that the central idea behind social etiquette is that, "when in a public place, one is supposed to keep one's nose out of other people's activity and go about one's own business."[2] Somehow, having visible tattoos interrupts this civil inattention, as Goffman dubs it, and people make contact with the tattooed women. From the women's perspective, they hope that their tattoos produce the least amount of social ripples in public places. Even though their self-expression may be unusual, they still hope to be treated in a way that is respectful. While many of Goffman's books overview the etiquette of microsocial interactions of daily life, he also observes that "we could learn about the structure of focused gatherings by examining what happens when their orderliness breaks down."[3] After a breakdown of the social etiquette within a given situation, there is an encounter that can lead either to a ritualized forgiveness of the slip, engaging further ritualistic behavior from both parties, or to continued behavior that can further the offensive interaction—which ultimately is a symbolic engagement expressing the worthiness of one's face, that is, that one's honor has been soiled publicly.[4]

Tattoos express personality, interests, or desires—in short, individuality. However, Goffman points out that "the way in which he [*sic*] can give the least amount of information about himself—is to fit in and act as persons of his kind are expected to act."[5] Visibly tattooed individuals must navigate this space between appearing bland enough to blend into their social surroundings and having their stylistic presentation

draw excessive attention to themselves. Goffman notes in *Behavior in Public Places* that "staring is widely used as a means of negative sanction, socially controlling all kinds of improper public conduct."[6] Tattoos attract staring. Staring can express a variety of intentions, from appreciation for the inked artwork, surprised/non-belief ("Are those real?"), to hostility, outrage, even disgust. Staring is the first level of behavior that may differentiate a tattooed individual from others: "the glance, look, penetration of the eyes."[7] From there, words may follow that may or may not be directed toward the object of attention. For example, strangers may start talking about tattoos to their companions within earshot of their tattooed object of attention. Or one may address the tattooed individual directly with a comment. Comments may express a variety of opinions, from enjoyment to disagreement. Finally, the most socially breaching behavior a stranger can make is that of physical contact: "the body, including the hands, as something that can touch and through this defile the sheath or possessions of another."[8]

These breaches of social etiquette and sanctioning behaviors directed toward tattooed individuals points to the continuing—albeit lessening—stigma associated with visual tattoos (especially on women).[9] Joanna Frueh observes that "modifications of the body modify a person's relation to society and her place within it."[10] Angus Vail agrees, saying that, "in short, their tattoos have profound effects on their interactions with intimates and non-intimates alike."[11] Becoming heavily tattooed for many participants marks the transition from blending in socially to standing out visually, and in some cases, extremely so, to the point of being treated as if one had a stigmatized identity. Goffman has also chronicled these social interactions in *Stigma*:

> When normals and stigmatized do in fact enter one another's immediate presence, especially when they there attempt to sustain a joint conversational encounter . . . in many cases, these moments will be the ones when the causes and effects of stigma must be directly confronted by both sides.[12]

First, in this interaction, is the "emotional double bind" upon the perceivers, about whether they should acknowledge the difference or ignore it.[13] For the "stigmatized" individuals, they may feel as if they are

"on" and managing their conveyed public impression. While a stranger may breach public behavior etiquette, the burden of the interaction and the potential of reinforcing stereotypes of tattooed people as anti-social weighs on the response of the tattooed person within the interaction. Goffman sums it up in this manner:

> In general, then, when a rule of conduct is broken, two individuals run the risk of becoming discredited; one with an obligation, who should have governed himself by the rule; the other with an expectation, who should have been treated in a particular way because of this governance. A bit of the definition of both actor and recipient is threatened, as is to a lesser degree the community that contains them both.[14]

Both participants in the interaction ritual have a role to play in order to escalate, or de-escalate, the interaction and save face for the members involved. Tattooed individuals feel that their "face" has been disrespected, and they aim to right this situation by regaining their status:

> Further, within limits the person has a right to forgive other participants for affronts to his sacred image. He can forbearantly overlook minor slurs upon his face, and in regard to somewhat greater injuries he is the one person who is in a position to accept apologies on behalf of his sacred self.[15]

Of course, Goffman also recognizes that offended parties may walk off in a huff, thus expressing that they have been wrongly offended and the other party has transgressed the social rules governing the interaction. Goffman also tempers the volatile interaction by explaining that offenders may simply not know any better and that they should be coaxed within the interaction to understand and behave better:

> Normals really mean no harm; when they do [cause harm], it is because they don't know better. They should therefore be tactfully helped to act nicely. Slights, snubs, and untactful remarks should not be answered in kind. Either no notice should be taken or the stigmatized individual should make an effort at sympathetic re-education of the normal, showing him, point for point, quietly, and with delicacy, that in spite

of appearances the stigmatized individual is, underneath it all, a fully-human being.[16]

Ultimately, Goffman admits that this blaming of the stigmatized for the negative social treatment they receive implies that they are overtly approachable by strangers. For heavily tattooed women, they eventually incorporate these social interactions into their daily rituals and understand them as part of their relationship to strangers. These social interactions become a shared commonality between visibly tattooed people, something that can be reinterpreted as a bonding experience between the tattooed.

Elite Tattoo Collectors and (Sub)cultural Capital

When tattooed people encounter each other on the street and have an interaction over their tattoos, the interaction is different. Generally, when non-tattooed strangers approach someone because of their tattoos, they are "othering" the individual in a negative or positive manner; that is, they are making a distinction between them. The stranger is often asking a question from an unknowing position (e.g., "Did that hurt?"). When two tattooed people interact over their similarity, they are often sharing their mutual subcultural membership. As with all subcultures, distinctions and hierarchies are demonstrated through conversation and subcultural knowledge. While having merely one tattoo brings one into the tattoo membership club, "elite tattoo collectors" distinguish their subcultural membership through their extensive, high-quality tattoo work—which often includes iconic classic imagery such as skulls, snakes, flames, and Japanese designs—as well as through their knowledge of high-end tattoo artists.[17] Such interactions may be based on demonstrating one's knowledge of a particular tattoo style or artist. They may also relate to each other based on stories of common treatment of themselves by the non-tattooed (e.g., "Have you told your mom?"). However, if two interacting tattooed people are on different hierarchical levels within the tattoo subculture, they may have a disconnect in their conversation, similar to that between the non-tattooed and tattooed. For example, if one is heavily tattooed and one is "lightly tattooed," there may be some subcultural posturing based on

the differential statuses of extensive coverage, quality of work, or design. Style is one of the most conspicuous ways to symbolize membership in a particular subculture. Besides membership in a "tattoo subculture," in general, one may also be a member of another overlapping subculture that is also heavily tattooed: punks, hipsters, military members, athletes, hip-hop fans, and so on.[18]

Pierre Bourdieu's concepts of habitus, distinction, and cultural capital can assist in understanding the public social interactions regarding tattoos. "Habitus" is our social context, our culture, subculture, the structures in which we are produced as social beings, the underlying framework guiding our logics, perceptions, actions, and, importantly, the limits to our comprehension.[19] Yet there are multiple habitus in which we are emerged: the larger national/cultural mainstream environment that has a mixed reaction to tattoos based upon a collage of popular culture references from music, television, and sports, as well as the subcultural habitus, in which the subcultural knowledge of tattoo culture offers one prestige and distinction. An object or action is not enough to definitively define one's status or class ranking; context matters. Bourdieu points out that, "for instance, the same behavior or even the same good can appear distinguished to one person, pretentious to someone else, and cheap or showy to yet another."[20] This statement is relevant to the complicated socially positioning of elite or extensive tattoo collectors because, while tattoos have been associated with the working class and some outlaw cultures, in contemporary American culture, tattoos are more prevalent within all classes and provide their own distinction between high- and low-quality work.

In *Distinction*, Bourdieu demonstrates how one's taste (in music, for example) "affirms one's 'class,' nothing more infallibly classifies."[21] Furthermore, "in matters of taste, . . . all determination is negation; and tastes are perhaps first and foremost distastes, disgust provoked by horror or visceral intolerance (sick-making) of the tastes of others."[22] This intolerance provides opportunities for one to "assert one's position in social space, as a rank to be upheld."[23] Visibly tattooed individuals often encounter this intolerance in public places; this "asserting one's position" or taste, demonstrating one's distinction within the social hierarchy by one's "aesthetic intolerance [which] can be terribly violent."[24] Bourdieu defines this distinction-making process as based on social

class; the "petit-bourgeois . . . defines itself against the 'aesthetic' of the working classes, refusing their favorite subjects."[25] With the rise and establishment of tattoo culture, the distinction shifts from the association of tattooing with the working class, toward the distinction between high-end and low-end tattoo artwork (for those in the subcultural habitus). Elite tattoo collectors differentiate their collection against those from "scratchers" (non-professional artists practicing out of their residence) or cheap street shops. Yet however much elite collectors attempt to reframe their collection as high-end art, others will mark them as deviant for being tattooed at all.

Moral Entrepreneurs Enforce Social Sanctions

Howard Becker coined the term "moral entrepreneur," meaning an individual or organization that takes it upon itself to publicly enforce a social rule by bringing the infraction to the attention of others.[26] This is similar to, but different from, Bourdieu's "aesthetically intolerant" classes reinforcing their distinctive petit bourgeois tastes. Both work to reinforce social norms against excessive tattoo art—for the aesthetically intolerant, they represent bad taste; for moral entrepreneurs, they represent deviant behavior. Moral entrepreneurs reinforce stereotypes against tattooed people, which are diminishing in general. And, of course, they blame the tattooed individual for provoking the sanctions instead of recognizing their sanctioning behavior as socially inappropriate. "Something ought to be done about the deviant," Stuart Hills writes in *Demystifying Social Deviance*, "exterminate, punish, harass, humiliate, cure, convert, or segregate him."[27] For women, they are embodying more than bad taste or historical deviance—they are transgressing gender norms of appropriate feminine behavior. This becomes part of the social sanctioning behavior for tattooed women—moral entrepreneurs who shame their lack of femininity.

Violating Gender Norms

Gender is performative, and tattooing plays into this performance.[28] Tattoos can accentuate femininity by being small, cute, and hidden, made of feminine, colorful designs that act as an accessory. Tattoos can

also be unfeminine and mark one as "ugly," which is a common response that heavily tattooed women receive. Choosing to be "ugly," as it is perceived, is one of the biggest gender crimes women can commit. Thus they provoke social sanctions from moral entrepreneurs that are often tainted with an insult against not only the tattooing but also the social crime of transgressing gender norms. Bourdieu describes how "middle class women are disposed to sacrifice much time and efforts to achieve the sense of meeting the social norms of self-presentation which is the precondition of forgetting oneself and one's body for others."[29] Indeed, tattooing can represent a self-focus that is unbecoming for women, as they are supposed to be other focused in their presentation. This is another underlying accusation from the moral entrepreneurs. Other studies have found that women receive specifically gender-oriented sanctions when they become heavily tattooed. For example, Daina Hawkes et al. conducted a study on the perception of heavily tattooed women and found that "it appears that women still take some social risks when they decide to acquire either a large or a visible tattoo."[30] Katherine Irwin also found that women received negative treatment for being heavily tattooed:

> Women find themselves the recipients of a different brand of ill treatment than men. Wearing many large tattoos is an extreme violation of conventional female beauty norms. For breaking these norms, female collectors and artists are sometimes accused of being "masculine," "ugly" or "slutty."[31]

This sanctioning behavior kept women from collecting larger, more visible pieces until the 1980s and 1990s, when tattooing became more acceptable. Two veteran tattooists described this transition. Debbie Lenz stated that

> with female clients in the past, they wanted to get a tattoo that was hidden. Maybe you could see it in their bikini, if it was on their lower stomach. I remember some of the first females that I tattooed with large pieces. I was so excited, "Oh my God!" I cannot believe that they are getting something that they were actually going to show. Nowadays, there are very few girls that get tattoos that are really small. They're talking

about rib pieces, full back pieces, or sleeves. They see that I have full sleeves, and they're like, "That's what I'm going to look like someday."

Cindy Leal had a similar experience during her long career as a tattooist:

As time went by, I started getting more women who wanted to get a big tattoo on their arm. I used to turn down a lot of women who wanted arm work, because I thought it would make them look like big truck drivers, or a little too masculine. I turned down some work because I didn't think that the woman was emotionally bold enough to carry arm tattoos. But now it's common. I have no problem at all now, if a woman comes in and she wants an anchor and a panther on her arm, I'll do it because it's more accepted now.

In the tattooing industry, it is common for tattooists to warn clients about tattoo designs that may elicit negative attention. While it may seem surprising that female tattooists actually turned down female clients because they wanted visible tattoos, we can appreciate that, in the 1970s and 1980s, few women sported extensive ink. The participants in this study still feel a gender stigma associated with their tattoo collections that they assume would not be applied to their male counterparts. Three participants from Washington State, a heavily tattooed region of the country, still received negative social sanctions with a particular gender bias. Dara Harvey stated:

There is a gender difference. If a man was heavily tattooed man, it's thought that he's got bravado, he's strong, and he can withstand a lot of pain. He's cool. And then from my point of view, being a woman that is heavily tattooed, people will be like, "Oh, there's something wrong with her. She's lost all her marbles." Because, why would she do that to her beautiful body?

Greta Purcell had a similar response:

I don't think that any of the people who have said something to me would say anything to a man with a tattoo. But with me, they feel that they can

ask me questions, look at it, and even touch me. Somehow, it's an invitation, and I don't think people do that to men as much.

Women's bodies are also considered more public: open to critique, touch, and sexual objectification. Sierra Furtwangler expressed that people seem to forget rules of personal space and respectability when presented with the heavily tattooed woman:

> Yeah, actually I have strangers ask me if they can see under my clothes fairly often. I don't think they would say that to me if I were a man. It is because there is still this stigma that, if you're a heavily tattooed woman, you're a whore.

As for moral entrepreneurs, they justify their behavior because they are attempting to save someone. The heavily tattooed woman is put in the position of upholding the order of public behavior. Some of the extreme reactions that the participants provoke borders on harassment.

Public Harassment

Women already face sexual objectification and harassment in public; it is behavior that is familiar and usually evokes an already-programed response,[32] which is often to ignore the harassment and seethe on the inside, feeling insulted and disempowered. For heavily tattooed women, getting negative attention for their body modification in particular is just an additional layer of gendered harassment to which they have already become accustomed. Women are more valued than men for their appearance, which becomes a public commodity open for comment. Modified women often receive the criticism like "You're such a pretty girl, why would you do that to yourself?" This comment reflects the essence of public harassment for heavily tattooed women: They are deviant in their gender presentation, and this transgression justifies public comment. Hawkes et al. found that "people with the lowest level of support for feminism were those who have the most negative views of women with tattoos," and they are, perhaps, the ones most likely to publicly criticize women.[33] In Lauraine Leblanc's study of adolescent punk

girls, she found that gendered public harassment was commonplace for her participants. It ranged in severity from obtrusive gazing to physical assault and included a good deal of verbal harassment.[34] The treatment these adolescent girls described was very similar to that of the participants in this study. Sharon Cafeo described how the negative treatment she received has lessened over the fifteen years that she has been modified, but that it is still quite severe:

> Publicly, it's more accepted now, but fifteen years ago, being a female having a tattoo was really bad. Growing up as a teenager, having tattoos was bad. Then I got older and I had a son. I take him to school and he would get treated very badly, because I was tattooed. People would pull their kids away from me in grocery stores. In the past four years it's not that bad. But I still get dirty looks, or get people talking about me, in my face. People are rude, really rude.

Ultimately, tattooed people understood that their visible tattoos would receive attention, but none of them expected the extent of it.

Stares, Grimaces, and Other Facial Expressions

Sociologist Shannon Bell says it is a myth that "people who have tattoos get them for the viewers or for the 'outside gaze,' that tattoos are some sort of personal advertisement."[35] Overwhelmingly, heavily tattooed women start their collection in spite of the attention they begin to receive, not in order to receive it. Many of the participants had fallen in love with tattooing as a form of self-expression for a myriad of reasons, none of them being to attract attention. Yet often they wanted to distinguish themselves from a normative self-presentation. And positive attention was accepted gratefully, especially from other tattoo collectors.

Tattooed people attract stares: some out of curiosity and interest, and some out of distaste. "Staring," Goffman reminds us, "is widely used as a means of negative sanction, socially controlling all kinds of improper public conduct."[36] Staring can express a variety of responses, from negativity to curiosity, and tattooed people receive them all. Tara Alton writes, "I was tired of the stares from little old ladies at the

supermarket who thought I was a criminal, a biker chick, or just plain insane."[37] The grocery store is a popular place for participants to report attracting stares. "When I got it I didn't expect old ladies would glare at me in the grocery store."[38] Jennifer Wilder recalls being stared at in the grocery store:

> When I'm out with my grandmother, she's eighty-four, and when we go grocery shopping, she doesn't understand why everyone is staring. She knows me, so this is normal to her. But she notices other peoples' reactions. I have to remind her, "I'm a heavily tattooed female, Grandma, and they don't see that in these parts."

When heavily tattooed women hang out in public with their other heavily tattooed girlfriends, the attention is exponential. That was the experience of Elisa Melendez:

> We were walking through the mall. Just walking our merry way, the three of us in a row, oblivious. My friend turns to us and says, "Can you believe how many people are looking at us?" It's a new awareness about how much attention this stuff actually gets from people.

The adolescent punk girls in Lauraine Leblanc's study reported some of the more extreme cases of visual harassment. This included unwanted photography. "Many punks undergo this at least once in their subcultural career, so much so that it is one of the common experiences which punks discuss among themselves."[39] Kristen Wall reported being photographed extensively at a car show because people assumed she was an alternative model:

> I went to a car show two weeks ago. I was dressed up really nice, curled my hair and everything. People thought I was a car model, just because I have these tattoos. I was walking around checking out cars. And I got stopped and everyone wanted to take a picture with me. They were like, "I want to take a picture with you." I was like, "I am not a model." But in the end, I still did it. I had fun. It gets a lot of attention. And I am an attention freak, so I can't really complain, because it comes with the territory.

After hearing so many stories of being stared at in public, I asked the participants how they respond to the attention. While Kristen Wall claims to be an attention freak, few of the other participants described themselves in such terms. Many had slowly developed a repertoire of responses, which often matched the hostility and manner of the questioner. Others were consciously polite, so as not to reinforce stereotypes about their character. For most, the situation was awkward, offensive, and unexpected. Goffman found that stigmatized individuals would often come up with story routines to address the common questions they would encounter in public. For example, "A one-legged girl, prone to many inquiries by strangers concerning her loss, developed a game she called 'Ham and Legs' in which the play was to answer an inquiry with a dramatically presented preposterous explanation."[40] She would create outrageous stories of accidents (war or motorcycle accidents) and adventure, each more grandiose than the last, in order to mock such questioning. In Samantha Holland's study of alternative-style older women, she found that some of her participants stared back, in an effort to demonstrate the rudeness of the behavior: "Staring back is not a traditionally feminine response and, while it may not be meant as 'defensive,' neither is it submissive."[41]

"Hey! Here's What I Think of Your Tattoos"

Pierre Bourdieu describes how evaluative comments are the way in which the petit bourgeois position themselves above—and against—those of the "vulgar" classes. He writes, "These refusals, almost always expressed in the mode of distaste, are often accompanied by pitying or indignant remarks about the corresponding tastes. ('I can't understand how anyone can like that!')"[42] This reaction describes the interactions that tattooed people often receive about their appearance from strangers. In this section, I explore the comments that heavily tattooed women recall receiving—both negative as well as positive—and the responses they have developed.

The responses that people get from strangers on the street are somewhat different from those received from family, friends, and co-workers, which are placed within a familiar context and fit within an ongoing relationship. Strangers can hide behind their anonymity and,

therefore, say harsh things without the ongoing social repercussions within relationships. For the recipient, however, these comments are hurtful, mean-spirited, and show a dark side of the public. Indeed, these experiences reflect Bourdieu's concept of "symbolic violence," in which the social-sanctioning significance of the interaction can cause more psychic harm to the recipient than a physical assault.[43] Sharon Cafeo described her experiences in Texas:

> I've had people tell me I was going to hell, that I am the devil, Satan's child. I might have my son with me, while going through the mall, and people are pulling their kids away from me. My son is trying to understand why these people are pulling their kids away and pointing and staring at his mother. I mean, it's pretty awful. I really can't even put my finger on it. But you know it's only made me a stronger person, throughout all of it.

Geographical location is also a significant factor affecting the type and amount of comments received. In the South, tattoos are common yet criticized, as Sharon demonstrates. In general, the West Coast is more "tattoo friendly" than the east. However, even in Long Beach, California, tattooist Kody Cushman still receives prejudicial remarks:

> I always think I have toilet paper stuck to my shoe. I forget that I'm tattooed, and I'll be walking around, and people are gasping around me, "Oh my God." Or you will hear rude verbal stuff sometimes. Do I have toilet paper stuck to my shoe or something? And then I remember, the tattoos. I forgot, because it's just part of who I am.

Debbie Lenz, the tattooist in Ohio, remembers an encounter with a stranger at the gas station:

> I was paying for my gas and he was in front of me. A little bit of my tattoo was sticking out. He had just left the register and he stood there and looked at me. "Is that tattoo on your chest?" and I said "Yeah," and he said, "Why would you do something like that?" He just shook his head and made a disgusted noise.

Tattooed people report a standard repertoire of basic questions that most strangers ask. First: "Why would you do that?" Usually followed by an example of repercussions that will follow. Rolene McClanathan describes some common questions she receives:

> I've heard: "Why do kids nowadays get that stuff on their bodies? Don't they know it last for ever?" I've had men tell me that "girls that have too many tattoos aren't pretty." You get attitude. Or people think that if you have tattoos, you must be some kind of loose woman. "Do you want to party?" You get the implication that you're easy because you have tattoos. Women don't seem to be as harsh, other than my mom. I see more curiosity from women. They wonder, "What brought you to that?" Almost like they are curious about it themselves.

Another common question is, "Did that hurt?" Followed by, "What does that mean?" Participants report receiving the same questions as each other:

> EUDORA DOE HAWKES: Some people say, "Wow that's a big tattoo." And, "Why did you get that?" Or "What is that?" Or "Why would you want that?" Girls are often times are really freaked out because it's so big. And then people wondering why I would get it. Yeah, it brings a lot of uninvited conversation into my life.

> CHARISSA VAUNDERBROAD: A lot of people will walk up to me when I'm in public and just expect me to decipher and explain my tattoos. As if they think I got them to attract attention so that I could tell people all about my self. And I didn't. They are for me. That's why I don't have any tattoos on my arms. I'm not ready to talk about my tattoos everywhere I go.

Questions about the designs are very common. As if tattoos are Rorschach inkblot tests, strangers often comment on what they perceive to be the design, or ask for an explanation, after gazing at the image for two seconds. Carmen Guadalupe, in Miami, described an encounter from the same day as our interview:

Today I went to Target and the cashier asked, "You have skulls on you?" And I reply, "Yeah." She asks, "Why are they smiling?" "I wouldn't [have] mean-looking skull on me; I want them to be happy." Everywhere I go I get comments like that. Or else: "Where did you get your tattoos at?" "They're so pretty." It is mostly positive stuff, never really big negative comments. . . . However, I think the worst was when I went to a Cuban bakery. This man walked in, and I'm standing there. He looks at me and asks, "You're such a pretty girl. Why would you make yourself so ugly with so many tattoos?" And I just laughed and I told him, "You know what, I like ugly." And the cashier said, "He's crazy, don't listen to him." She liked my tattoos. But some men are icky about it.

Such interactions remind the heavily tattooed women that they always are at risk for unsolicited comments about their appearance. Receiving such comments over and over, often on a daily basis, can create a sense of apprehension and defensiveness. While the questioner might approach a tattooed person only once every few years, the tattooed person receives a barrage of these comments, evaluative stares, and touches on a constant basis. While they may have originally gotten their tattoo to express themselves, they may learn to weigh the possibility of public reactions when selecting their daily wardrobe to reduce this occurrence.

Not all comments that tattooed women receive are negative; however, it is the negative comments that make them weary. Positive comments are taken cautiously. Sometimes positive comments are overly enthusiastic or inhibiting toward daily life, and this can be exasperating as well. Jacqueline Beach still gets reactions everywhere she goes in Seattle, albeit overwhelmingly positive comments:

Most reactions that I get are incredibly positive. Most people just automatically say how beautiful they are and ask me where I get them. And then sometimes, here in Seattle, specifically, it's actually kind of getting annoying to me, and I cover up when I go to the mall. Because otherwise every single retail person in the whole entire mall stops me, talks to me, and tells me all about the tattoos they want. And I don't get my grocery shopping done, and I can't get in and out of the mall to

pick up what I want. . . . The general public doesn't quite know tattoo etiquette yet, and that's okay. I'll deal with it. That's a minor thing to deal with.

While positive, the interactions still breech personal space. Another common reported response is for the stranger to show them a small tattoo they have. In Miami, Eilene Megias encounters both negative and positive comments about her tattoos, but each new approaching stranger makes her feel uneasy:

It really depends on the vibe. It's usually people that are kind of caught up in the enthusiasm, and they usually want to confess something, either they have a hidden tattoo or they want one. People are usually really friendly. As long as people aren't being rude and nasty, I'll talk to them as long as I have time to—for the most part.

Sometimes the responses can be extremely positive. The tattooed person is expressing herself and her interests publicly and non-verbally, which can attract others who are interested in the same topic, leading to a positive exchange about a shared passion. In Miami, Elisa Melendez collected music-themed tattoos, her biggest passion:

I remember going into the University of Miami music school, where I had band practice with my band. A lot of the music students would stop me and say, "Hey really nice tattoo, really nice." So it was a connection. There's that recognition that I know you're a musician, just like me.

All the women with visible tattoos told stories about comments from strangers, ranging from positive to negative. How did they respond to these comments, especially since they faced the same ones over and over, which would make it easy to have an arsenal of retorts? For the adolescent punk girls, Lauraine Leblanc found that the most common response from them was "to ignore or block the incident, a response I call 'the whatever strategy.'"[44] Many of the participants in this study were somewhat friendly, more so than the situation often necessitated. Kristen Wall was quite open to the attention:

Mostly everyone just wants to see them. They'll see something sticking out of your shirt. They'll run up and say, "Let me see, let me see." I don't mind. That's the whole point of getting them. I don't mind people wanting to see, whatever. No, it doesn't bother me.

Leblanc found that her participants were often sarcastic; in order to "remind harassers of common rules of etiquette governing public behavior (the impropriety of staring), these punks inverted their social positioning, placing the harasser as the deviant norm-breaker."[45] This was a common response for participants in this study as well. Sharon Cafeo described how she had used sarcastic responses in the past: "I smiled at them, sometimes I blew kisses. I wave at them and tell them it's great that they're teaching their kids intolerance." The women either matched the attitude of the questioners or took the high road, since this was a common experience for which they were prepared. They often tried to understand that questioners just did not know better and to help them be more reflexive about their behavior. With positive responses, the women would often have conversations about their tattoos with the strangers. In these situations, they could feel that they had further educated the public. Rita Martinez-Rushka viewed these experiences in a positive light:

I have people that look at my stuff and enjoy it. I get that with this arm now, since it is a devotional sleeve. People ask, "You're Hindu?" It opens that conversation up. Which in a way, for me was good, because I get to talk about my religion, what I love, my faith. And in a way, I teach people. They ask me questions and leave with that knowledge.

Goffman urges those with stigmatized identities to go easy on the questioning or rude strangers encountered in public places.[46] He therefore places the responsibility of the civility of the interaction on the offended party, the one who has grown accustomed to such interactions, who understands that the stranger is acting out of ignorance, interest, or hostility but must be assisted along on their journey of understanding, including gentle reminders on what makes up appropriate public behavior and civility. Overwhelmingly, the tattooed women are civil and understanding in their response. However, when the strangers begin

to cross further into their personal space—by physically reaching out and touching their body and tattoos—it becomes increasingly difficult to tolerate.

Tattoos Are Not for Touching

Besides stares, comments, and questions, tattooed people are often shocked to learn that strangers will come up and touch their tattoos unexpectedly. A stranger might see some ink sticking out from under a woman's shirt and may pull the shirt to expose the tattoo. This often happens without any warning given or permission asked. It can happen when the woman is standing in line at the store when she suddenly feels a hand on her back. Besides tattoos, pregnant bellies have been known to solicit touching from strangers and perhaps some hairstyles as well (mohawks, dreadlocks, or afros). Some participants also report strangers touching (facial) piercings. Study participants did not anticipate strangers touching their tattoos, and they do not understand the impulse, as tattoos don't "feel" like anything. If not interested in the feel of tattoos, strangers might be attempting to shift articles of clothing to get a better look at glimpsed tattoos. This physical invasion of space was a nearly universal experience. Evelyn Park described two of her experiences:

> The first thing that I noticed was in comparison to my tattooed male friends. People don't seem to have any boundaries with me. . . . You don't see some big tattooed guy walking down the street, with everyone grabbing him. But people grabbed me on the street. They constantly stopped and asked me questions. It's always the starting point for getting hit on. It's definitely a different ballgame for us. My guy friends that have a lot of ink don't really get bothered as much. They get the questions, but nobody touches them as much. And it's been a disconcerting experience for me, for sure. . . . Another time, I was on Collins Street, having dinner with a friend at one of those outdoor restaurants, so we were sitting on the street. Some guy just walks by, stops, and grabs me. I couldn't believe the audacity! And he grabbed my arm and says, "Hey, I know you. You were on that show!" And I responded, "No, I was not on a show. Please take your hands off of me and keep walking." "Oh, I'm sorry I didn't

mean any disrespect, you know, I just think it's cool." I was like, how do you just walk up to somebody and grab them on the street. What's wrong with you? If you have tattoos, you have no personal space? I don't understand that.

Typically, curiosity overcomes tattoo touchers, and they reach for a tattoo, oblivious for a moment, that they are breaking the interactive rules of social boundaries, as Goffman categorizes them in *Behavior in Public Places*. When I asked, "Touching?" the participants would explode with their answer, "Yes! All the time!" Sharon Cafeo told me:

> That really drives me crazy. I will be out somewhere: People pull down my shirt in order to look at my back. It's just, don't touch me, you know, this is my body. You don't need to be touching me. But that happens a lot. People come up and grabbed my arm. People I don't know.

Rather than take responsibility for their breach of social etiquette, strangers justify their behavior by blaming the tattooed person for having something so alluring. Jennifer Wilder, with 80 percent of her body covered in ink, received such responses frequently:

> I've had people say, "Well it's your own fault, obviously you wanted them to look. Or you would not have covered your body in it." Well, it's my art, and it's for me. A lot of times, I will completely cover it up. And then, people want to pull up your shirt and look. That's my artwork, it's my choice if I share it with you or not. Just because I am tattooed, it doesn't mean that you can come over and gawk at me. I'm still a human.

With such awkward public interactions involving their personal space, tattooed women are put in a complex interactional situation: negative stereotypes, their own emotional frustration, the attitude of the stranger, and the larger social context. Oftentimes, they let the interaction pass with the least amount of hostility, even though they may be upset. In the end, as Goffman implies in the previous quote, it is often up to the one with a stigmatized identity to be even more appropriate and accommodating in her behavior, even when the stranger is the one transgressing social norms of public behavior. Living in Tennessee, Talia

Robertson gave some insight into her attempts to understand and cope with invasive attention:

> So I've got to understand the social boundaries and how people perceive what it means to be tattooed. People just don't understand it. So then they forget the social rules about not reaching out and touching somebody, or asking blunt questions, which in any other situation would be perceived as very rude.

As Carol Brooks Gardner explored in her large-scale study, *Passing By*, women already negotiate verbal objectification; tattoo discrimination simply adds another layer.[47] Some participants had a set arsenal of comebacks for tattoo comments, for example, Dawn Harris in Texas, who said that "normally I try politely as possible to move my arm away and just break the contact altogether, without having to say anything. But there's been a couple of instances where I had to be like okay, enough." The majority of participants struggled with the appropriate response, similar to Eudora Doe Hawkes: "I haven't really come up with a way to deal with that really. I don't think I've dealt with it besides pulling away. I have never really said anything. I probably should have, but . . ." Politeness is the safest response in the situation, and most follow that path in order to reduce conflict. However, the constant barrage of attention can wear one down. If someone approaches at the wrong time some of the tattooed have responded in a hostile manner. This usually provokes further rejection and discrimination from the questioner. In Spencer Cahill and Robin Eggleston's research on wheelchair users, they find that "users who refuse or resist unsolicited acts of sympathetic assistance risk being viewed as having 'an attitude' or 'a chip on their shoulder.'"[48] In Spokane, Washington, teenager Erica was often exasperated by the negative attention she received:

> Okay, so, sometimes, it's like, "Fuck you" or, "What the fuck are you looking at?" Especially when someone is just being blatant and rude to me. I really wanted to tell that old lady in the doctor's office just to fuck off, because she really hurt my feelings. Later, I kind of laughed about it, just the way she was like, "Oh my God." When I thought about it later, it was pretty funny. But right then, I was pretty pissed off.

If visible tattoos provoke such interactions on a daily basis, it is understandable that the participants would choose to cover up their tattoos with clothing to avoid such situations.

Covering Up

As this chapter demonstrates, the heavily tattooed person can become weary about public attention because of these daily encounters. She begins to take her tattoo visibility level into account when selecting her daily wardrobe: Do tattoos need to be concealed for work? What about a short trip to the mall? Or for a family visit? "People with tattoos often feel that they should cover their body markings in public or risk social rejection."[49] While visible tattoos are becoming more common, such exposure was more of an issue decades ago. Older tattoo artists describe the change over time:

> So I wound up getting this skull and bats on my arm [and I wore] that around for a while, but it [seemed] like every time I got on the bus or went somewhere people thought I was a tough girl, in a gang, or a biker chick. I got treated really weird. And I just got tired of it, so I covered it up when I [went] out in the public.

In this quote, Vyvyn Lazonga demonstrates the social perceptions she experienced during the early days of her tattoo collection in Seattle. Now she covers her tattoos as a learned defense, at the same time that Seattle has become a heavily tattooed haven. Yet even though seeing ink work is commonplace, it still attracts a lot of attention, albeit more positive. Debbie Lenz, a tattooist in Ohio, also became accustomed to negative treatment in the past:

> For years, if I would go to the mall, I would cover my arms. I remember the first time I got a positive reaction to my tattoos. I was shopping in the mall, in the makeup department, and I had three-quarter length sleeves on, and so they were showing. This woman that worked there came running over and was like, "Oh my God, I love it. Can I see your arms?" And I felt like—wow this is great. Since then, I've had mainly really good reactions. But sometimes I get looks, or you get a negative response.

Nearly all of the participants choose to conceal their tattoos in order to ease certain social situations. In Spokane, Sparkill-icious reports:

> Yeah, sometimes I do get irritated with the way the public treats me. If I don't want to deal or be hassled, I will wear long sleeves, have my hair down, you can't see any of my tattoos when my hair is down, and take my piercings out. You don't even know that I'm tattooed or pierced. My daughter is on the softball team as well as Girl Scouts, and a lot of times last summer the parents really, really snubbed me. It kind of bothered me but, you know, I am here doing the same exact thing they're doing, so what can I do about it?

In Long Beach, California, Shorty Kushman has a similar response: "I usually wear hoodies all the time. I'm also cold all the time. So I'm usually always covered." But concealment can be difficult, if not impossible, for some heavily tattooed people with public ink. In her study of tattooed people, Shannon Bell provides an example:

> More heavily tattooed people have a harder time covering their tattoos, which may lead one to assume that they like it that way and enjoy the attention. From my experience and interactions with numerous other heavily tattooed people over the years, this is not the case.[50]

Concealment can also create anxiety, fear, and stress about the possibility of exposure.[51] For those who are hiding extensively in their social lives, they may "become obsessively preoccupied with thoughts of their stigmas. Such effects have important implications for daily functioning, and for the psychological—and even physical—well-being of stigmatized persons."[52] Hiding an important aspect of oneself creates negative psychological ramifications, where the pressures of concealment are constantly activating internal stress responses.

Toward Social Acceptance

Erving Goffman argues that a central motivating desire for stigmatized individuals is to find social acceptance.[53] Study participants may not have realized that there would be a lingering tattoo stigma or how it

would affect their daily lives until they had become visible tattooed. The attention they receive in public often crosses the line of socially appropriate behavior, which is upsetting to the participants. Tattooed women consistently state that they want appropriate public behavioral norms upheld—studied indifference, no comments on appearance, and respectful treatment. Most comments about participants' tattoos were uttered with little communicative purpose except to express the observation that one is tattooed. Such comments are unnecessary. Appropriate comments might include an interest in a particular tattoo style or to inquire about the artist because one wants to also get a similarly styled tattoo. If one must comment on tattoos, it is more appropriate to be mindful, to ask permission to comment, and to refrain from expressing one's own negative reaction to the ways others have chosen to decorate themselves. Strangers would be more supportive if they withheld their verbal comments and provided silent approval toward their tattooed community members. It is never acceptable to touch another person without explicit permission in such situations. Rather than verbalizing one's approval of another's ink, it would be more progressive for us as a community to demonstrate that we are moving past imposing a tattoo stigma on others by simply not remarking on their presence. Once tattoos are unremarkable, we can begin the process of assimilation.

Conclusion

Visible tattoos attract attention, there is no doubt. Strangers are sometimes drawn to them, even staring or commenting upon them. Therefore, the presence of body art alters behaviors and interactions in public spaces. As Erving Goffman has observed, strangers are trained to practice a civil inattention to others in public by ignoring overheard conversations or other people's behavior in general, but this practice is disrupted by a stranger's pressing interest to break social boundaries in order to question the presence of ink. This is not necessarily a negative occurrence; it simply provides an opportunity for social interaction. Both negative and positive interactions follow: a comment about how beautiful the body art appears, or a socially sanctioning grimace and negative statement. For sociologists, these daily microinteractions

matter: They demonstrate how social behaviors manifest, how differences in power, status, and lifestyle alter interaction. On the one hand, these microinteractions show us that, while tattoo presence is increasing (as noted by the positive comments), a tattoo stigma still lingers (as represented by the hostile comments that are still received). On the other hand, with the growing popularity of tattoos, there are more diverse tattooed people, and they have their own subcultural style of interacting with each other in public, which often differs from the approach of non-tattooed strangers. When heavily tattooed people interact, they may not discuss their similarly inked status, or their relevant conversation may share insider knowledge about styles of tattoo art or specific artists. They may even share stories about reactions they have received. These different types of interaction point to an underlying social structure that Pierre Bourdieu calls "habitus." The approach others have toward a tattooed person illustrates their social position related to the topic; their discursive approach demonstrates (again, as Bourdieu labels them) their taste, distinction, or cultural capital. Are they demonstrating a petit bourgeois distancing from the "vulgar" tastes of the working class? Are they demonstrating subcultural knowledge by discussing the various styles of tattoo art, from classic Americana to Japanese art? What is the purpose of their statements? Is it in order to recognize the growing social acceptance of body art, or to police boundaries of appropriate feminine behavior? The intention and social context of the comments matter.

Tattooed people still face social stigma toward their visible tattoos as demonstrated by the level of hostile interactions they continue to experience. All of the participants have experienced negative social sanctions that have ranged from stares, to grimaces, to rude comments, and to touching. People who respond in such a manner are acting in the role of what Howard Becker calls the "moral entrepreneur," one who upholds social rules by bringing the infraction of such rules to the attention of others. Sanctioning comments put tattooed women in the defensive position of protecting their "face" (according to Goffman, the most important aspect of an individual within social interactions). Such a barrage of attention can lead one to cover up one's tattoos with clothing to reduce such public behavior. What the interactions in this

chapter demonstrate is the desire of tattooed women for a "tattoo etiquette," which simply attempts to reinstates Goffman's idea that civil inattention and normative public behavior rituals should be applied to tattooed individuals equally. The fact that an individual has visible tattoos should not be reason enough to breech social conventions of propriety.

Conclusion

Toward a Tattoo Etiquette

Heavily tattooed women have something to contribute to our understanding of our social world. Historically, tattooing in the United States has been associated with men and masculine subcultures, especially so-called deviant ones. Women have been nearly invisible in the history of the practice and simply offhandedly assumed to be similarly deviant as tattooed men. However, women have a different history of tattooing, one that is important to understand when we consider the overall history. Starting off as heavily tattooed sideshow performers, these few women eclipsed the men on stage with their tantalizing revealment of flesh and their exciting tales of being kidnapped and tattooed against their will. These stories shielded the women from taking responsibility for their condition—they cast themselves as victims who were making the best of a situation forced on them. Other tattooed women were wives of tattoo artists who became tattooed as stand-ins for a portfolio demonstrating their husband's work. Many decades later, with the rise of motorcycle club members' reliance on tattoos to foster their hyper-masculine, tough-guy appearance, women again collected tattoos along with their partners. These were often "property of . . ." tattoos, which branded their bodies with the names of their male partners. Still other women collected small and hidden tattoos in the mid-twentieth century, as a thrilling secret that demonstrated their wild side. But it was not until the 1960s and 1970s, with the rise of social movements, especially the women's movement, when women began to get tattoos that reflected their own identity. This was a significant shift from being branded by tattoos as property of male ownership. Now women were reclaiming their bodies for themselves.

The women's movement provides an appropriate background for understanding the rise of women becoming more heavily tattooed

since the 1970s. While women struggle to define their own identity, lifestyle, and appearance, they face constant pressure from the media and the overall culture to behave properly—to be "feminine." Tattooing, therefore, can be perceived as one manner of rejecting femininity, of rejecting the notion that women need to keep in their "proper" place, and of expressing agency. Or, as other study participants have demonstrated, tattooing is an expression of feminine beauty, with women often re-interpreting their tattoos, seen as unfeminine and ugly by the overall culture, as feminine and beautiful. But no matter their intention, heavily tattooed women will, for the foreseeable future, encounter social resistance to their embodied practices with which they must contend. It is that daily interactive struggle with others that this book has addressed. The heavily tattooed women's voices in this book have discussed their struggles to be understood by family members, strangers on the street, and employers. Often, others do not understand the desire to become heavily tattooed because they are unfamiliar with the practice, are misinformed, or have stereotypical beliefs about tattooing. Therefore, the women challenge stereotypes in their daily lives. The Seattle tattooist Jacqueline Beach used the term "tattoo etiquette" with me as we discussed responses she has received to her tattoos in public. Ultimately, it is a goal that resonates with the women: being treated with respect and not having their tattoos provoke hostility or even verbal curiosity.

So what would a tattoo etiquette look like? To begin with, it would recognize that the stigmas associated with tattooing were developed fifty to one hundred years ago, based on reaction to small groups of subcultural men becoming tattooed as a means to enhance their tough appearance (sailors, criminals, and bikers). However, since the 1970s and 1980s, tattooing has gone mainstream. Tattoos are widely visible in the media, especially on reality television shows that cast non-actors (i.e., "real people"). Also, a large percentage of the population—nearly 25 percent—is now tattooed. Therefore, to cast someone as a deviant for simply having a tattoo—or ten—is historically inaccurate and lazy. Since becoming heavily tattooed no longer represents deviant behavior, such associated stigmas should lessen.

Erving Goffman's theories of social interaction demonstrate the details of behavior in public places and their social enforcement. He

even cites manuals of manners and etiquette to demonstrate the ways in which we are told to behave. Yet somehow, when an individual has many tattoos on her arms, such social rules are breached, as a curious bystander reaches out to touch the tattoos or asks a question such as, "Did that hurt?" So absorbed is the bystander in looking at the ink work, she overlooks or misunderstands the sigh that the tattooed person makes as she gently retracts her arm from the grasp of the stranger. But how do we implement a "tattoo etiquette" between strangers, especially when the offending party does not see her behavior as inappropriate? Does the interaction rely on the heavily tattooed person operating as educator, and as the "bigger person," by not recoiling in defense? Every day, these microinteractions are happening, for better or worse outcomes. Some individuals naturally take to this public education role and do not mind when strangers grab their arms; others, like myself, are too introverted to come up with a proper response in the moment. Changing social interactions takes time.

In the chapter on tattooed women in the workplace, I showed that formal rules and regulations regarding dress codes affect heavily tattooed people directly, and yet even these rules are enforced unevenly—leading to more blurred boundaries and lawsuits. These dress codes are most often found in the service industry and the military. However, for white-collar professionals, who are assumed to be upstanding and non-tattooed, they rarely have explicit rules regarding dress code; rather, they rely on informal understandings of dressing professionally, or "fitting in." Yet, as we can see, for example, in the photography book *Inked Inc.*, plenty of white-collar workers are also hiding, or not hiding, ink under their suits.[1] As we have seen, there are businesses that are more "tattoo friendly" than others, practicing non-discrimination against the modified. Other companies require employees to cover up tattoos and piercings, often resulting in employees wearing bandages on their arms or face, as if they suffer an endless injury. Is this a better image than the butterfly or skull tattoo underneath the bandage? One idea to counteract this discrimination against tattoos in the workplace, I suggest, would be to dismiss laws that regulate against visible tattoos. As previously noted, there are regulations in certain U.S. cities and in some other countries that ban discrimination based upon appearances. However, the actual number of lawsuits filed under these laws is minuscule,

Figure C.1. Kristen Wall is a heavily tattooed model and
student in Houston, Texas.

demonstrating that they are underutilized. Furthermore, in practice, the
law always takes the side of the employers, seeing no harm in allow-
ing employers to dictate the appearance of their company and their
company's employees. With the current low rates of labor union mem-
bership in the United States, workers do not have the power to make
further gains in their protection. I would hope that with a stronger labor
force, more employees will have the power to combat laws that regu-
late their appearance, among other things. Therefore, strengthening the
labor movement and workers' rights should work in the direction of
protecting diverse appearances in the workforce.

As the tattooed population grows, we require new social rules to navigate the proper interactions regarding tattoo etiquette. These interactions—both getting tattooed as well as pointing at them—merely indicate that there is a social shift taking place on the front of self-expression and public shaming that continues to evolve. In short, Goffman's guide to normative behavior in public places still remains true, decades later, on a topic he would not have anticipated (although his book *Stigma* nicely frames the issue).[2] In public, civil inattention is still anticipated by all parties: If someone's tattooed body does not directly involve oneself, it is best to leave it untouched and uncommented upon. All of us have aspects of our personal appearance that we would prefer the general public to civilly ignore or not comment upon, and it is best to remember that when we feel moved to comment upon the looks of others. This models acceptance and normalcy for others to follow. When I find myself in a grocery store in short sleeves, with other tattooed people milling about the isles, and the cashier makes small talk with me but does not mention my tattoos, or my unnatural hair color, I internally sigh relief and feel almost normal and socially accepted. And I go about my day.

NOTES

INTRODUCTION

1. Diane DiMassa, *Hothead Paisan: Homicidal Lesbian Terrorist* (Pittsburgh, PA: Cleis Press, 1993).

2. Howard S. Becker, *Outsiders: Studies in the Sociology of Deviance* (1963; reprint, New York: Free Press, 1991).

3. See, e.g., Richard S. Post, "The Relationship of Tattoos to Personality Disorders," *Journal of Criminal Law, Criminology, and Police Science* 59 (1968): 516–524; Luke Birmingham, Debbie Mason, and Don Grubin, "The Psychiatric Implications of Visible Tattoos in an Adult Male Prison Population," *Journal of Forensic Psychiatry* 10 (1999): 687–695; William Piley, "Interpreting Gang Tattoos," *Corrections Today* (2006): 46–53.

4. Jeff Ferrell, *Crimes of Style: Urban Graffiti and the Politics of Criminality* (New York: Garland, 1993).

5. Robert Garot, *Who You Claim: Performing Gang Identity in School and on the Streets* (New York: New York University Press, 2010).

6. Jeff Ferrell and Clinton R. Sanders, "Style Matters: Criminal Identity and Social Control," in *Cultural Criminology* (Boston: Northeastern University Press, 1995), 169–189, quoted at 182.

7. Lauraine Leblanc, *Pretty in Punk: Girls' Gender Resistance in a Boys' Subculture* (New Brunswick, NJ: Rutgers University Press, 1999).

8. The founding father of the stigmatizing literature on tattooing is Cesare Lombroso; among his volumes are *Criminal Woman, the Prostitute, and the Normal Woman* (with Gulielmo Ferrero, 1893; reprint, Durham, NC: Duke University Press, 2004), *The Female Offender* (Charleston, SC: Nabu Press, 2010), and *Criminal Man* (Durham, NC: Duke University Press, 2006).

9. In his study, Sanders interviewed 108 men and 52 women. See Clinton R. Sanders with D. Angus Vail, *Customizing the Body: The Art and Culture of Tattooing* (1989; reprint, Philadelphia: Temple University Press, 2008), 193.

10. Ibid., 48.

11. Margo DeMello, *Bodies of Inscription: A Cultural History of the Modern Tattoo Community* (Durham, NC: Duke University Press, 2000), vii.

12. Ibid.

13. Ibid., 160.

14. Michael Atkinson, *Tattooed: The Sociogenesis of a Body Art* (Toronto: University of Toronto Press, 2003), 4.

15. Ibid., 77.

16. Ibid., 80.

17. Victoria Pitts, *In the Flesh: The Cultural Politics of Body Modification* (New York: Palgrave Macmillan, 2003).

18. Ibid.80.

19. See Beverly Yuen Thompson, dir., *Covered* (DVD; Snakegirl Productions, 2010). Also available online at http://youtu.be/lz1p73hoKd4?list=UUNcDqjcVmYZk3mUM qesg_Gg.

20. There is a long and tortured past of making assumptions about skin and hair tone among various races. African Americans in the United States have faced numerous racist assumptions, often with exclusionary results. See, e.g., Margaret L. Hunter, *Race, Gender, and the Politics of Skin Tone* (New York: Routledge, 2005); and Evelyn Nakano Glenn, *Shades of Difference: Why Skin Color Matters* (Stanford, CA: Stanford University Press, 2009).

21. See Beverly Yuen Thompson, "The Challenges of Identity Formation for Bisexual-Multiracial Women of Asian/White Descent," in *Selves, Symbols, and Sexualities: Contemporary Readings*, ed. Staci Newmahr and Thomas Weinberg (Thousand Oaks, CA: Sage Publications, 2013).

CHAPTER 1. SAILORS, CRIMINALS, AND PROSTITUTES

1. Maarten Hesselt Van Dinter, *The World of Tattoo: An Illustrated History* (Amsterdam: Kit Publishers, 2005).

2. Joanna White, "Marks of Transgression: The Tattooing of Europeans in the Pacific Islands," in *Tattoo: Bodies, Art and Exchange in the Pacific and the West*, ed. Thomas Nicholas, Anna Cole, and Bronwen Douglas (Durham, NC: Duke University Press, 2005), 87.

3. Per Hage, Frank Harary, and Bojka Milicic, "Tattooing, Gender and Social Stratification in Micro-Polynesia," *Journal of the Royal Anthropological Institute* 2 (1996): 335–350, quoted at 339.

4. Ibid., 343.

5. Sean Mallon, "Samoan *Tatau* as Global Practice," in Nicholas et al., *Tattoo*, 145–169, quoted at 169.

6. Van Dinter, *The World of Tattoo*, 10.

7. Quoted in ibid., 11.

8. See Linda Waimarie Nikora, Mohi Rua, and Ngahuia Te Awakotuku, "Wearing Moko: Maori Facial Marking in Today's World," in Nicholas et al., *Tattoo*, 193; and Peter Gathercole, "Contexts of Maori *Moko*," in *Marks of Civilization*, ed. Arnold Rubin (Los Angeles: University of California Press, 1988), 191–203, 191.

9. Makiko Kuwahara, "Multiple Skins: Space, Time and Tattooing in Tahiti," in Nicholas et al., *Tattoo*, 171–190, esp. 171.

10. Sean Mallon, "Samoan *Tatau* as Global Practice," in Nicholas et al., *Tattoo*, 145–169, esp. 150.

11. See Van Dinter, *The World of Tattoo*, 12; and Adrienne Kaeppler, "Hawaiian Tattoo: A Conjunction of Genealogy and Aesthetics," in Rubin, *Marks of Civilization*, 157–170, esp. 157.

12. Joy Gritton, "Labrets and Tattooing in Native Alaska," in Rubin, *Marks of Civilization*, 181–190, esp. 184.

13. Nicholas Thomas, "Embodied Exchanges and Their Limits," in Nicholas et al., *Tattoo*, 223–226, esp. 223.

14. Kuwahara, "Multiple Skins," 185.

15. Margo DeMello, *Bodies of Inscription: A Cultural History of the Modern Tattoo Community* (Durham, NC: Duke University Press, 2000), 48.

16. Leo W. Banks, *Stalwart Women: Frontier Stories of Indomitable Spirit* (Phoenix: Arizona Highways, Books Divison, 1999).

17. Royal B. Stratton, *Captivity of the Oatman Girls: Being an Interesting Narrative of Life among the Apache and Mohave Indians*, Classics of the Old West (New York: Time-Life, 1982).

18. See Christine Braunberger, "Revolting Bodies: The Monster Beauty of Tattooed Women," *NWSA Journal* 12, no. 2 (2000): 1–23; and Amelia Klem, "A Life of Her Own Choosing: Anna Gibbons' Fifty Years as a Tattooed Lady," *Wisconsin Magazine of History* 89 (2006): 28–39.

19. Michael Atkinson, "Pretty in Ink: Conformity, Resistance, and Negotiation in Women's Tattooing," *Sex Roles* 47, nos. 5/6 (2002): 219–235.

20. Margot Mifflin, *Bodies of Subversion: A Secret History of Women and Tattoo* (New York: Juno Books, 1997), 25.

21. Amelia Klem Osterud, *The Tattooed Lady: A History* (Golden, CO: Speck Press, 2009), 40.

22. Steve Gilbert, *Tattoo History* (New York: Juno Books, 2000), 138.

23. See Jill Fisher, "Tattooing the Body, Marking Culture," *Body and Society* 8, no. 4 (2002): 91–107; and Atkinson, "Pretty in Ink."

24. Osterud, *The Tattooed Lady*, 63.

25. Gilbert, *Tattoo History*, 126.

26. Ibid., 127.

27. Mindy Fenske, *Tattoos in American Visual Culture* (New York: Palgrave, 2007), 1.

28. William Piley, "Interpreting Gang Tattoos," *Corrections Today* (2006): 46–53.

29. Quoted in Nikki Sullivan, *Tattooed Bodies: Subjectivity, Textuality, Ethics, and Pleasure* (Westport, CT: Praeger, 2001), 24.

30. Richard S. Post, "The Relationship of Tattoos to Personality Disorders," *Journal of Criminal Law, Criminology, and Police Science* 59, no. 4 (1968): 516–524.

31. Piley, "Interpreting Gang Tattoos," 53.

32. Timothy A. Roberts and Sheryl A. Ryan, "Tattooing and High-Risk Behavior in Adolescents," *Pediatrics* 110, no. 6 (2002): 1058–1063.

33. Post, "The Relationship of Tattoos," 524.

34. Roberts and Ryan, "Tattooing and High-Risk Behavior," 1061.

35. Julie Hicinbothem, Sonia Gonsalves, and David Lester, "Body Modification and Suicidal Behavior," *Death Studies* 30 (2006): 351–363.

36. Victoria Pitts, *In the Flesh: The Cultural Politics of Body Modification* (New York: Palgrave Macmillan, 2003), 380.

37. Albert Parry, *Tattoo: Secrets of a Strange Art* (1933; reprint, Mineola, NY: Dover Publications, 2003), 21.

38. Post, "The Relationship of Tattoos," 519.

39. Samuel Steward, *Bad Boys and Tough Tattoos: A Social History of the Tattoo with Gangs, Sailors, and Street-Corner Punks* (New York: Harrington Park Press, 1990).

40. Justin Spring, *Secret Historian: The Life and Times of Samuel Steward, Professor, Tattoo Artist, and Sexual Renegade* (New York: Farrar, Straus & Giroux, 2010).

41. Steward, *Bad Boys and Tough Tattoos*, 9.

42. Ibid., 127.

43. Ibid., 128.

44. Ibid., 129.

45. Cesare Lombroso and Gulielmo Ferrero, *Criminal Woman, the Prostitute and the Normal Woman* (1893; reprint, Durham, NC: Duke University Press, 2004).

46. Fisher, "Tattooing the Body," 96.

47. Myrna Armstrong, "Career-Oriented Women with Tattoos," *Journal of Nursing Scholarship* 23, no. 4 (1991): 215–220.

48. Steward, *Bad Boys and Tough Tattoos*, 129.

49. Daina Hawkes, Charlene Y. Senn, and Chantal Thorn, "Factors That Influence Attitudes toward Women with Tattoos," *Sex Roles* 50, nos. 9/10 (2004): 593–604, quoted at 594.

50. Xuan Santos, "The Chicana Canvas: Doing Class, Gender, Race, and Sexuality through Tattooing in East Los Angeles," *NWSA Journal* 21, no. 3 (2009): 91–120, esp. 92.

51. Karen Bettez Halnon and Saundra Cohen, "Muscles, Motorcycles and Tattoos: Gentrification in a New Frontier," *Journal of Consumer Culture* 6, no. 1 (2006): 33–56, esp. 41.

52. Ibid., 35; and Mary Kosut, "Tattoo Narratives: The Intersection of the Body, Self-Identity, and Society," *Visual Sociology* 15 (2000): 79–100.

53. Josh Adams, "Marked Difference: Tattooing and Its Association with Deviance in the United States," *Deviant Behavior* 30 (2009): 266–292, esp. 277.

CHAPTER 2. "I WANT TO BE COVERED"

1. See Judith Butler, *Gender Trouble: Feminism and the Subversion of Identity* (New York: Routledge, 2006), and *Bodies That Matter: On the Discursive Limits of Sex* (New York: Routledge, 1993).

2. See Anne Fausto-Sterling, *Sexing the Body: Gender Politics and the Construction of Sexuality* (New York: Basic Books, 2000).

3. See Alphonso Lingis, "The Subjectification of the Body," in *The Body*, ed. Donn Welton (Oxford: Blackwell Publishing, 2004); Catherine B. Burroughs and Jeffrey David Ehrenreich, eds., *Reading the Social Body* (Iowa City: University of Iowa Press, 1993); and Tamsin Wilton, "Temporality, Materiality: Towards a Body in Time," in *Discipline and Transgression*, ed. Jane Arthurs and Jean Grimshaw (London: Cassell, 1997).

4. Elizabeth Grosz, *Volatile Bodies: Toward a Corporeal Feminism* (Bloomington: Indiana University Press, 1994), x.

5. Michael Atkinson, *Tattooed: The Sociogenesis of a Body Art* (Toronto: University of Toronto Press, 2003), 16.

6. See, e.g., Kathy Peiss, *Hope in a Jar: The Making of America's Beauty Culture* (Philadelphia: University of Pennsylvania Press, 2011); and Joan Jacobs Brumberg, *The Body Project: An Intimate History of American Girls* (New York: Vintage Press, 2010).

7. Mary Kosut, "Tattoo Narratives: The Intersection of the Body, Self-Identity, and Society," *Visual Sociology* 15 (2000): 79–100, quoted at 79.

8. Shiela Namir, "Embodiments and Disembodiments: The Relation of Body Modifications to Two Psychoanalytic Treatments," in *Bodies in the Making: Transgressions and Transformations*, ed. Nancy N. Chen and Helene Moglen (Santa Cruz, CA: New Pacific Press, 2006), 76–84, quoted at 81.

9. Nikki Sullivan, *Tattooed Bodies: Subjectivity, Textuality, Ethics, and Pleasure* (Westport, CT: Praeger, 2001), 3.

10. Gail Weiss, *Body Images: Embodiment as Intercorporeality* (New York: Routledge, 1999), 43.

11. Jay Prosser, "Skin Memories," in *Thinking through the Skin*, ed. Sara Ahmed and Jackie Stacey (New York: Routledge, 2001), 52–68, quoted at 52.

12. Terence Turner, "The Social Skin," in Burroughs and Ehrenreich, *Reading the Social Body*, 15–39, esp. 15.

13. Trinh T. Minh-ha, "Not You/Like You: Post-colonial Women and the Interlocking Questions of Identity and Difference," in Gloria Anzaldua (ed.), *Making Face, Making Soul: Haciendo Caras*, ed. Gloria Anzaldua (San Francisco: Aunt Lute Books, 1990), 371–375, quoted at 371.

14. Gloria Anzaldua, "Haciendo Caras, una Entrada," in Anzaldua, *Making Face, Making Soul*, xv–xxvii, quoted at xxv.

15. Maria Lugones, "Playfulness, 'World'-Travelling, and Loving Perception," in Anzaldua, *Making Face, Making Soul*, 390–402, quoted at 396.

16. Simon J. Williams, and Gillian Bendelow, *The Lived Body: Sociological Themes, Embodied Issues* (London: Routledge, 1998), 22.

17. See e.g., Liz Frost, "Theorizing the Young Woman in the Body," *Body and Society* 11 (2005): 63–85; and Butler, *Gender Trouble*.

18. Diane Griffin Crowder, "Lesbians and the (Re/De)Construction of the Female Body," in Burroughs and Ehrenreich, *Reading the Social Body* (Iowa City: University of Iowa Press), 61–84, quoted at 68.

19. Kathryn Pauly Morgan, "Women and the Knife: Cosmetic Surgery and Colonization of Women's Bodies," in Rose Weitz, ed., *The Politics of Women's Bodies: Sexuality, Appearance, and Behavior* (New York: Oxford University Press, 2003), 164–183, esp. 165.

20. The American Society for Aesthetic Plastic Surgery (ASAPS), Press Center: Statistics, Surveys, and Trends, "Survey Shows That More than Half of Americans Approve of Cosmetic Plastic Surgery," 2011, www.surgery.org/media/news-releases/survey-shows-that-more-than-half-of-americans-approve-of-cosmetic-plastic-surgery.

21. Emily Jenkins, *Tongue First: Adventures in Physical Culture* (New York: Henry Holt & Co., 1998), 77.

22. John W. Schouten, "Selves in Transition: Symbolic Consumption in Personal Rites of Passage and Identity Reconstruction," *Journal of Consumer Research* 17, no. 4 (March 1991): 412–425, esp. 415.

23. Ibid., 416.

24. See Victoria Pitts-Taylor, *Surgery Junkies: Wellness and Pathology in Cosmetic Culture* (New York: Routledge, 2007); and Victoria Pitts, *In the Flesh: The Cultural Politics of Body Modification* (New York: Palgrave Macmillan, 2003).

25. See the entry for Janis Joplin at "The Vanishing Tattoo," n.d., www.vanishing tattoo.com/tattoo/celeb-joplin.htm.

26. Patricia MacCormack, "The Great Ephemeral Tattooed Skin," *Body and Society* 12, no. 2 (2006): 57–82, 68.

27. Katherine Irwin, "Saints and Sinners: Elite Tattoo Collectors and Tattooists as Positive and Negative Deviants," *Sociological Spectrum* 23 (2003): 27–57, quoted at 40.

28. See ibid., and Angus Vail, "Tattoos Are Like Potato Chips . . . You Can't Have Just One: The Process of Becoming and Being a Collector," *Deviant Behavior: An Interdisciplinary Journal* 20 (1999): 253–273.

29. Irwin, "Saints and Sinners," 29.

30. Ibid., 39–40.

31. Christine Braunberger, "Revolting Bodies: The Monster Beauty of Tattooed Women," *NWSA Journal* 12, no. 2 (2000): 1–23.

32. Ibid., 1.

33. Xuan Santos, "The Chicana Canvas: Doing Class, Gender, Race, and Sexuality through Tattooing in East Los Angeles," *NWSA Journal* 21, no. 3 (2009): 91–120, quoted at 103.

34. Irwin, "Saints and Sinners," 38.

35. Lee Damsky, "Beauty Secrets," in *Body Outlaws: Rewriting the Rules of Beauty and Body Image*, ed. Ophira Edut (Emeryville, CA: Seal Press, 2003), 133–143, quoted at 139.

36. See Kim Kane, "No Apologies," in *Chick Ink*, ed. Karen L. Hudson (Avon, MA: Adams Media, 2007), 141–144; Silja Talvi, "Marked for Life: Tattoos and the Redefinition of Self," in Edut, *Body Outlaws*, 211–218; and the Harris Interactive Poll, 2012, www.harrisinteractive.com.

37. Paul Sweetman, "Anchoring the (Postmodern) Self? Body Modification, Fashion, and Identity," *Body and Society* 5 no. 2 (1999): 51–76, quoted at 68.

38. See Chrys Ingraham, *White Weddings: Romancing Heterosexuality in Popular Culture* (New York: Routledge, 2008).

39. Charles Guignon, *On Being Authentic* (New York: Routledge, 2004).

40. Sarah C. E. Riley and Sharon Cahill, "Managing Meaning and Belonging: Young Women's Negotiation of Authenticity in Body Art," *Journal of Youth Studies* 8, no. 3 (2005): 261–279.

41. Paul Sweetman, "Anchoring the (Postmodern) Self?" 69.

42. Margo DeMello, *Bodies of Inscription: A Cultural History of the Modern Tattoo Community* (Durham, NC: Duke University Press, 2000), 173.

43. A design by the early pioneer tattooist known as Sailor Jerry.

44. Samantha Holland, *Alternative Femininities: Body, Age, and Identity* (Oxford: Berg Publishers, 2004), 122.

CHAPTER 3. "I ♥ MOM"

1. William S. Aquilino, "From Adolescent to Young Adult: A Prospective Study of Parent-Child Relations during the Transition to Adulthood, *Journal of Marriage and Family* 59, no. 3 (1997): 670–686, esp. 677.

2. Ibid., 678.

3. Jerome R. Koch, Alden E. Roberts, and Julie Harms Cannon, "College Students, Tattooing, and the Health Belief Model: Extending Social Psychological Perspectives on Youth Culture and Deviance," *Sociological Spectrum* 25 (2005): 79–102, esp. 96.

4. Abdul Khaleque and Ronald P. Rohner, "Perceived Parental Acceptance-Rejection and Psychological Adjustment: A Meta-analysis of Cross-Cultural and Intercultural Studies," *Journal of Marriage and Family* 64, no. 1 (2002): 54–64, esp. 61.

5. Kimberly A. Updegraff, Susan M. McHale, Ann C. Crouter, and Kristina Kupanoff, "Parents' Involvement in Adolescents' Peer Relationships: A Comparison of Mothers' and Fathers' Roles," *Journal of Marriage and Family* 63, no. 3 (2001): 655–668, quoted at 664.

6. Catrin Finkenauer, Rutger C. M. E. Engels, Susan J. T. Branje, and Wim Meeus, "Disclosure and Relationship Satisfaction in Families," *Journal of Marriage and Family* 66, no. 1 (2004): 195–209, quoted at 204.

7. Updegraff et al., "Parents' Involvement," 79.

8. Carolyn S. Henry, "Family System Characteristics, Parental Behaviors, and Adolescent Family Life Satisfaction," *Family Relations* 43, no. 4 (1994): 447–455.

9. Ibid., 452.

10. Judith G. Smetana, Aaron Metzger, Denise C. Gettman, and Nicole Campione-Barr, "Disclosure and Secrecy in Adolescent-Parent Relationships," *Child Development* 77, no. 1 (2006): 201–217, esp. 213.

11. Henry, "Family System Characteristics," 452.

12. Lauraine Leblanc, *Pretty in Punk: Girls' Gender Resistance in a Boys' Subculture* (New Brunswick, NJ: Rutgers University Press, 1999), 94.

13. Ronald L. Simons and Joan F. Robertson, "The Impact of Parenting Factors, Deviant Peers, and Coping Style upon Adolescent Drug Use," *Family Relations* 38, no. 3 (1989): 273–281, quoted at 274.

14. Leblanc, *Pretty in Punk*, 95.

15. Ibid., 97.

16. Xuan Santos, "The Chicana Canvas: Doing Class, Gender, Race, and Sexuality through Tattooing in East Los Angeles," *NWSA Journal* 21, no. 3 (2009): 91–120, quoted at 105.

17. See, e.g., Lisa Lowe, *Immigrant Acts: On Asian American Cultural Politics* (Philadelphia: Duke University Press, 1996); Joann Faung Jean Lee, *Asian Americans: Oral Histories of First to Fourth Generation Americans from China, the Philippines, Japan, India, the Pacific Islands, Vietnam* (New York: New Press, 1992).

18. See Angelika Bammer, ed., *Displacements: Cultural Identities in Question* (Indianapolis: Indiana University Press, 1994); Oliva M. Espín, *Women Crossing Boundaries: A Psychology of Immigration and Transformations of Sexuality* (New York: Routledge, 1999); Alice Yaeger Kaplan, "On Language Memoir," in Bammer, *Displacements*; S. Okazaki, "Influences of Culture on Asian Americans' Sexuality," *Journal of Sex Research* 39, no. 1 (2002): 34–41; K. D. Pyke and D. L. Johnson, "Asian American Women and Racialized Femininities: "Doing" Gender across Cultural Worlds, *Gender and Society* 17 (2003): 33–53.

19. C. N. Le, *Asian American Assimilation: Ethnicity, Immigration, and Socioeconomic Attainment* (New York: LFB Scholarly Publishing, 2007).

20. Donald S. Williamson, "An Essay for Practitioners: Disclosure Is a Family Event," *Family Relations* 47, no. 1 (1998): 23–25, quoted on 24.

21. See Adrienne Rich, *Of Woman Born: Motherhood as Experience and Institution* (New York: W. W. Norton & Co., 2005); Susan Douglas and Meredith Michaels, *The Mommy Myth: The Idealization of Motherhood and How It Has Undermined All Women* (New York: Free Press, 2005); Judith Warner, *Perfect Madness: Motherhood in the Age of Anxiety* (New York: Riverhead Trade, 2006).

22. Juleigh Howard-Hobson, "They Don't Teach This in School," in *Chick Ink*, ed. Karen L. Hudon (Avon, MA: Adams Media, 2007), 89–94, quoted at 93.

23. Cyma Gauze, William M. Bukowski, Jasmin Aquan-Assee, and Lorrie K. Sippola, "Interactions between Family Environment and Friendship and Associations with Self-Perceived Well-Being during Early Adolescence," *Child Development* 67, no. 5 (1996): 2201–2216, quoted at 2213.

CHAPTER 4. "COVERING" WORK

1. *Dictionary.com*, s.v. "discrimination," n.d., http://dictionary.reference.com/browse/discrimination.

2. Gregory B. Reilly, "Employees' Personal Appearance," *Labor Lawyer* 11, no. 2 (1995): 261–272, esp. 264.

3. Robert Garot, *Who You Claim: Performing Gang Identity in School and on the Streets* (New York: NYU Press, 2010).

4. Ibid., 50.

5. Nick Canedo, "Starbucks' New Employee Dress Code Bans Engagement Rings, Tattoos Ok," *Syracuse.com*, November 4, 2014, www.syracuse.com/news/index.ssf/2014/11/starbucks_new_employee_dress_code_bans_engagement_rings_tattoos_ok.html.

6. Catherine Hakim, *Erotic Capital: The Power of Attraction in the Boardroom and the Bedroom* (New York: Basic Books, 2011), 176.

7. Erich Weiss, dir., *Hori Smoku Sailor Jerry: The Life of Norman K. Collins* (DVD; IndiePix Films, 2009).

8. Nancy Schiesari, dir., *Tattooed under Fire*, produced by Nancy Schiesari and Laura Sobel (DVD; Amazon, 2009).

9. Army Regulation 670-1, "Wear and Appearance of Army Uniforms and Insignia," September 15, 2014, www.apd.army.mil/jw2/xmldemo/r670_1/main.asp.

10. Daniel S. Hamermesh, *Beauty Pays: Why Attractive People Are More Successful* (Princeton, NJ: Princeton University Press, 2011), 154.

11. Michael Starr and Amy L. Strauss, "Sex Stereotyping in Employment: Can the Center Hold?" *Labor Lawyer* 21, no. 3 (2006): 213–246, esp. 215.

12. Hamermesh, *Beauty Pays*, 86.

13. Ibid., 158.

14. Nancy Etcoff, *Survival of the Prettiest: The Science of Beauty* (New York: Anchor Books, 1999).

15. Hakim, *Erotic Capital*.

16. Ibid., 111.

17. Deborah Rhode, *The Beauty Bias: The Injustice of Appearance in Life and Law* (New York: Oxford University Press, 2010).

18. Philippe Bourgois, *In Search of Respect: Selling Crack in El Barrio* (New York: Cambridge University Press, 2006).

19. Ibid., 102.

20. Ibid., 142.

21. Ibid., 158–159.

22. Ibid., 145.

23. Lucille M. Ponte and Jennifer L. Gillian, "Gender Performance over Job Performance: Body Art Work Rules and the Continuing Subordination of the Feminine," *Duke Journal of Gender Law and Policy* 14 (2007): 319–368, esp. 333.

24. *Hollins v. Atlantic*, 188 F.3d 652 (6th Cir. 1999).

25. Steve Giegerich, "Dreads Lock St. Louis Convenience Store Worker Out of a Job," *McClatchy—Tribune Business News* (2012): C-4.

26. "One in Five U.S. Adults Now Has a Tattoo," February 23, 2012, www.harrisinteractive.com/NewsRoom/HarrisPolls/tabid/447/mid/1508/articleId/970/ctl/ReadCustom%20Default/Default.aspx.

27. Quoted in Elisa F. Topper, "Working Knowledge: Designing Dress Codes," *American Libraries* 36, no. 9 (2005): 80.

28. See Jill A. Fisher, "Tattooing the Body, Marking Culture," *Body and Society* 8,

no. 4 (2002): 91–107, esp. 101; and Shannon Bell, "Tattooed: A Participant Observer's Exploration of Meaning," *Journal of American Culture* 22, no. 2 (1999): 53–58, esp. 56.

29. Katharine T. Bartlett, "Only Girls Wear Barrettes: Dress and Appearance Standards, Community Norms, and Workplace Equality" *Michigan Law Review* 92, no. 8 (1994): 2541–2582, esp. 2551.

30. See, e.g., "The Modified Mind: Employment Line," n.d., www.modified-mind.com/employline.html; or "Tatoo Friendly Jobs," *Tat2X Blog: Tatoo Style, Culture and Trends*, September 17, 2012, http://tattoo-culture-style.com/2012/09/17/tattoo-friendly-jobs/.

31. Kathrine Irwin, "Saints and Sinners: Elite Tattoo Collectors and Tattooists as Positive and Negative Deviants," *Sociological Spectrum* 23 (2003): 27–57, esp. 37–38.

32. Shannon Bell, "Tattooed, 56.

33. Beverly Yuen Thompson, Kristen Wall photograph, August 16, 2013, "Snakegirl Productions," *Flickr*, www.flickr.com/photos/snakegirlproductions/9525786856/.

34. Ponte and Gillian, "Gender Performance," 351.

35. Bartlett, "Only Girls Wear Barrettes," 2557.

36. Cloutier v. Costco Wholesale Corp., 390 F.3d 126 (1st Cir. December 1, 2004).

37. Swartzentruber v. Gunite Corporation, 99 F.Supp.2d 976 (2000).

38. Americans with Disabilities Act, 42 U.S.C. 12111–17; Rehabilitation Act, 29 U.S.C. 794; Baldetta v. Harborview Medical Center, 116 F.3d 482 (9th Cir. 1997).

39. Bussell v. Motorola, Inc,. 163 F. 850 (11th Cir., 2005).

40. Riggs v. City of Fort Worth, 229 F.Supp.2d 572 (N.D. Tex. 2002).

41. Ibid.

42. Inturri v. City of Hartford, #05–2114, 165 Fed. Appx. 66, 2006 U.S. App. Lexis 2538 (2d Cir., Jan. 31, 2006).

43. Duncan Lewis, "Workplace Bullying," in *The Body in Qualitative Research*, ed. John Richardson and Alison Shaw (Aldershot: Ashgate, 1998), 91–106, quoted at 103.

44. Eliza K. Pavalko, Krysia N. Mossakowski, and Vanessa J. Hamilton, "Does Perceived Discrimination Affect Health? Longitudinal Relationships between Work Discrimination and Women's Physical and Emotional Health," *Journal of Health and Social Behavior* 44, no. 1 (2003): 18–33, quoted at 28.

45. Bartlett, "Only Girls Wear Barrettes," 2580.

46. Rhode, *The Beauty Bias*, 12.

47. Ibid., 101.

48. Steven Shriffrin, *Dissent, Injustice, and the Meanings of America* (Princeton, NJ: Princeton University Press, 1999), 10.

49. American Civil Liberties Union, "After ACLU Lawsuit, Rhode Island Town Repeals Tattoo Ban," press release, January 30, 2003, www.aclu.org/free-speech/after-aclu-lawsuit-rhode-island-town-repeals-tattoo-ban.

50. Gregory B. Reilly, "Employees' Personal Appearance," *Labor Lawyer* 11, no. 2 (1995): 261–272, esp. 270.

51. Ponte and Gillian, "Gender Performance," 366–367.

52. *Frank v. United Airlines Inc.*, Case No. 92-CV-0692 (N.D. Cal. Feb. 11, 2004), http://caselaw.findlaw.com/us-9th-circuit/1436481.html.

53. Rhode, *The Beauty Bias*, 20.

54. Hamermesh, *Beauty Pays*, 164.

55. Edward L. Rubin, "Passing through the Door: Social Movement Literature and Legal Scholarship," *University of Pennsylvania Law Review* 150 (2001): 1–83, esp. 69.

56. Victorian Equal Opportunity and Human Rights Commission, "Submission to the Australian Human Rights Commission's Consultation on Protection from Discrimination on the Basis of Sexual Orientation and Sex and/or Gender Identity," November 2010, www.google.com/url?sa=t&rct=j&q=&esrc=s&source=web&cd=1&ved=0CCAQ FjAA&url=http%3A%2F%2Fwww.humanrights.gov.au%2Fsites%2Fdefault%2Ffiles%2F content%2Fhuman_rights%2Flgbti%2Flgbticonsult%2Fcomments%2FVictorian%2520E qual%2520Opportunity%2520and%2520Human%2520Rights%2520Commission%2520 -%2520Comment%2520121.doc&ei=UL5kVMvhN6S1sASc20GgBw&usg=AFQjCNHr -dQU5EtmRO_kpaDaHy_9qCaglg&sig2=dtoqbkhQorKLHgpLF7HoDA&bvm=bv .79189006,d.cWc.

57. Basic Law for the Federal Republic of Germany, Art. 2, at the *German Law Archive*, IUSCOMP: The Comparative Law Society, December 20, 1993, www.iuscomp .org/gla/statutes/GG.htm#2.

58. Ibid., Art. 5.

59. Government of France, Art. L. 122-45.

60. Quoted in Elisa F. Topper, "Working Knowledge: Designing Dress Codes," *American Libraries* 36, no. 9 (2005): 80.

61. Quoted in Giegerich, "Dreads Lock St. Louis Convenience Store Worker Out of a Job," C-4.

62. Tracey L. Adams, "Feminization of Professions: The Case of Women in Dentistry," *Canadian Journal of Sociology* 30, no. 1 (2005): 266–292, esp. 274.

CHAPTER 5. "IS THE TATTOO GUY HERE?"

1. Margaret L. Cassidy and Bruce O. Warren, "Status Consistency and Work Satisfaction among Professional and Managerial Women and Men," *Gender and Society* 5 (1991): 193–206.

2. Jeanie Ahern Greene, *Blue-Collar Women at Work with Men: Negotiating the Hostile Environment* (Westport, CT: Praeger Publishers, 2006); and Michelle J. Budig, "Male Advantage and the Gender Composition of Jobs: Who Rides the Glass Escalator? *Social Problems* 49 (2002): 258–277.

3. Joan Acker, "Hierarchies, Jobs, Bodies: A Theory of Gendered Organizations," *Gender and Society* 4 (1990): 139–158.

4. Jacqueline H. Watts, "Porn, Pride and Pessimism: Experiences of Women Working in Professional Construction Roles," *Work, Employment and Society* 21 (2007): 299–316.

5. For example, see Irene Padavic and Barbara F. Reskin, "Men's Behavior and Women's Interest in Blue-Collar Jobs," *Social Problems* 37 (1990): 613–628; Cynthia F. Epstein, "Encountering the Male Establishment: Sex-Status Limits on Women's Careers in the Professions," *American Journal of Sociology* 75 (1970): 965–982; and Jane Latour, *Sisters in the Brotherhood: Working Women Organizing for Equality in New York City* (New York: Palgrave Macmillan, 2008).

6. For example, see Latour, *Sisters in the Brotherhood*; Tracey L. Adams, "Feminization of Professions: The Case of Women in Dentistry," *Canadian Journal of Sociology* 30 (2005): 71–94; and Lynn Zimmer, "Tokenism and Women in the Workplace: The Limits of Gender Neutral Theory," *Social Problems* 35 (1988): 64–77.

7. Janice D. Yoder, "Rethinking Tokenism: Looking beyond the Numbers," *Gender and Society* 5 (1991): 178–192, esp. 188.

8. Howard S. Becker, *Art Worlds* (Berkeley: University of California Press, 1982; reprint, 2008).

9. Alison Bain, "Constructing an Artistic Identity," *Work, Employment and Society* 19 (2005): 25–46, quoted at 34.

10. Ibid.

11. Mary Kosut, "Tattoo Narratives: The Intersection of the Body, Self-Identity, and Society," *Visual Sociology* 15 (2000): 79–100.

12. Margot Mifflin, *Bodies of Subversion: A Secret History of Women and Tattoo* (New York: Juno Books, 1997), iv.

13. Samuel M. Steward, *Bad Boys and Tough Tattoos: A Social History of the Tattoo with Gangs, Sailors, and Street-Corner Punks* (New York: Harrington Park Press, 1990).

14. Ibid, 32.

15. Ibid., 12.

16. Ibid., 68.

17. Ibid., 128.

18. Melissa Tyler and Laurie Cohen, "Spaces That Matter: Gender Performativity and Organizational Space," *Organizational Studies* 31 (2010): 175–198, esp. 187.

19. Patricia Yancey Martin, " 'Said and Done' versus 'Saying and Doing': Gendering Practices, Practicing Gender at Work," *Gender and Society* 17 (2003): 342–366.

20. Schroedel, Jean Reith, *Alone in a Crowd: Women in the Trades Tell Their Stories* (Philadelphia: Temple University Press, 1985), 80.

21. Mary Thierry Texeira, " 'Who Protects and Serves Me?' A Case Study of Sexual Harassment of African American Women in One U.S. Law Enforcement Agency," *Gender and Society* 16 (2002): 524–545; and Greene, *Blue-Collar Women*.

22. See Margo DeMello, *Bodies of Inscription: A Cultural History of the Modern Tattoo Community* (Durham, NC: Duke University Press, 2000), 110; Myrna L. Armstrong, "Career-Oriented Women with Tattoos," *Journal of Nursing Scholarship* 23 (1991): 215–220, esp. 217; and Kat Von D, *High Voltage Tattoo* (New York: Collins Designs, 2009), p. 22.

23. See Cynthia F. Epstein, "Encountering the Male Establishment: Sex-Status

Limits on Women's Careers in the Professions," *American Journal of Sociology* 75 (1970): 965–982; and Matt L. Huffman and Lisa Torres, "It's Not Only 'Who You Know' That Matters: Gender, Personal Contacts, and Job Lead Quality," *Gender and Society* 16, no. 6 (2002): 793–813.

24. See David Marshall Hunt and Carol Michael, "Mentorship: A Career Training and Development Tool," *Academy of Management Review* 8 (1983): 475–485; and Marian Swerdlow, "Men's Accommodations to Women Entering a Nontraditional Occupation: A Case of Rapid Transit Operatives," *Gender and Society* 3, no. 3 (1989): 373–387.

25. Epstein, "Encountering the Male Establishment," 970.

26. Hunt and Michael, "Mentorship."

27. Adia M. Harvey, "Becoming Entrepreneurs: Intersections of Race, Class, and Gender at the Black Beauty Salon," *Gender and Society* 19 (2005): 789–808.

28. Deana Lippens, "The Turning Point," in *Chick Ink*, ed. Karen L. Hudson (Avon, MA: Adams Media, 2007), 38.

29. Michael Atkinson, *Tattooed: The Sociogenesis of a Body Art* (Toronto: University of Toronto Press, 2003), 44.

30. Karla Erickson and Jennifer L. Pierce, "Farewell to the Organization Man: The Feminization of Loyalty in High-End and Low-End Service Jobs," *Ethnography* 6 (2005): 283–313.

31. Ibid., 306–307.

32. Amanda Cancilla, "Rewarding Challenges," Hudson, *Chick Ink*, 17.

33. Babette Lane Jinkins, "Just One of the Guys," in Hudson, *Chick Ink*, 215.

34. Xuan Santos, "The Chicana Canvas: Doing Class, Gender, Race, and Sexuality through Tattooing in East Los Angeles," *NWSA Journal* 21 (2009): 91–120, quoted at 103.

35. Sasha Merritt, "Living Canvas," in Hudson, *Chick Ink*, 47.

36. Greene, *Blue-Collar Women*, 119.

37. DeMello, *Bodies of Inscription*, 21.

38. Ibid., 126.

39. Michelle Delio, *Tattoo: The Exotic Art of Skin Decoration* (New York: St. Martin's Press, 1994), 54.

40. Epstein, "Encountering the Male Establishment," 974.

41. Christine Braunberger, "Revolting Bodies: The Monster Beauty of Tattooed Women," *NWSA Journal* 12 (2000): 1–23, esp. 16.

CHAPTER 6. TATTOOS ARE NOT FOR TOUCHING

1. Erving Goffman, *Interaction Ritual: Essays on Face-to-Face Behavior* (New York: Pantheon Books, 1967), 19.

2. Erving Goffman, *The Presentation of Self in Everyday Life* (New York: Anchor Books, 1959), 230.

3. Erving Goffman, *Encounters: Two Studies in the Sociology of Interaction* (Indianapolis: Bobbs-Merrill Co., 1961), 19.

4. See Erving Goffman, *Relations in Public: Microstudies of the Public Order* (New Brunswick, NJ: Transaction Publishers, 2010).

5. Erving Goffman, *Behavior in Public Places: Notes on the Social Organization of Gatherings* (New York: Free Press, 1963), 35.

6. Ibid., 88.

7. Goffman, *Relations in Public*, 45.

8. Ibid.

9. See, e.g., David Muggleton, *Inside Subculture: The Postmodern Meaning of Style* (Oxford: Berg, 2000), 167.

10. Joanna Frueh, "Beauty Loves Company," in *Bodies in the Making: Trangressions and Transformations*, ed. Nancy N. Chen and Helene Moglen (Santa Cruz, CA: New Pacific Press, 2006), 19–26, quoted at 23.

11. Angus Vail, "Tattoos Are Like Potato Chips . . . You Can't Have Just One: The Process of Becoming and Being a Collector," *Deviant Behavior: An Interdisciplinary Journal* 20 (1999): 253–273, quoted at 270.

12. Erving Goffman, *Stigma: Notes of the Management of Spoiled Identity* (New York: Simon & Schuster, 1963), 13.

13. For example, see Carolyn Ellis, "'I Hate My Voice': Coming to Terms with Minor Bodily Stigmas," *Sociological Quarterly* 39, no. 4 (1998): 517–537, esp. 524.

14. Goffman, *Relations in Public*, 343.

15. Goffman, *Interaction Ritual*, 32.

16. Goffman, *Stigma*, 116.

17. See Katherine Irwin, "Saints and Sinners: Elite Tattoo Collectors and Tattooists as Positive and Negative Deviants," *Sociological Spectrum* 23 (2003): 27–57; and Paul Sweetman, "Tourists and Travelers? 'Subcultures,' Reflexive Identities and Neo-tribal Sociality," in *After Subculture: Critical Studies in Contemporary Youth Culture*, ed. Andy Bennett and Keith Kahn-Harris (New York: Palgrave, 2004), 79–93, esp. 89.

18. William Ryan Force, "Consumption Styles and the Fluid Complexity of Punk Authenticity," *Symbolic Interaction* 32, no. 4 (2009): 289–309, esp. 291.

19. Pierre Bourdieu, *The Logic of Practice* (Stanford, CA: Stanford University Press, 1980), 55–56.

20. Ibid, 8.

21. Pierre Bourdieu, *Distinction: A Social Critique of the Judgment of Taste* (Cambridge, MA: Harvard University Press, 1984), 18.

22. Ibid., 56.

23. Ibid., 57.

24. Ibid., 56.

25. Ibid., 58.

26. Howard S. Becker, *Outsiders: Studies in the Sociology of Deviance* (New York: Free Press, 1963; reprint, 1991), 122.

27. Stuart L. Hills, *Demystifying Social Deviance* (New York: McGraw-Hill Book Co., 1980), 15.

28. For gender performance, see Judith Butler, *Undoing Gender* (New York:

Routledge, 2004), and *Gender Trouble: Feminism and the Subversion of Identity* (New York: Routledge, 2006).

29. Bourdieu, *Distinction*, 214.

30. Daina Hawkes, Charlene Y. Senn, and Chantal Thorn, "Factors That Influence Attitudes toward Women with Tattoos," *Sex Roles* 50, nos. 9/10 (2004): 593–604, quoted at 604.

31. Irwin, "Saints and Sinners, 38.

32. See Linda McDowell, *Gender, Identity, and Place: Understanding Feminist Geographies* (Minneapolis: University of Minnesota Press, 1999); and Carol Brooks Gardner, *Passing By: Gender and Public Harassment* (Berkeley: University of California Press, 1995).

33. Hawkes et al., "Factors That Influence Attitudes," 601.

34. Lauraine Leblanc, *Pretty in Punk: Girls' Gender Resistance in a Boys' Subculture* (New Brunswick, NJ: Rutgers University Press, 1999), 173.

35. Shannon Bell, "Tattooed: A Participant Observer's Exploration of Meaning," *Journal of American Culture* 22, no. 2 (1999): 53–58, quoted at 56.

36. Goffman, *Behavior in Public Places*, 88.

37. Tara Alton, "Tattoo Fever," in *Chick Ink*, ed. Karen L. Hudson (Avon, MA: Adams Media, 2007), 161–166, quoted at 162.

38. A participant quoted in Patricia MacCormack, "The Great Ephemeral Tattooed Skin," *Body and Society* 12, no. 2 (2006): 57–82, quoted at 68.

39. Leblanc, *Pretty in Punk*, 177.

40. Goffman, *Stigma*, 136.

41. Samantha Holland, *Alternative Femininities: Body, Age, and Identity* (Oxford: Berg Publishers, 2004), 98.

42. Bourdieu, *Distinction*, 61.

43. Bourdieu, *The Logic of Practice*.

44. Leblanc, *Pretty in Punk*, 184.

45. Ibid., 191.

46. Goffman, *Stigma*, 116.

47. Gardner, *Passing By*.

48. Spencer E. Cahill and Robin Eggleston, "Managing Emotions in Public: The Case of Wheelchair Users," *Social Psychology Quarterly* 57, no. 4 (1994): 300–312, quoted at 309.

49. Jill Fisher, "Tattooing the Body, Marking Culture," *Body and Society* 8, no. 4 (2002): 91–107, quoted at 101.

50. Bell, "Tattooed." quoted at 56.

51. Carol T. Miller and Brenda Major, "Coping with Stigma and Prejudice," in *The Social Psychology of Stigma*, ed. Todd F. Heatherton, Robert E. Kleck, Michelle R. Hebl, and Jay G. Hull (New York: Guilford Press, 2000), 243–272, esp. 263.

52. Laura Smart and Daniel M. Wegner, "The Hidden Costs of Hidden Stigma," in Heatherton et al., *The Social Psychology of Stigma*, 220–242, quoted at 221–222.

53. Goffman, *Stigma*, 8.

CONCLUSION

1. Dave Kimelberg, *Inked Inc.: Tattooed Professionals* (Charlestown, MA: Inked Inc. Press, 2007).

2. Erving Goffman, *Stigma: Notes of the Management of Spoiled Identity* (New York: Simon & Schuster, 1963).

INDEX

ABOUT THE AUTHOR

Beverly Yuen Thompson is Assistant Professor of Sociology at Siena College in Loudonville, New York.

Lightning Source UK Ltd.
Milton Keynes UK
UKOW02f2011251016
286146UK00004B/332/P